IMAGES
of America

WESTFIELD

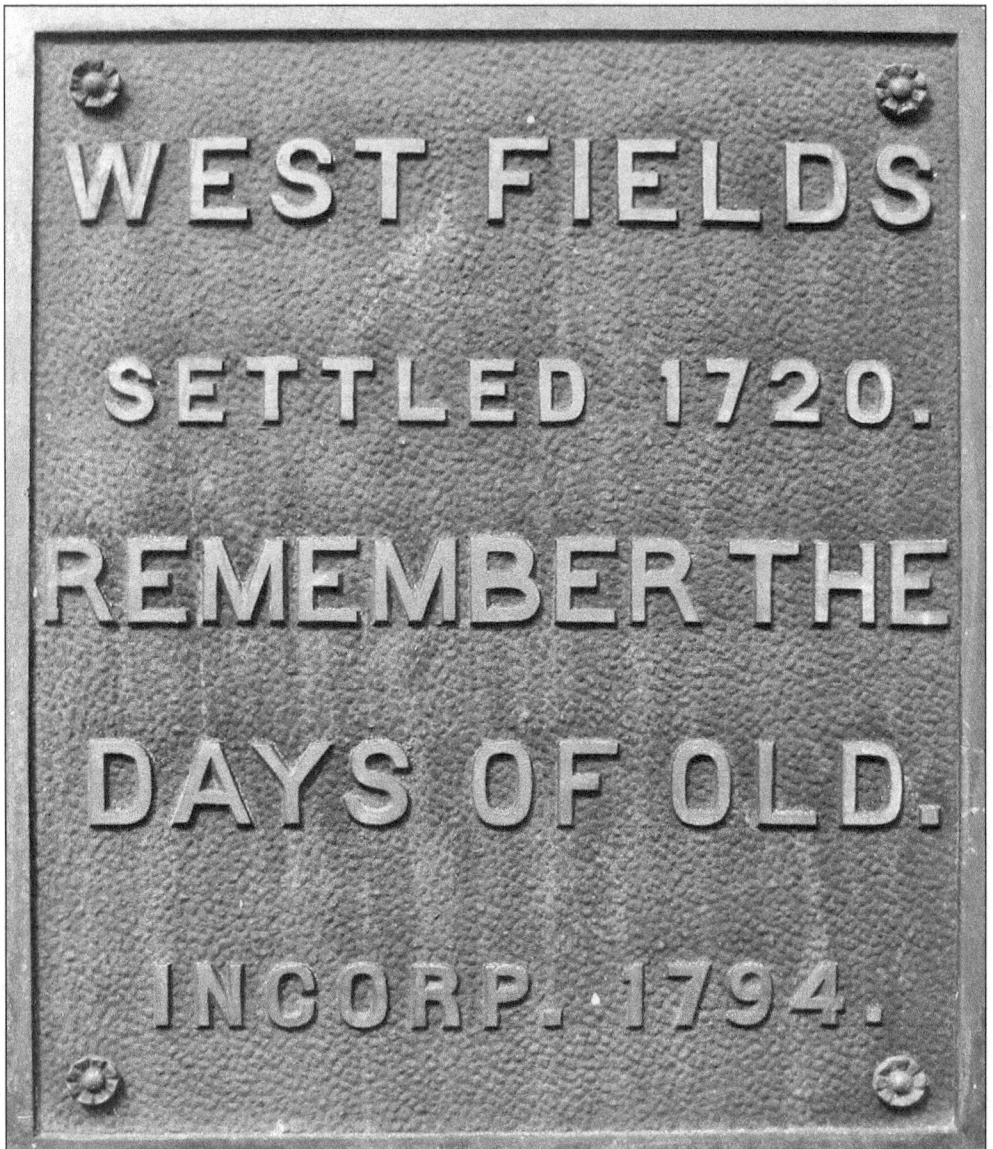

In 1959, this plaque was placed on the building at 231–237 East Broad Street, marking the spot where the town's first hotel and store stood. The sign was found on a tree stump near the building. It was cleaned up and refurbished before being dedicated by mayor and historian Charles A. Philhower. (Courtesy of the author.)

ON THE COVER: The Peoples Bank and Trust Company opened in 1907. The original financial institution, People's National Bank, rented space in a store in the Abbott Building. As the population of Westfield grew, so did the number of patrons. By 1923, this structure was constructed to house the popular bank. Parked in front of the bank is the Westfield Fire Department's fleet of fire-fighting equipment, operated by the fire company men. (Courtesy of the Westfield Historical Society.)

IMAGES
of America

WESTFIELD

Jayne Book Salomon

ARCADIA
PUBLISHING

Published by Arcadia Publishing
Charleston, South Carolina

Library of Congress Control Number: 2010925579

For all general information, please contact Arcadia Publishing:
Telephone 843-853-2070
Fax 843-853-0044
E-mail sales@arcadiapublishing.com
For customer service and orders:
Toll-Free 1-888-313-2665

Visit us on the Internet at www.arcadiapublishing.com

*To my beautiful sons—Michael, Jason, and
Jeffrey—the three sunshines of my life*

CONTENTS

ACKNOWLEDGMENTS

First, I must thank George Hawley, Ph.D, supervising librarian at the Newark Public Library, whose attentive cooperation was invaluable in getting this project started. The following helped in some way, whether big or small, and I thank them all: Horace Corbin, publisher of the *Westfield Leader*; Michael Pollack, arts and entertainment editor of the *Westfield Leader*; Nancy Priest, president of the Westfield Historical Society; Stan Lipson, Ed Wittke, Donald Mokrauer, and the entire board of the Westfield Historical Society. Without the help of my technical support people, Sebastian Kucik and Marty Cohen, this endeavor would not have reached completion. I particularly thank Ralph Jones for his extensive work in researching, gathering, and documenting the historical information that has become the backbone of the Westfield Historical Society's archives. Thank you to all the families who have donated their personal photographs and accounts of historical events. Without these valuable contributions, this book would not have been possible. A big thank you to my friend Patricia Cunniff, whose faith in me and in this project helped turn this effort into a success. Additionally, the input and cooperation that were so lovingly given by my friend Veronica Sidhu and my cousin Priscilla Gandel will never be forgotten. I also wish to thank my editor at Arcadia Publishing, Erin M. Rocha, for her professional guidance.

Finally, thank you to my husband, Garry, for his helpful input, and a heartfelt thank you to my sons, Michael, Jason, and Jeffrey, for their encouragement, support, enthusiasm, and insightful perceptions.

As with any history book, it can be difficult to verify the accuracy of dates, events, and other important data, as resource materials are sometimes inaccurate and even contradictory. During the research and writing of this book, I have uncovered several accounts of events relating to people, places, or things that are fable, legend, or anecdote. I have put forth my best effort to distinguish between the three and to illustrate, to the best of my knowledge, only the facts. The majority of the photographs used are the property of the Westfield Historical Society. During the process, however, it became apparent that some images, although the property of the society, were taken from the cameras of professional photographers. I thank Karl Baumann and Westfield Photography. Other sources consulted include *The History of Union County, New Jersey*, by F. W. Ricord (1897); *The Olde Towne* and *The Olde Town Scrapbooks*, by Robert V. Hoffman (1937); *A History of Town of WestField, Union County, New Jersey*, by Charles A. Philhower, M.A.; *Colonial Westfield: Past and Present*, compiled and published under the auspices of the Westfield Tercentenary Committee; and Internet sites www.wikipedia.com and www.westfieldnj.com.

Unless otherwise noted, all images appear courtesy of the Westfield Historical Society.

INTRODUCTION

Over 400 years ago, Native Americans wandered the undeveloped, heavily wooded land that today is the charming suburban community of Westfield, New Jersey. Several tribes inhabited this part of the state. Among them were the Raritans, Leni Lenapes, and Unamis. These first settlers have been remembered with street, park, lake, and country club names. Lenape Trail, Mindowaskin Park, Minisink Way, Shackamaxon Country Club, and Raritan Road in the next town of Clark are a few examples. It has always been important to the folks of Westfield to recognize these inhabitants, who were the first to begin making the land livable.

On September 6, 1609, John Coleman first explored the tract of land that is now Westfield, under the direction of Henry Hudson. On that same day, an arrow from a native killed Coleman. Later, Dutch immigrants, who had begun colonizing Manhattan and Staten Islands, unsuccessfully attempted to settle the region. Apparently the tribes were well aware of the brutal attacks the Dutch colonists had bestowed upon their brethren in Staten Island and the surrounding areas, and they forcefully resisted these intruders.

In the mid-17th century, the governor of New York, Richard Nicolls, arranged to purchase the tract of land west of Elizabeth Town, known then as the West Fields, from the natives occupying the territory in exchange for a minimal amount of supplies. The land was acquired for two coats, two guns, two kettles, 10 bars of lead, 20 handfuls of powder, and 400 fathoms of wampum (beads). At this time, the West Fields included Perth Amboy, Woodbridge, Rahway, Union, Springfield, and Westfield. The land cost only 1¢ per 10 acres. Today Westfield is one of New Jersey's more premium and expensive suburban towns. For several years, there was some discrepancy as to who held the rights to the area. In 1664, the Duke of York granted a portion of the land between the Hudson and Delaware Rivers to his friends Lord John Berkeley and Sir George Cartaret, unaware of the trade between Nicolls and the tribes. Berkeley and Cartaret named the territory New Jersey, after the English island.

It was the English who eventually settled the West Fields in 1720. It is not clear who the very first British settlers were, but the names Wilcox, Badgley, Clark, Woodruff, Marsh, Miller, Cory, Pierson, Scudder, French, Welch, and Crane were among the earliest. Many of their headstones and those of their family members can be found in Westfield's historic Revolutionary Cemetery, which sits across the street from and is affiliated with the Presbyterian Church in Westfield. In the 1770s, the West Fields consisted of the post towns of Plainfield, Scotch Plains, and Mountainside and portions of several surrounding towns, including Cranes Ford (Cranford) and Garwood. Westfield was a small village then with few settlers, most of whom were farmers who mainly cultivated wheat, rye, barley, and corn. Growth was slow for a long period of time. In the 18th century, the village had one church (the Presbyterian Church in Westfield), one school, one blacksmith, one store, one tavern, and about 14 homes.

In 1774, Westfield became an independent township, separate from Elizabeth Town (now Elizabeth), to which it had been connected for 100 years. The town was originally part of Essex

County but later joined with Elizabeth and the land to the west to form Union County. The large celebration that ensued as a result of Westfield's founding was probably the first of its kind in the area but certainly not the last. The party, attended by the entire town, included a big feast complete with plenty of gin and the town's signature drink, apple cider. It is reported that everyone went home happy and content and with a renewed sense of town pride. Since then, many other celebrations have followed, as Westfield has always had a strong sense of patriotism as well as a keen appreciation for milestones.

When the Revolutionary War broke out in 1775, Westfield's citizens established a command post led by Capt. Eliakim Littell and largely composed of volunteers. The company was named the Jersey Blues after the color of the uniforms the soldiers donned. Throughout the Revolutionary War, several militia units were based in Westfield. The most notable was headed up by Mad Anthony Wayne during the winter of 1779–1780. He was known for his brave capture of Stony Point, New York.

When the War of 1812 broke out, the men of Westfield once again rushed to serve their country. There was not much involvement, because the conflict was mostly fought by the navy and too far from Westfield to have much of an impact.

During the War of 1812, the governor of New Jersey, Joseph Bloomfield, was forced to leave the state on business. He assigned custody of the state seal to the vice president of the state, the Honorable Charles Clark of Westfield. It was protocol to assign the seal to a high-ranking official in the governor's absence. In essence, Westfield was the capital of New Jersey for the brief period he held possession of the Great Seal.

With the advent of the Elizabeth Town and Somerville Railroad in the 1830s came the promise of future growth. Prior to this, public transportation was strictly limited to stagecoach lines. Suddenly New York had become closer to Westfield. Improved transportation increased commuter traffic, which led to the gradual changeover from small farming village to attractive suburban community. In the early 20th century, local real estate developers began to reap the benefits of Westfield's formative growth period. During the Depression, progress continued through WPA projects. As the economy recovered, Westfield's downtown expanded to meet the needs of the many residents.

Nestled between the two major cities of New York and Philadelphia, with proximity to the New Jersey Shore, and possessing outstanding architectural, educational, and cultural amenities, Westfield remains a desirable town to call home.

One

HISTORIC HOMES

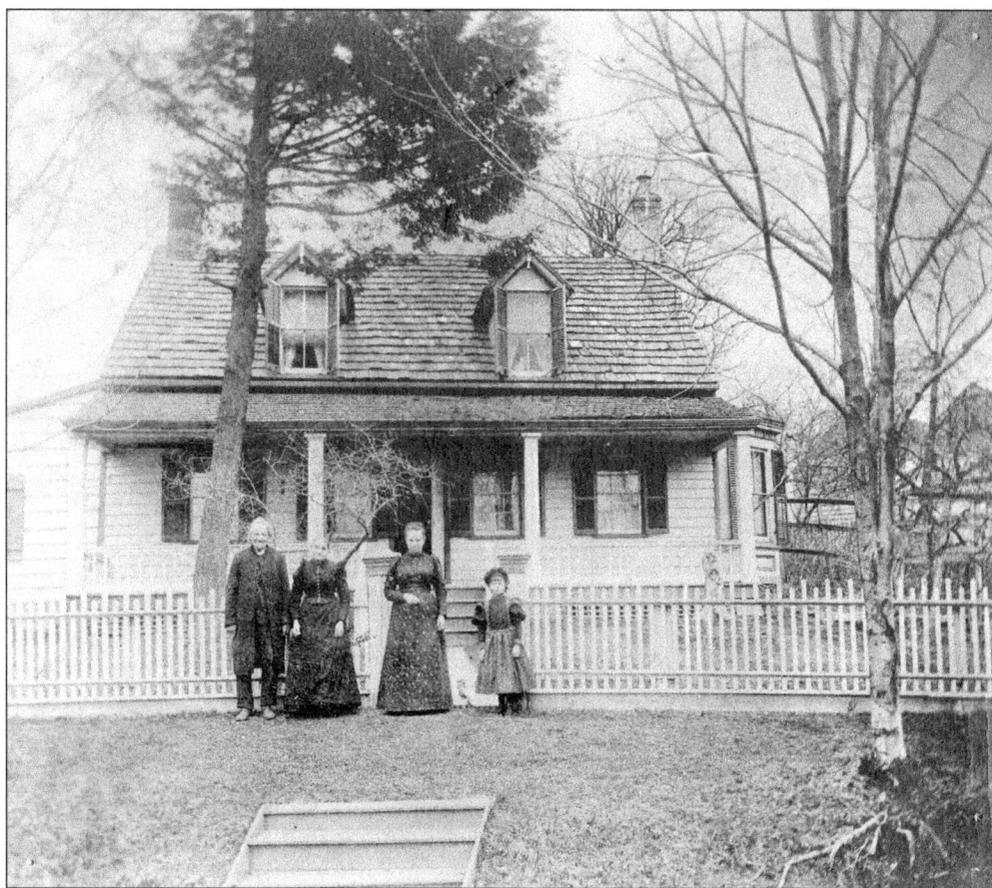

The Benjamin Pierson home was located at 231 Benson Place. During the Revolutionary War, British soldiers stopped here on their retreat from Springfield and were met by Westfield's minutemen. A famous scrimmage ensued. Some time in the 1890s, three generations of the Pierson family pose in front of the home. Built in 1689, the house survived for over 300 years. It was razed in 2004.

A descendant of the original Pierson family, Charles Pierson was born in 1818. He owned a large farm that he inherited from his ancestors where he spent most of his life. When Pierson passed away in 1903, his sons continued the tradition of running the family farm. Below are the Pierson brothers, John (left) and Charles (right), the last of a long line of family members to tend the large property known as the David Pierson farm. This photograph of the two sons was taken in the 1940s, when they were well into their 80s. In the early 1900s, Westfield was enjoying a period of growth. Charles Pierson profited by significantly increasing his herd of dairy cows, founding a milk route, and growing the dairy business to become a leader in the industry. He eventually sold the dairy farm and milk route to Edward G. Fink, a relative of his wife, and Edward Dougherty.

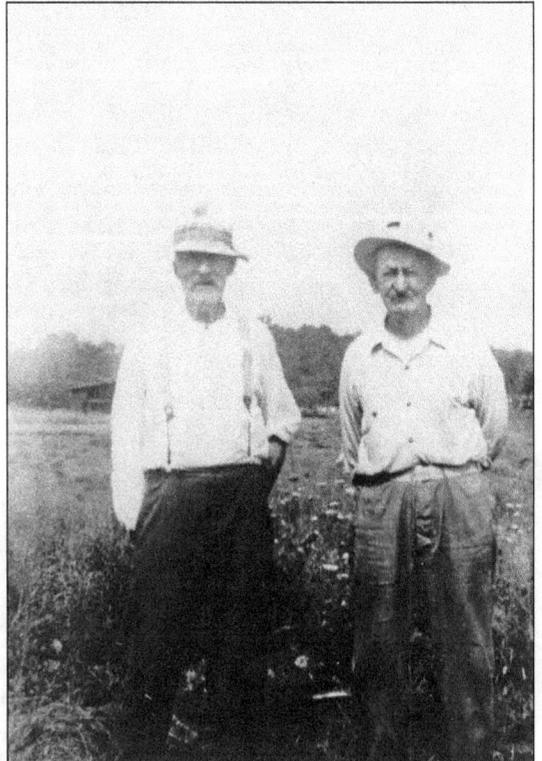

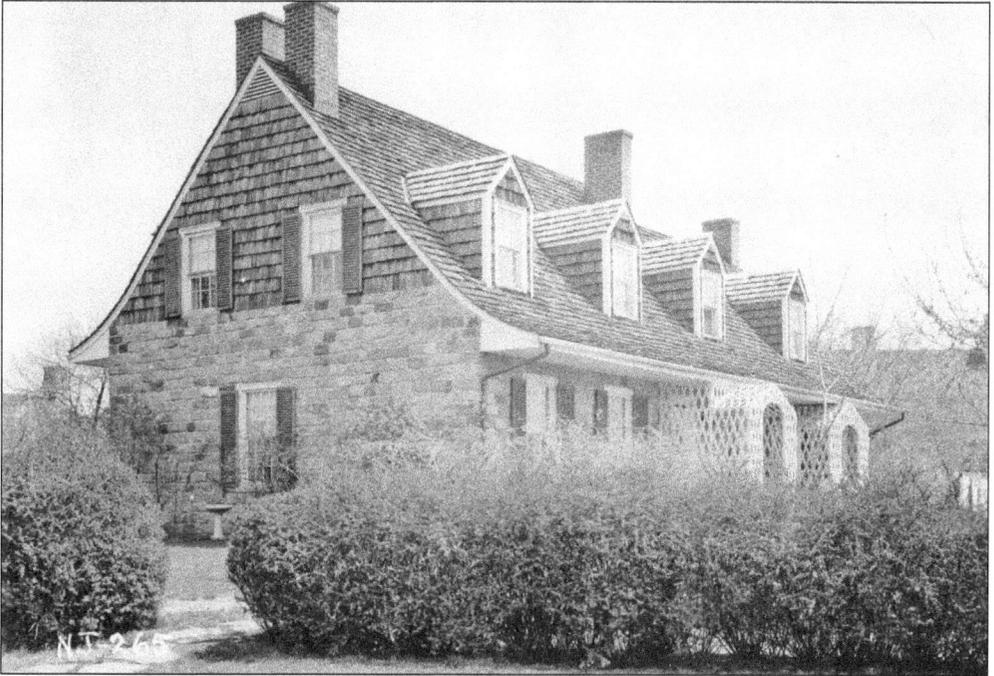

The Sip Manor, built in 1664 by Nicholas Varleth, is not only the oldest home in Westfield but probably the oldest home in the state of New Jersey. This prime example of a Dutch Colonial home was originally built in Jersey City and owned by Jan Adriaensen Sip. It remained in the Sip family for many years until it was transplanted to Westfield in 1928, where it remains at 5 Cherry Street. This photograph is from 1939.

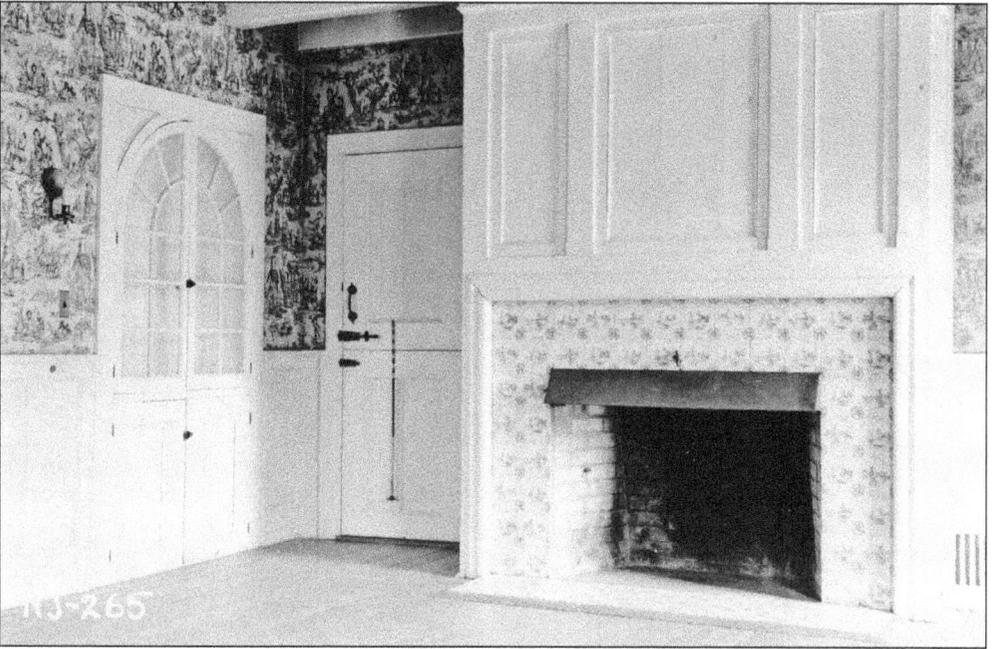

This photograph of the dining room in the Sip Manor was taken around the same time. The room is beautifully detailed, particularly around the fireplace.

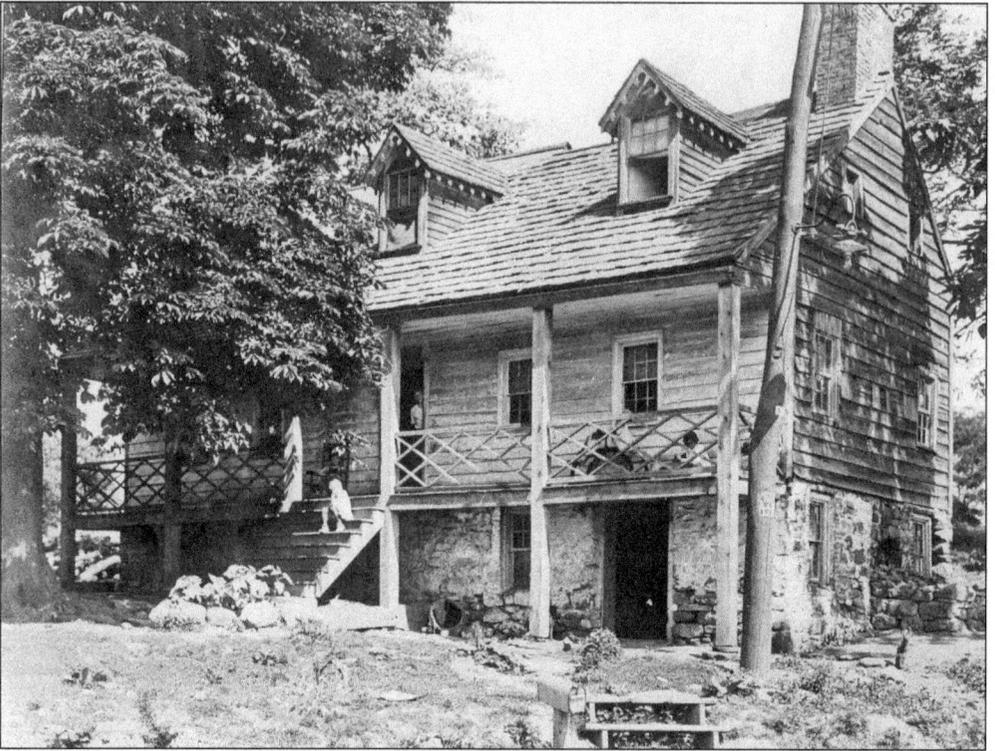

Built in 1755, the Daniel Pierson home was also one of Westfield's first homes, located on the north side of East Broad Street near Springfield Avenue. It later became the home of J. Lawrence Clark. Below is a photograph of the home when it belonged to Clark.

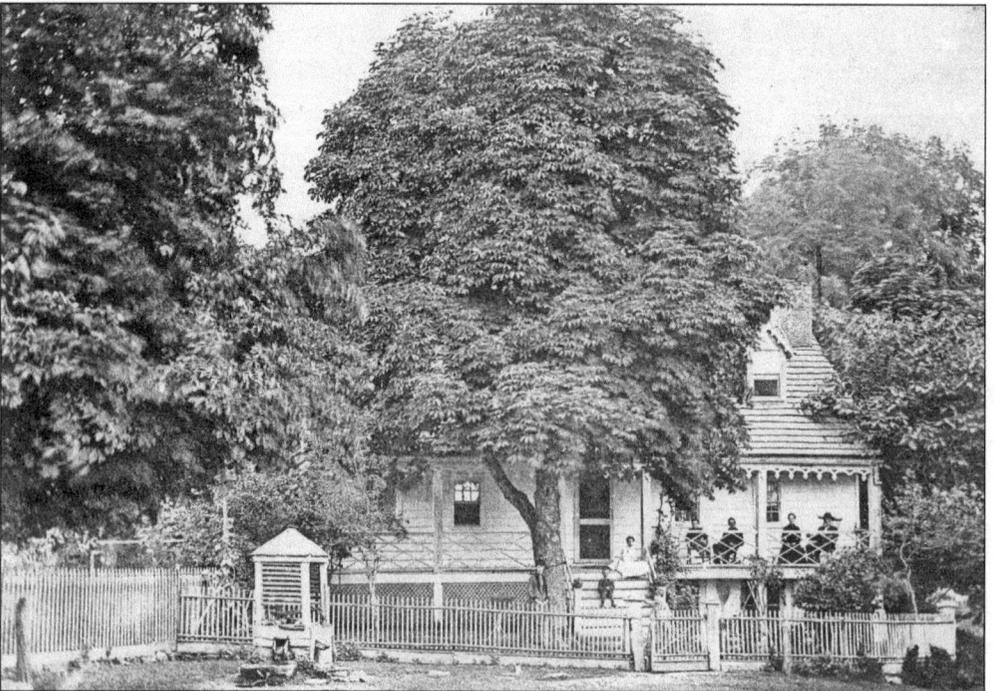

The Miller family settled here in the mid-1700s. This was their home at 126 Elmer Street, which was named for Westfield's first physician, Dr. Philemon Elmer. Most families at that time owned horse-drawn carts that traversed the dirt roads of Westfield.

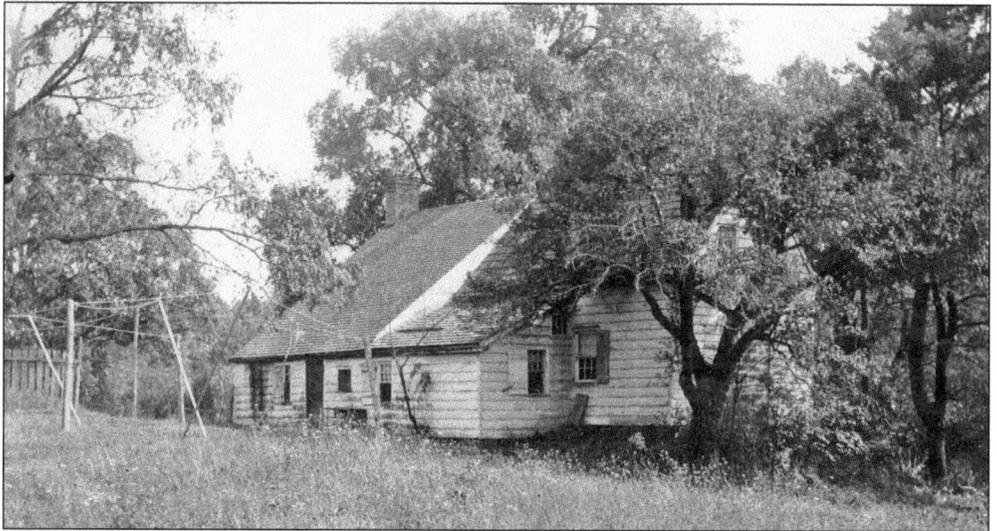

The Badgley family settled in the area between New Providence and Westfield some time around 1736 or 1737. Two brothers—John, who was born in the early 1700s and died in 1759, and James, who was born between 1700 and 1705 and died in 1777, built the home in 1738. It was here where the Presbyterian Church in Westfield first held Sunday school classes. The house was known in most recent times as Dyre's Barn and was used by the Union County Parks Maintenance Division until it was destroyed by arson in 1985. Cited as a historical site by the State of New Jersey, it had been one of the oldest buildings in Union County. The area where the home sat was once part of the Township of Westfield. Today it is part of Mountainside.

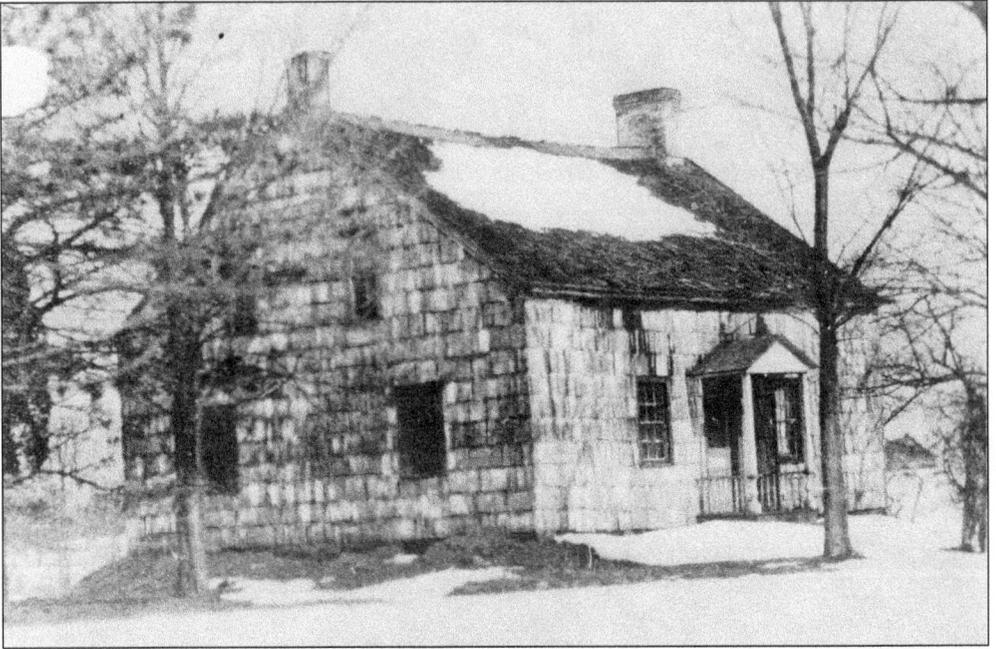

It is believed that this was the home of Aaron Miller Jr., New Jersey's second clockmaker. His foundry, which also produced church bells, was located in Elizabeth. Because a Mr. Kline owned the home at 804 Mountain Avenue in the early 20th century, it was known as the Kline house. Although it has been torn down, a well can still be found at the rear of the property.

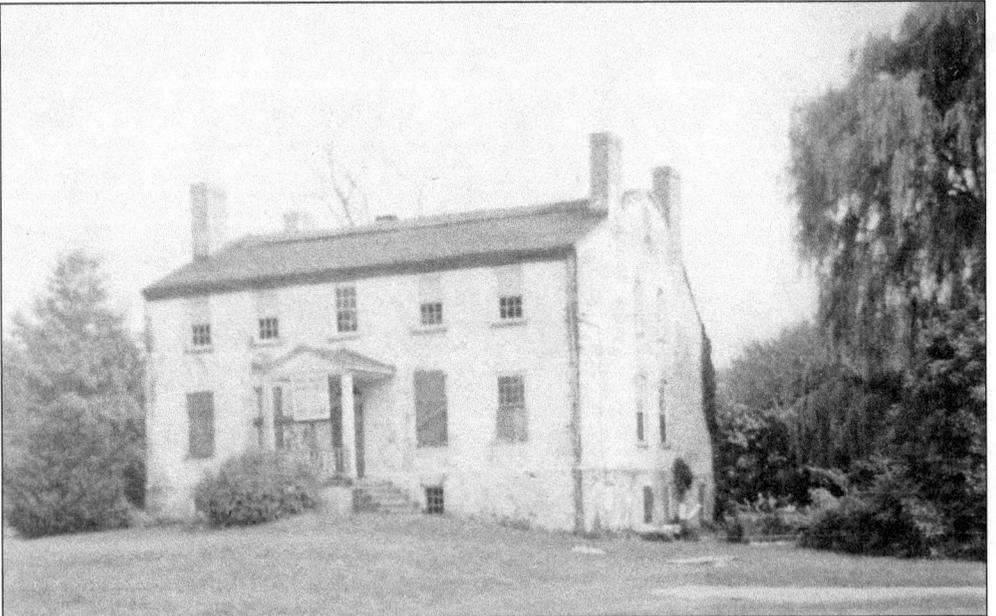

The Scudder family owned some 1,500 acres of desirable land on the south side of town. They acquired this property in the original Clinker Lot Division of 1699–1700, when the West Fields were first auctioned off into 100-acre parcels by the Elizabethtown Associates. Pictured is the solid stone Ephraim Scudder home on Picton Street. His son, Amos, a skilled mason, built it in 1813. The Scudder property abutted the Ross Manor.

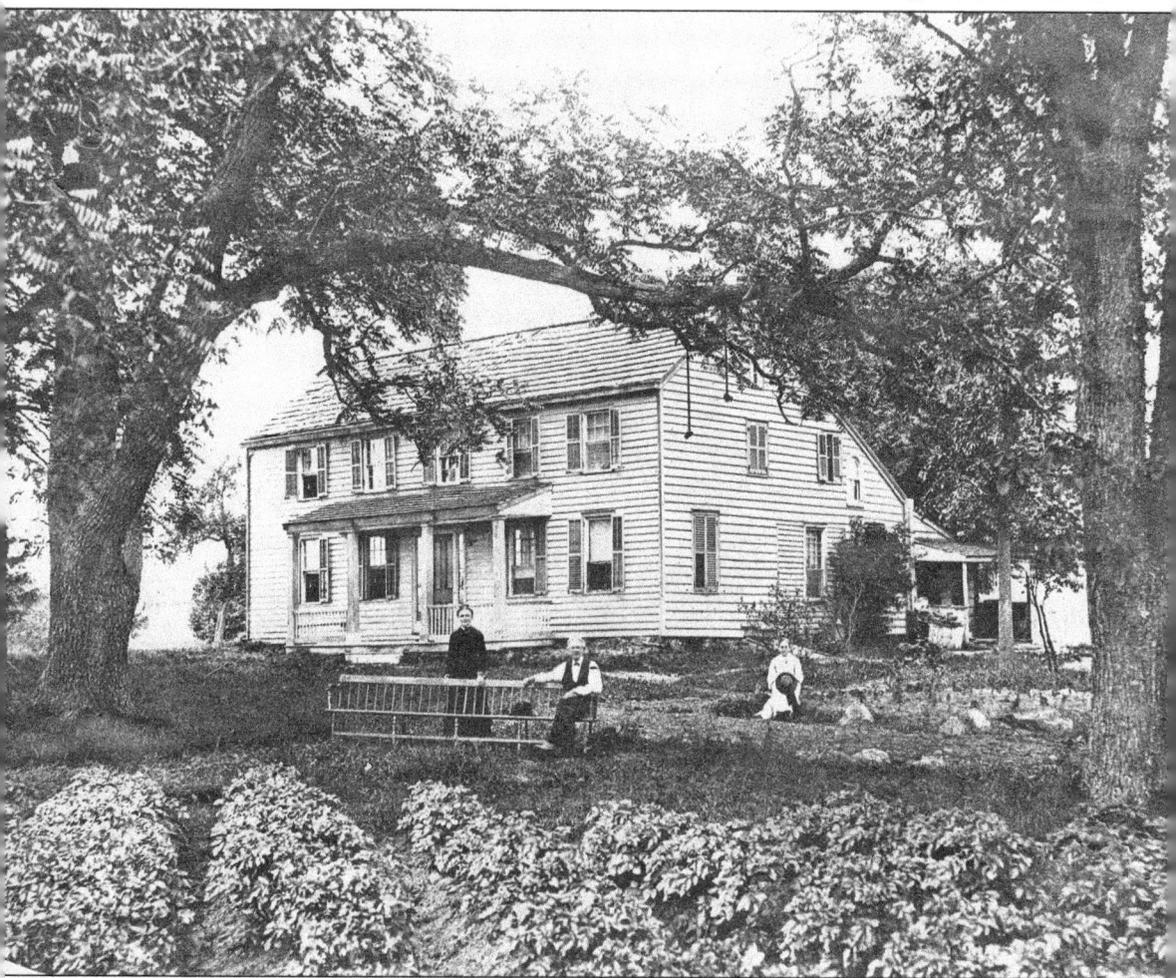

This pre-Revolutionary house, built by Henry Baker in 1750, was later the home of Daniel Baker. In 1865, William Still purchased the residence. It was under the walnut trees on the lawn of this home at the corner of East Broad Street and Chestnut Street that the Methodists held their first services. The home was demolished in 1988. Pictured in this 1872 photograph are, from left to right, Cynthia Stitt (née Cynthia Louise Rosenkranz), William Stitt, and their daughter, Lizzie Drake Stitt, who died in 1882.

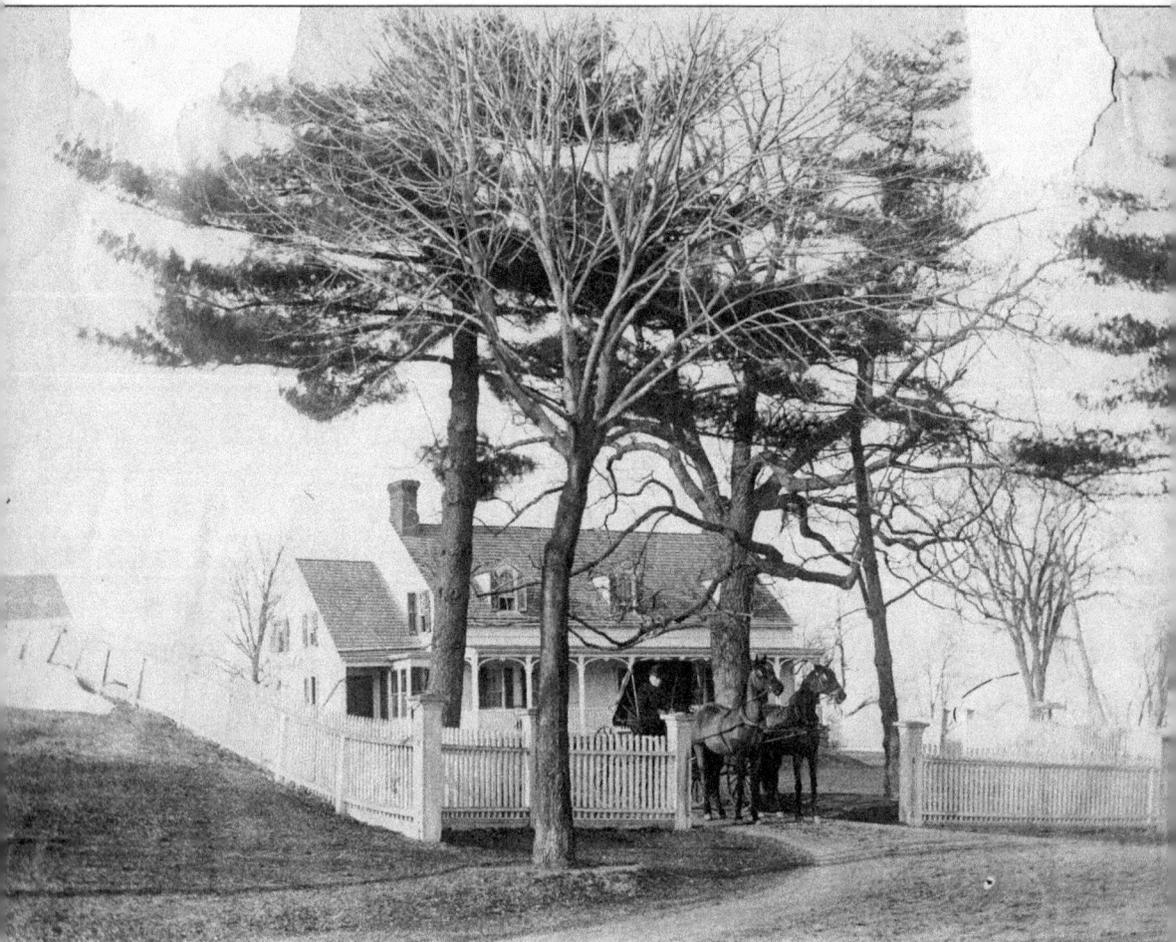

During the Revolutionary War, Tories looted the Matthias Sayre house at 667 Fourth Street. An inventory filed with the state in 1789 indicated the value of the property stolen at £66 9s 6d. Constructed in 1763, the home remains listed as a national landmark. From 1822 until 1831, prominent businessman and founding father Samuel Downer Jr. owned this home, named for its original owner, Matthias Sayre (1746–1792).

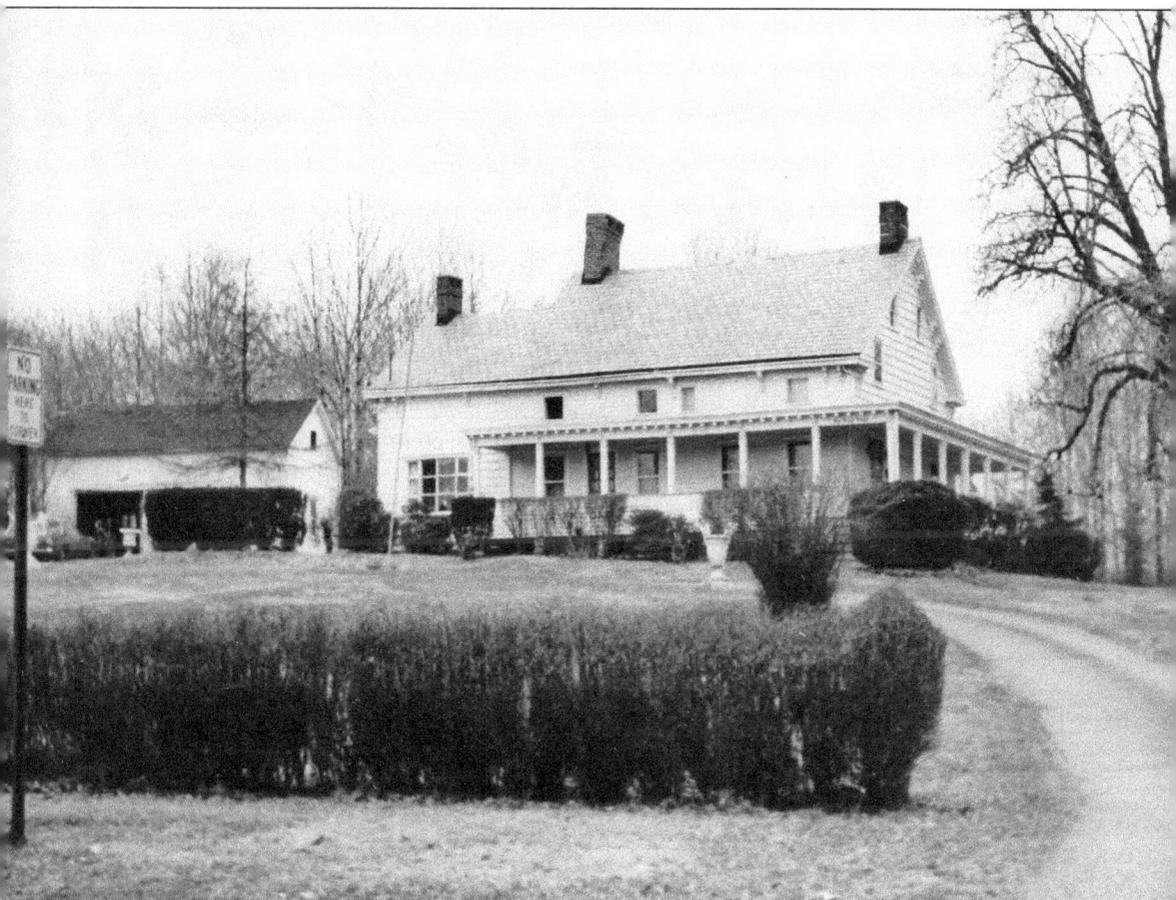

John Ross, a patriot and mayor of Elizabeth Town, was the first owner of the Ross Manor. Built in 1747 at 231 Elizabeth Avenue, the manor consisted of 20 acres of both woodland and farmland. The woods, nicknamed "Big Woods," provided great hunting. The stable was home to the finest horses and cattle, proclaimed by the local butchers as the "best fit" cattle in the state. When Chauncey B. Ripley, a rotund, well-liked member of the bar, married Cornelia Ross, the great-granddaughter of John Ross, they occupied the estate. Ripley had ties to Pres. Grover Cleveland and wanted nothing more than for him to visit the estate. This never happened. In 1893, Ripley took his own life in a New York hotel that he owned.

The Frazee family was among Westfield's first major settlers, contributing immensely to growth through their various business and community efforts. The family's legacy dates back to the late 1600s. Their home was located at what was once known as 1922 Central Avenue. Today, the home remains, but it is now at 1737 Nevada Street. Moving homes from one location to another was popular, but that is not the case with this old house. The land was simply redivided, and almost miraculously, this home remains. Above is the rear view as seen from Central Avenue. There is a legend about "Aunt" Betty Frazee, a Revolutionary War wife. Her home was on the south side of Westfield, not too far from this house. As the story goes, one summer day she was baking breads in her home when General Cornwallis and his troops, having smelled the aroma wafting through the air, knocked on her door demanding to have some of the bread. She agreed but told them she was giving it to them in fear and not in love. The men did not accept and left. Below is her grave with a plaque in tribute to her valor placed by the Westfield Rotary Club.

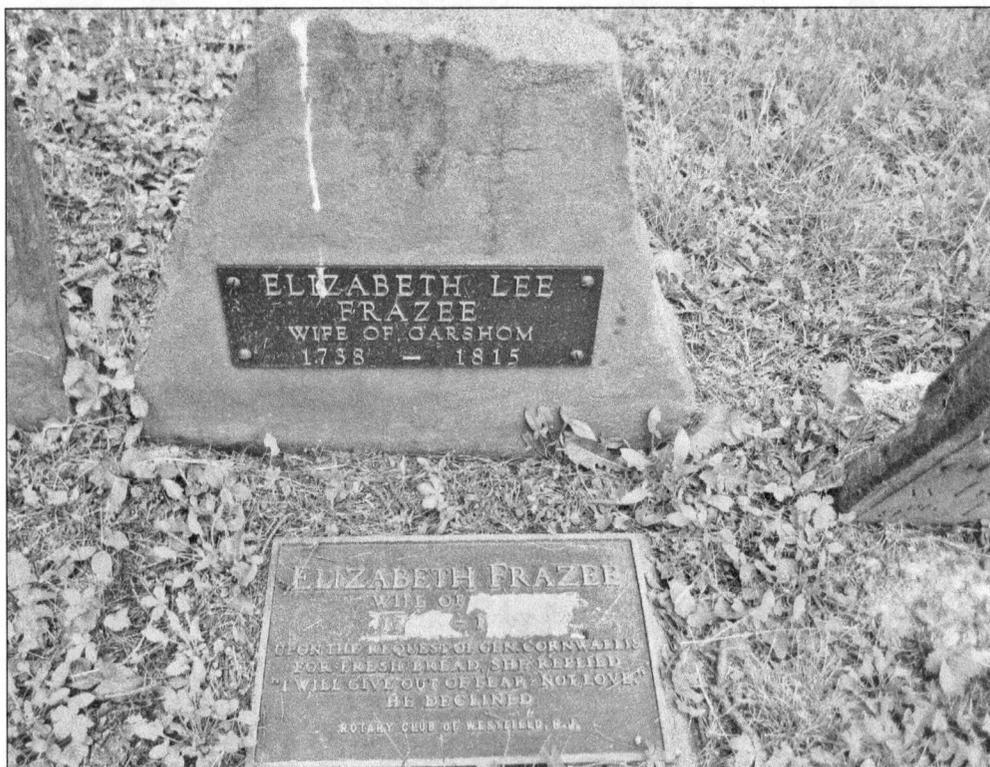

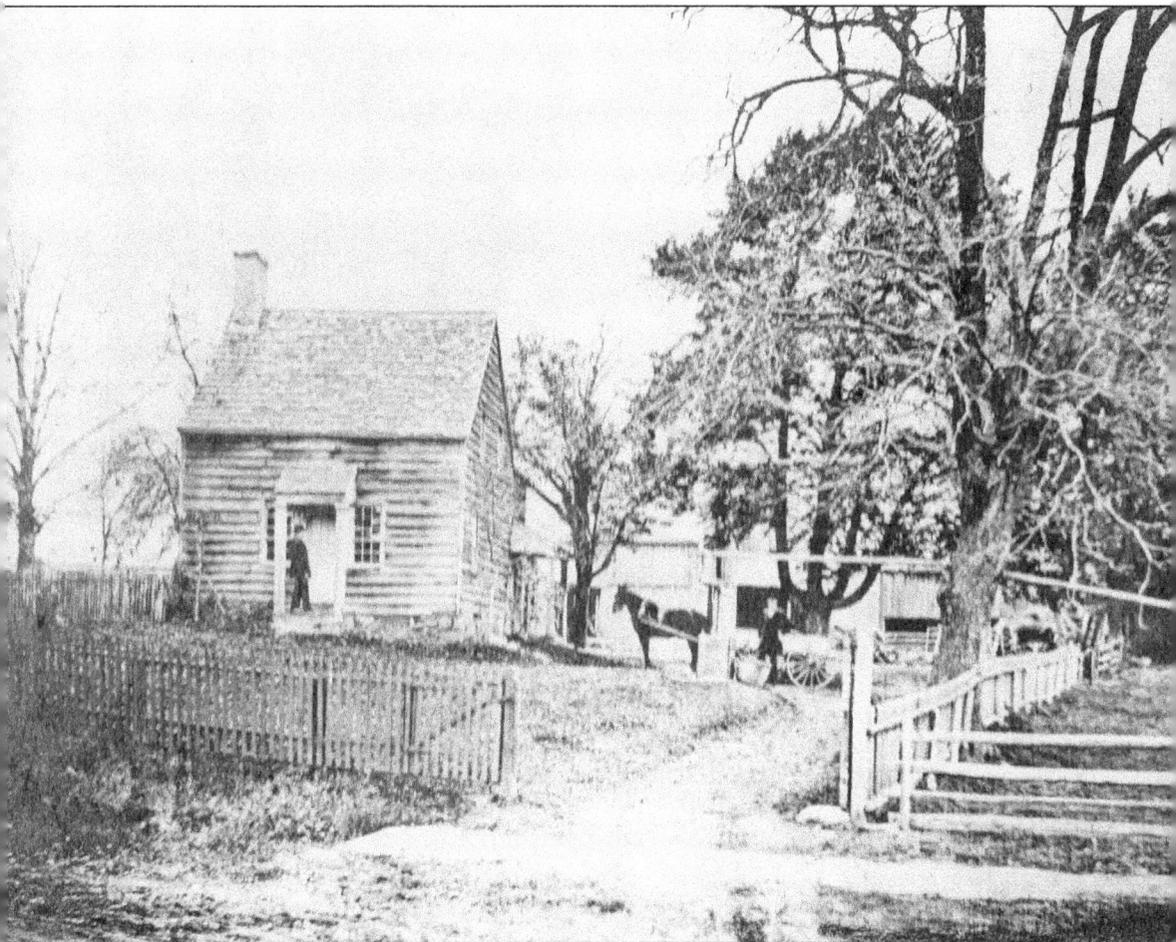

Isaac French's son, Robert III, is standing in the doorway of the family home which was at one time located at 630 Clark Street. This prerevolutionary home was inherited by Robert French's son, James, and subsequently moved to 649 Prospect Street, directly opposite Newton Place, where it remains today, although renovated. When the home, built by Manor Tucker, stood on Clark Street, it was the site of a famous Revolutionary War story. According to the story, at the time of the invasion of Springfield, three mounted British officers came knocking at Rachel French's door asking for her husband. She told them he had gone to the mill, to which they replied that it seemed strange that all the men in town had gone to the mill. They ordered her to give them dinner and feed their horses, to which she complied. They did not harm her but returned a few days later with a few others. The men of the house saw them approaching and hid themselves in the barn. The officers again asked for dinner, and she again complied. They were afraid to drink the beer, claiming that it contained poison. She told them there was cider in the basement if they wanted to get it. They stacked their muskets on the ground outside of the cellar door. She slammed and barred the door and called to the men from the barn. The British officers were then taken as prisoners.

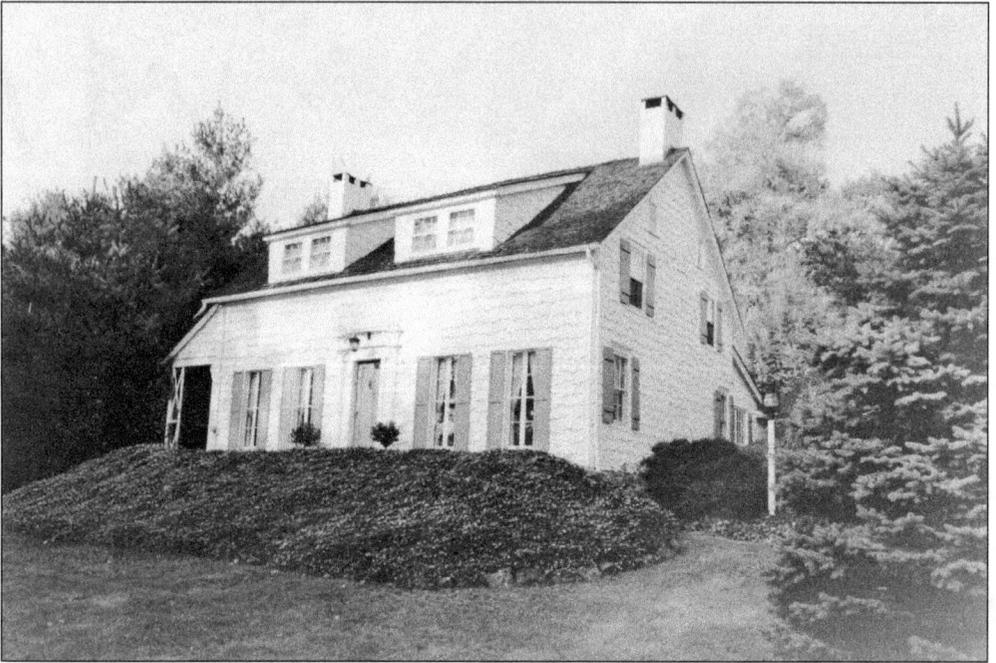

One of the oldest standing homes in Westfield is the John Ross house. Built some time around 1751, the home was once accompanied by 40 acres. In the early 1800s, Ross sold the residence along with all the land to the Mulford family for $1,750. The Colonial-style home stood on Broad Street up until recently, when it was turned to face Karen Street to make way for new construction.

Still standing at the bend in Mountain Avenue is the historic Reeve home. The 1870s Victorian home belonged to the Reeve family for almost 100 years. William Edgar Reeve was a leader in the community and particularly known for his work in leading the fund-raising campaign that led to the establishment of Mindowaskin Park. Reeve generously donated a portion of his own property to help create the park. This photograph was taken around 1893.

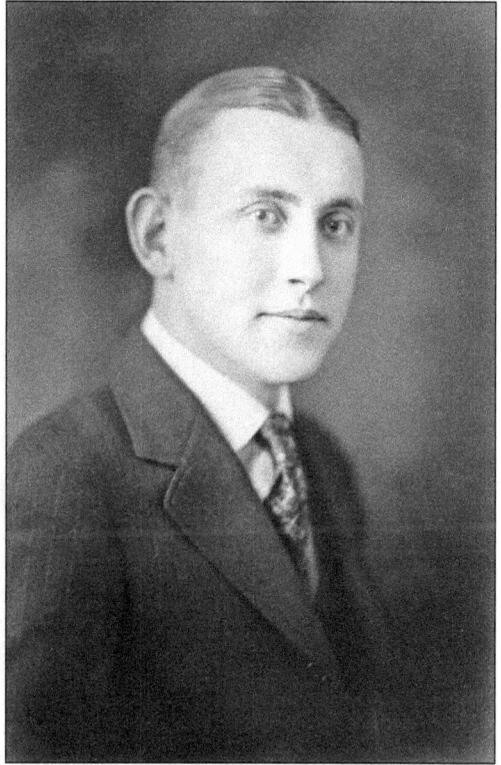

Ralph Tichenor Reeve is pictured some time around 1920. He and his brother Edgar donated the three-story, 3,000-square-foot Reeve home along with the adjoining property to the town of Westfield in 1985. Below is the plaque that is set into a large boulder and sits on the front lawn of the landmark Reeve house.

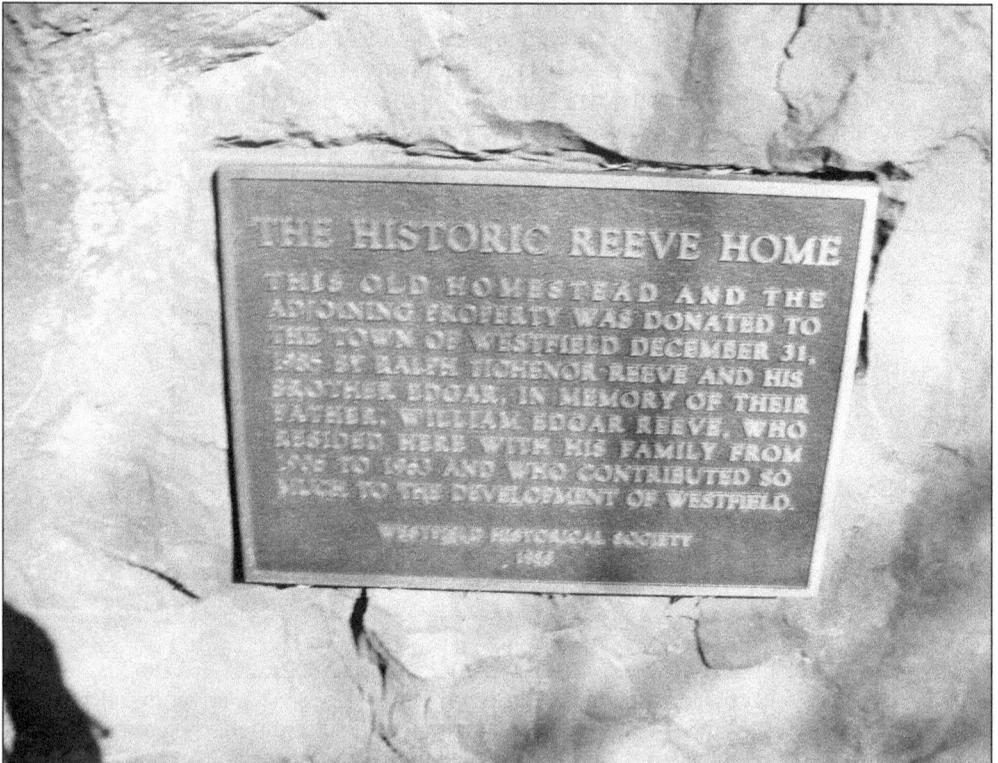

THE HISTORIC REEVE HOME
THIS OLD HOMESTEAD AND THE ADJOINING PROPERTY WAS DONATED TO THE TOWN OF WESTFIELD DECEMBER 31, 1985 BY RALPH TICHENOR REEVE AND HIS BROTHER EDGAR, IN MEMORY OF THEIR FATHER, WILLIAM EDGAR REEVE, WHO RESIDED HERE WITH HIS FAMILY FROM 1918 TO 1963 AND WHO CONTRIBUTED SO MUCH TO THE DEVELOPMENT OF WESTFIELD.
WESTFIELD HISTORICAL SOCIETY
1985

The Reeve home boasts several rare and unique trees that have grown on the property for over a century. At the far right side of the home sits this English yew, which has become one of New Jersey's largest specimen trees with a crown diameter of 65 feet. Interestingly, the tree does not qualify as a national landmark because its species is not native to America. Starting in 2007, the house has undergone a major renovation facilitated by the Westfield Historical Society, which will be relocating here. This tree and several others have been carefully preserved.

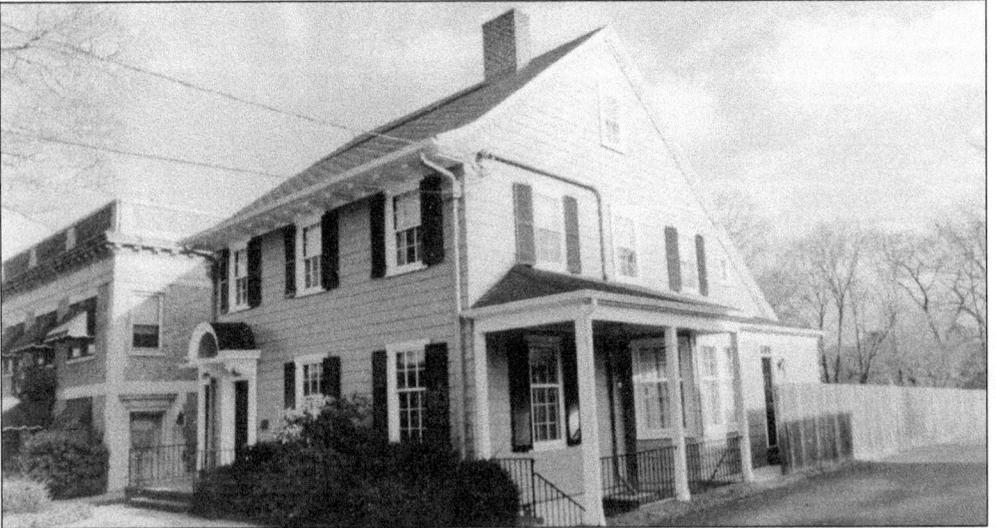

The home of Westfield's first physician, Dr. Philemon Elmer (1750–1827), is pictured here at 316 East Broad Street. The home is long gone, but in true Westfield tradition, the cross street that was cut near his home, Elmer Street, has been named in his memory.

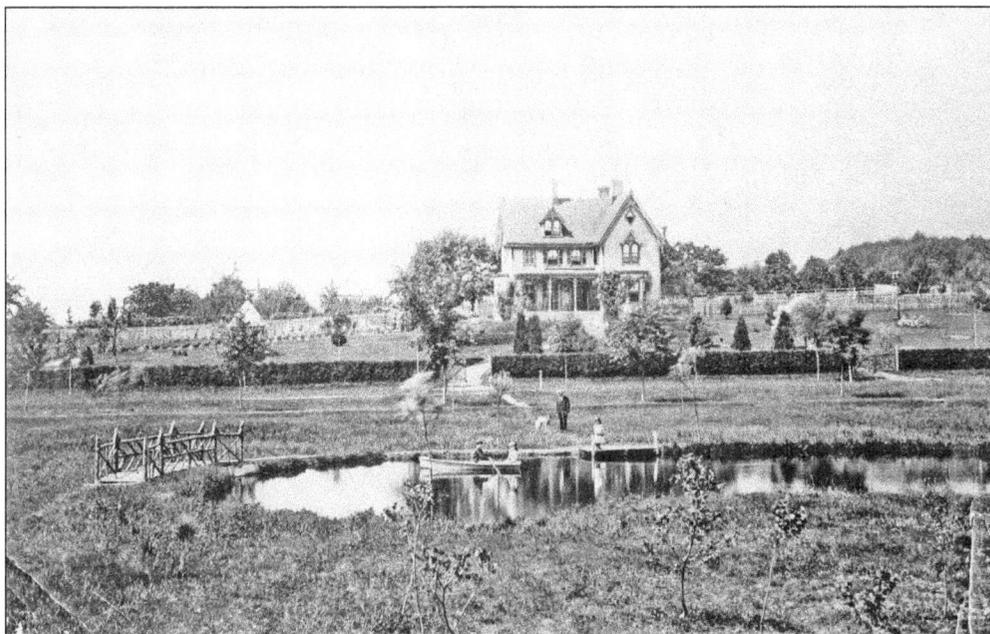

For over 100 years, the home at 219 Elm Street sat as a local landmark. Built by Westfield's third physician, Dr. Cora Osborn, in 1859, it was home to several prominent citizens. In the 1880s, the family of state senator James L. Miller lived here. In the front of the residence, children are enjoying canoeing on the quaint pond that Miller created by damming a steam. During this era, Westfield had many streams and ponds. Below is the home in 1908. In the 20th century, the house was successively owned by two dentists. Coincidentally, both served as Westfield Republican chairmen. They were Dr. Chauncey M. F. Egel and Dr. Leland Davis. Egel maintained his dental office in the home. In 1961, the house was razed. It has since been the site of several supermarkets.

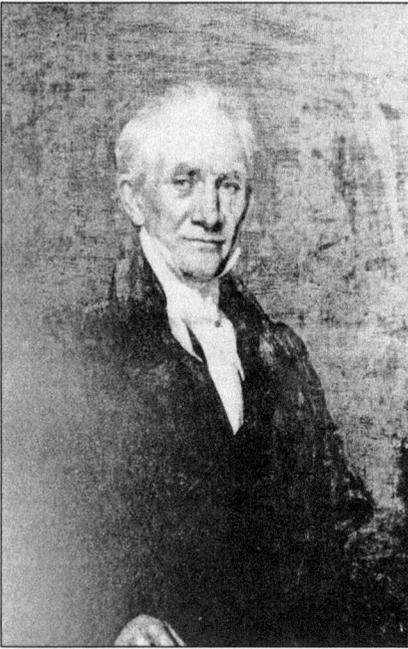

Samuel Downer Jr. (1760–1846) was one of Westfield's leading citizens. He was a veteran of the Revolutionary War, a banker, a merchant, a politician, a postmaster, and a churchman. During the mid-18th century, he owned practically all of the business property in Westfield.

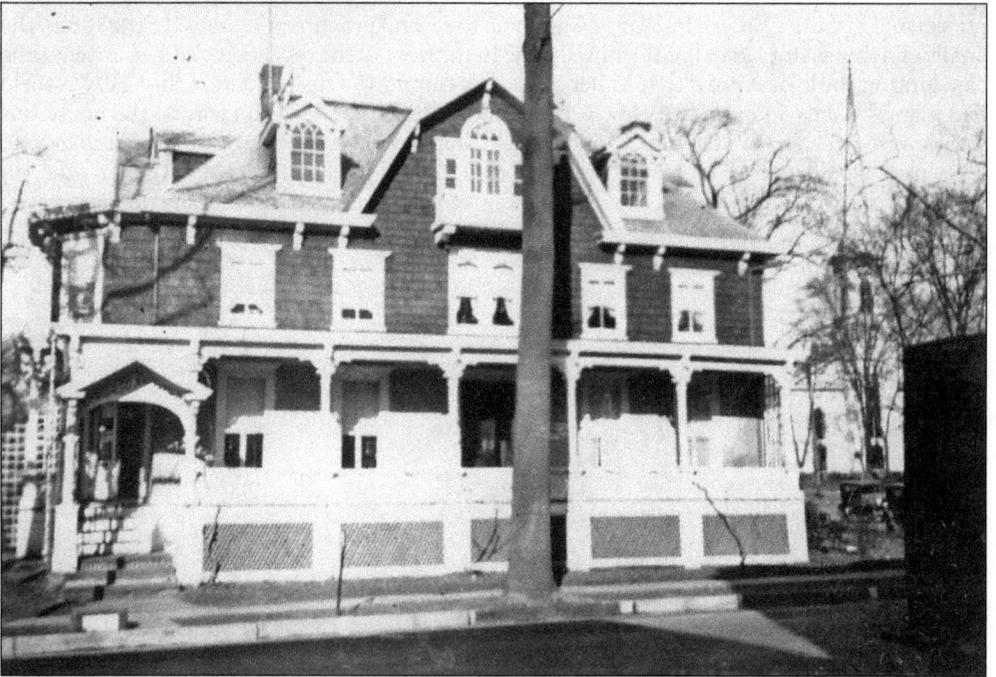

Although not factually proven, it is believed that Gen. George Washington visited and slept at the home of Samuel Downer Jr. after the battle of Trenton in 1777 and again in November 1778, while he was travelling from his headquarters in Middlebrook to Elizabeth Town. The Downer home sat prominently on the corner of East Broad Street and Mountain Avenue, in the center of the Westfield village. Downer was the first in Westfield to build real estate on farmland. He bought the home's property from the Presbyterian church, which can be seen in the background. He was the town's first storekeeper, beginning his business on this property.

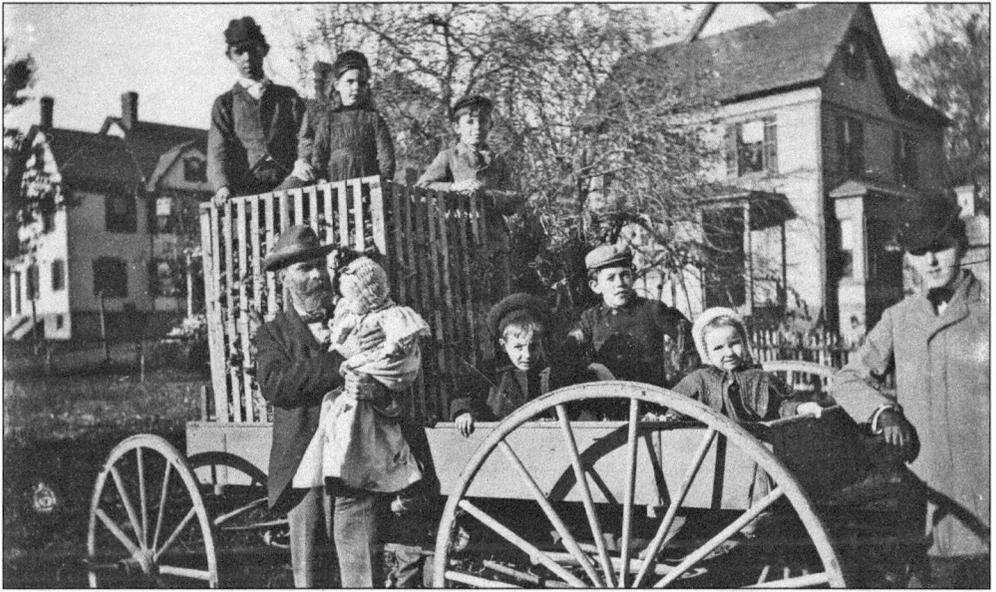

Pictured some time between 1905 and 1907 are Edgar Pearsall and his daughter. Pearsall was an important contributor to growth and commerce in Westfield in the early 20th century. He bought the town newspaper, the *Independent*, in 1885 and changed its name to the *Union County Standard* in 1887. Arthur Hurst is standing in front of the wagon. The Pearsall and Genzel children occupy the wagon. The cage in the rear was made to carry leaves. The photograph was taken in the rear of the Pearsall home at 112 Ferris Place.

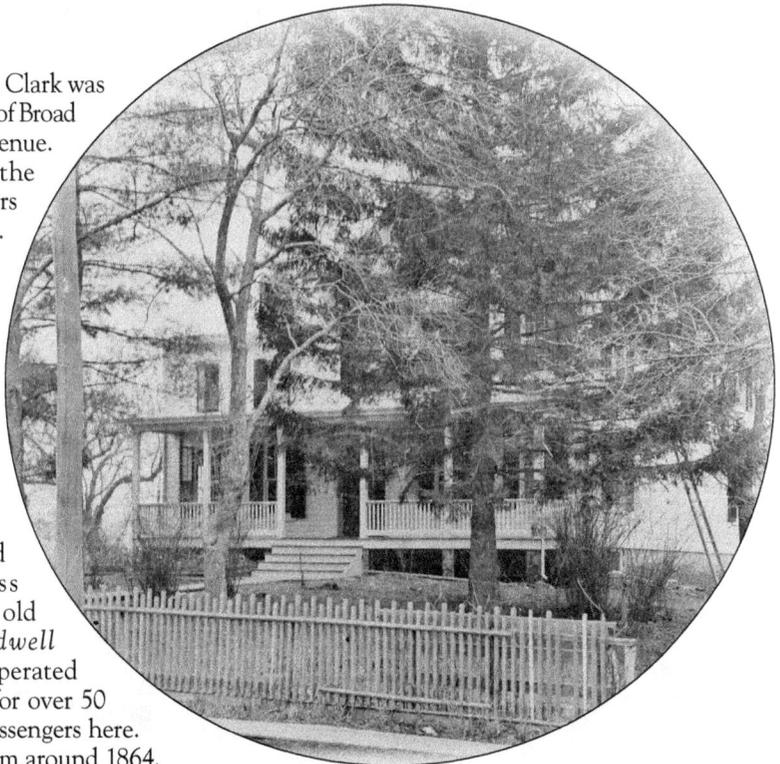

The home of Charles Clark was located on the corner of Broad Street and South Avenue. This later became the site of Tuttle Brothers and then J. S. Irving Lumber and Coal. Clark was a storekeeper and postmaster. His mercantile, on the corner of South Avenue and Clark Street, was the community center where important townspeople would gather to discuss local politics. The old stagecoach *Speedwell Stage*, which was operated by George Tingley for over 50 years, stopped for passengers here. This image dates from around 1864.

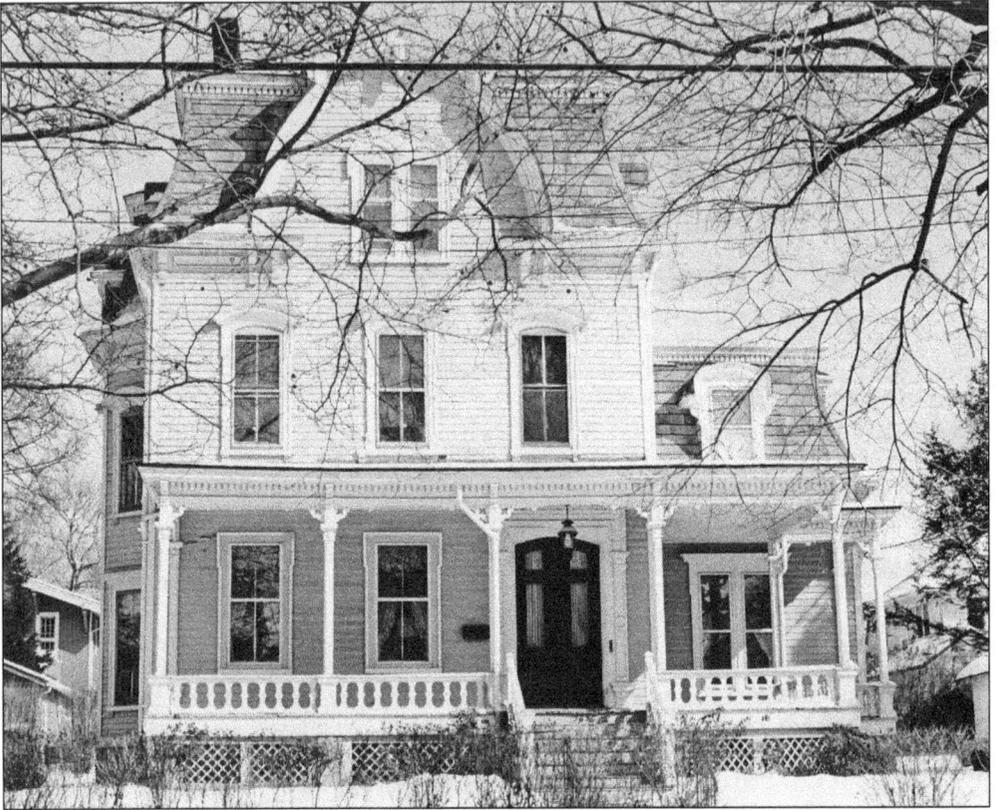

The Brunner home was built between 1870 and 1872 in true Second Empire style with detailing and ornate trim. Caroline and Frank Brunner raised their four sons and one daughter at the home at 563 Westfield Avenue. Brunner owned an engraving and die-making business in New York City. In a barn behind the house, he also set up headquarters for the business, for which all four of his sons worked. The home still stands, now the offices of a medical group. One son, John, has gained fame as a woodcarver and artist. The barn has been moved to 546 Westfield Avenue. Below, the family poses for a photograph.

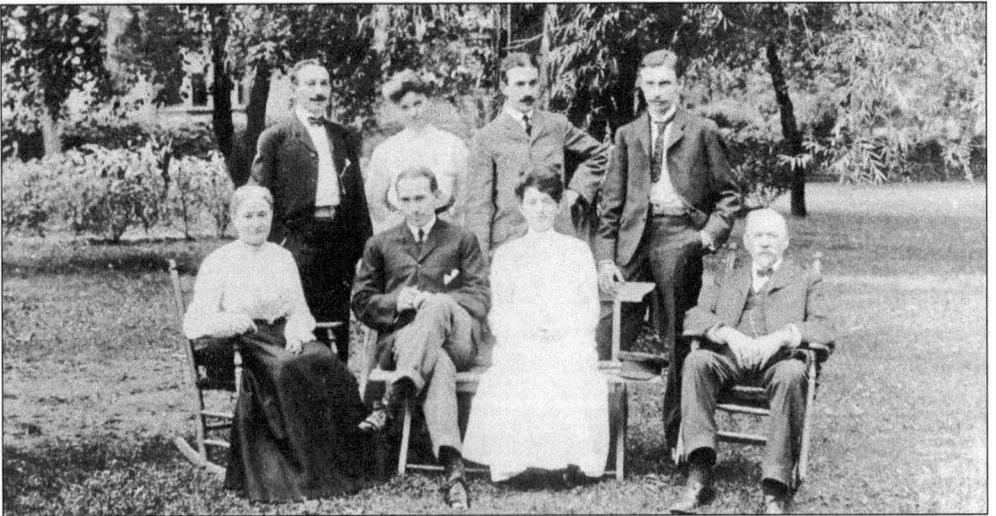

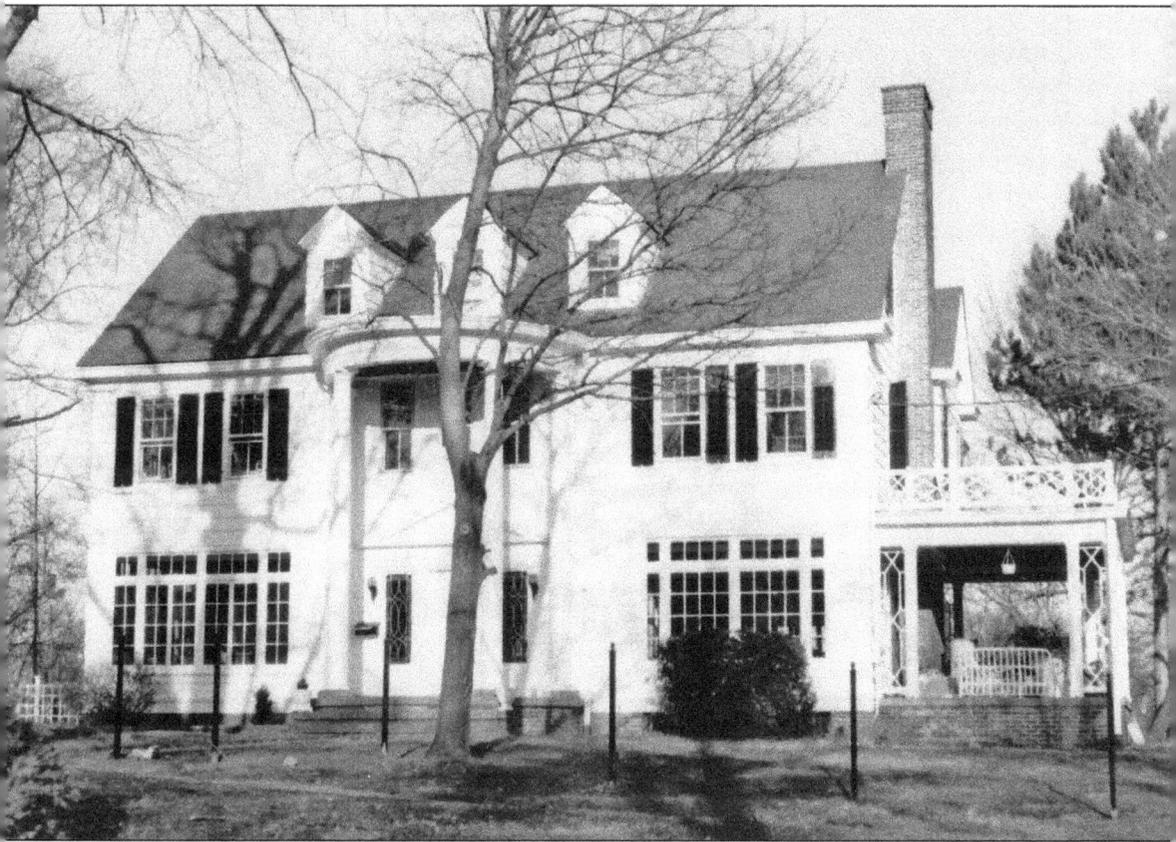

Charles N. Codding was the owner of this c. 1890 home, known as the Squires Club. Squire Codding, a prominent attorney, assemblyman, and Republican leader, successfully argued the controversial case for the passage of the bill of incorporation for the town of Westfield in March 1903. The social center received many visitors. Among the important guests who visited the club were Theodore Roosevelt, Robert Benchley, and Amelia Earhart. The home suffered a fire in the early 1900s. Although it was quite a devastating blaze, the structure survived. The library in the residence at 545 Boulevard was dismantled from an English abbey and rebuilt in the home. Fortunately, the library survived the destructive fire.

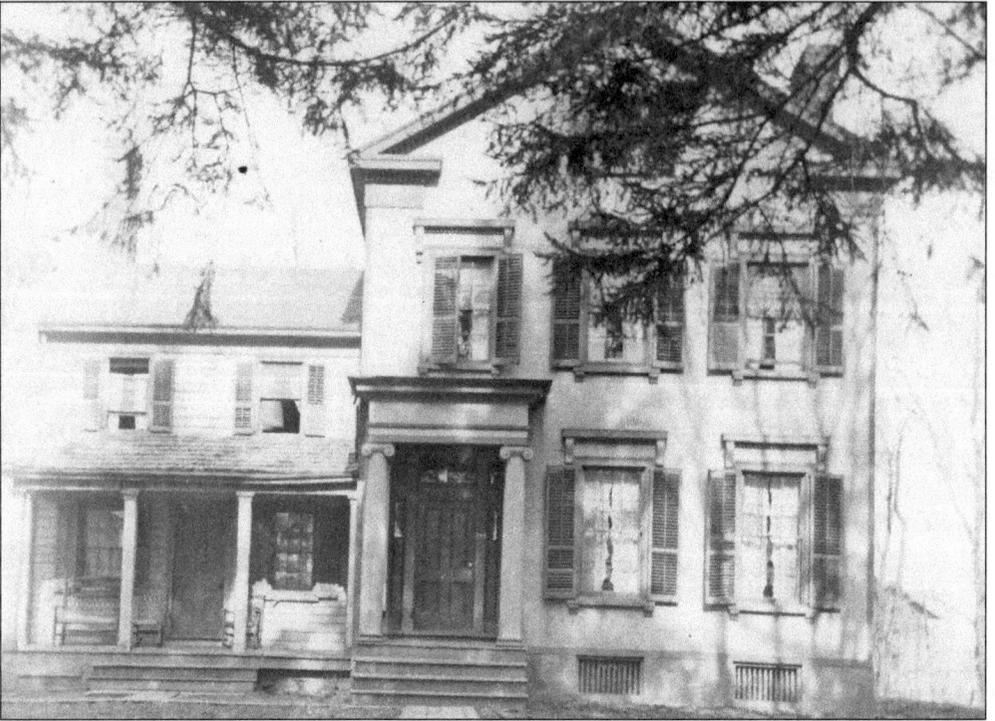

The home of Thomas and "Aunt" Abby Clark was situated on East Broad Street. A famous story is told to schoolchildren about Aunt Abby, a much-loved woman. She owned the pond where children and adults alike spent winter days enjoying ice-skating. One day, her son put up a sign that read: "Skating, 5 cents." The children could not afford this and were very upset. Aunt Abby removed the sign immediately, and the children happily resumed skating.

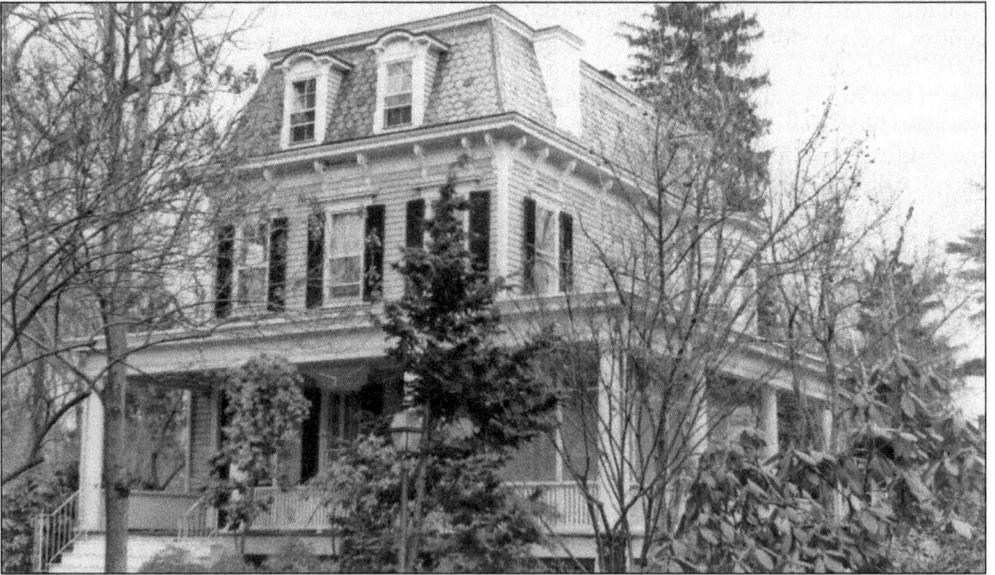

This home built in 1872 is a prime example of a Victorian Second Empire home, a very popular style in the late 19th century. Located at 538 Lawrence Avenue, the house is one of this prestigious street's most distinguished homes.

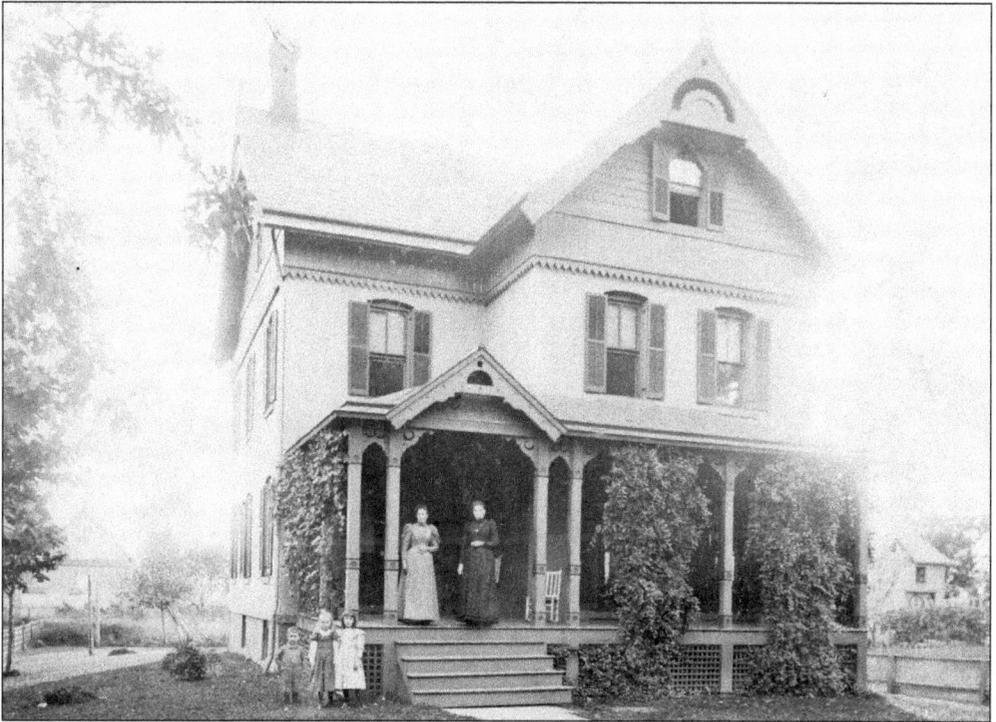

The home of William S. and Mary Welch was located at 538 Westfield Avenue. The Welch family has a long legacy in Westfield. This home was built by grandpa Charles Welch around 1887. Members of the family pose in front.

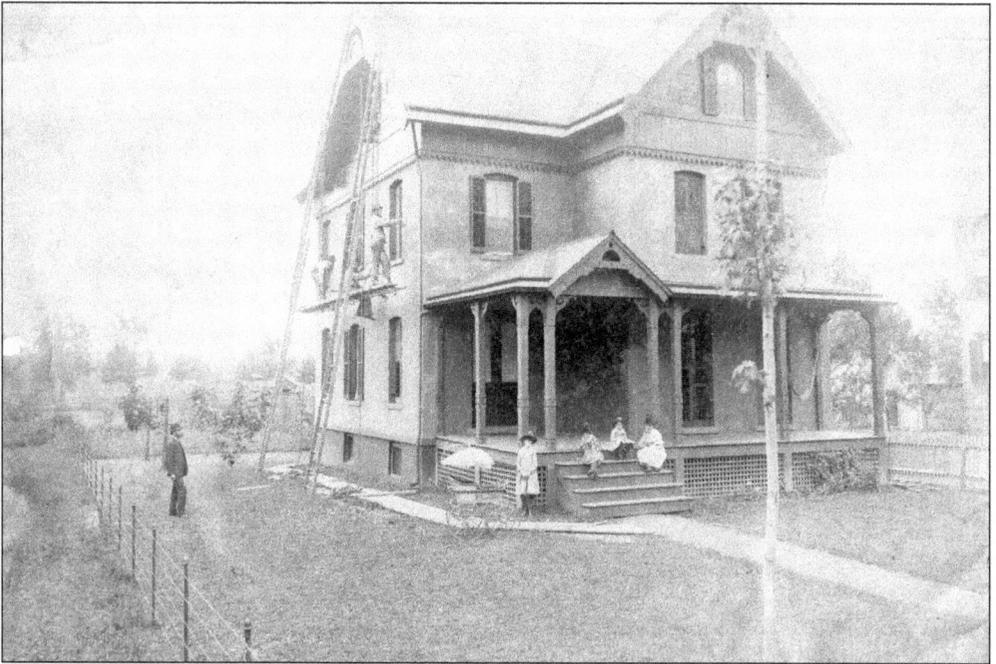

William S. Welch watches the window washers while the children enjoy a warm day outside the family home.

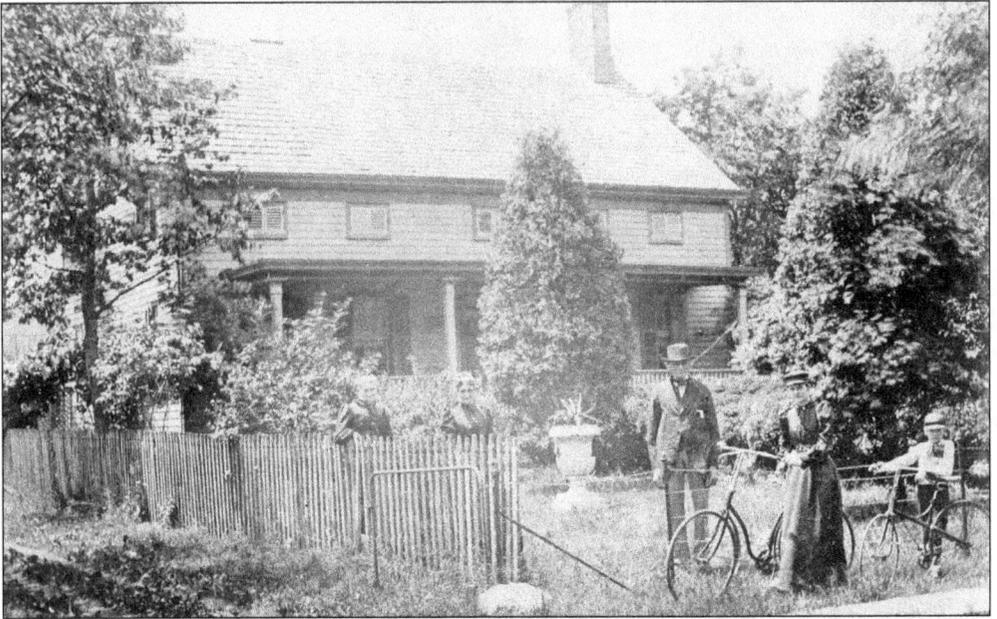

The home of the French family is shown in 1890. The Frenches owned several businesses in town and were important contributors to the successful settlement of Westfield. Many generations of Frenches occupied this home, which was originally owned by Robert French and his wife, Phebe. Pictured in front of 138 Central Avenue are, from left to right, Martha Miller (neighbor), unidentified, Robert French III, Ida M. Clark, and Robert Warren French (age 6). The home belonged to Robert French III. Later, his daughter, Mary Elizabeth (French) Clark, and her husband, Joseph Clark, owned the house until her brother Robert M. French purchased it from her in 1910.

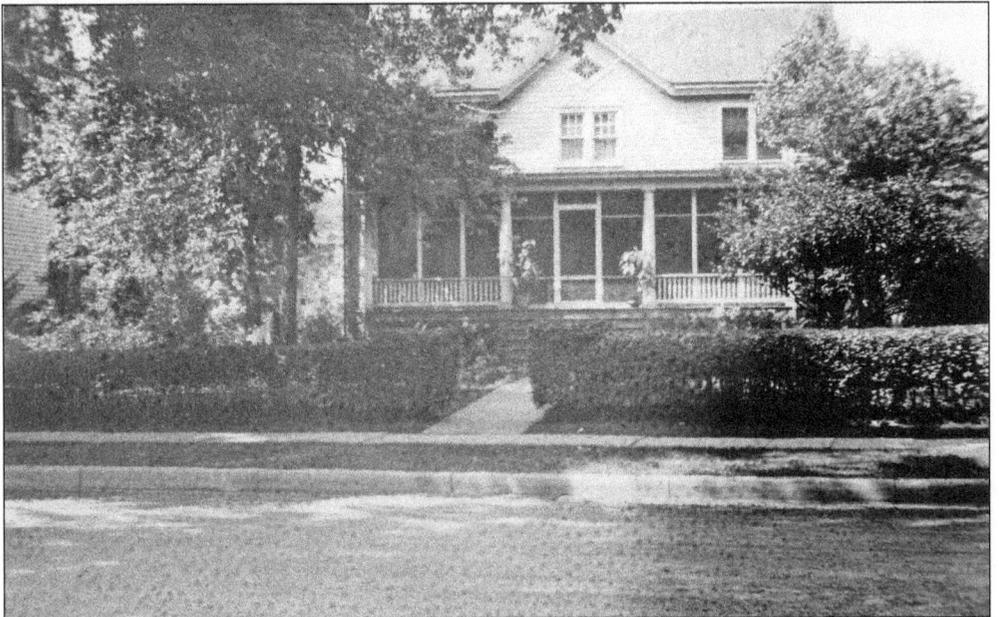

In 1911, when Robert M. French and his wife, Georgina Gilby French, owned the home, it underwent a major alteration. French was a longtime furniture retailer downtown and his wife a beloved teacher. Their son, Homer, took this c. 1916 photograph.

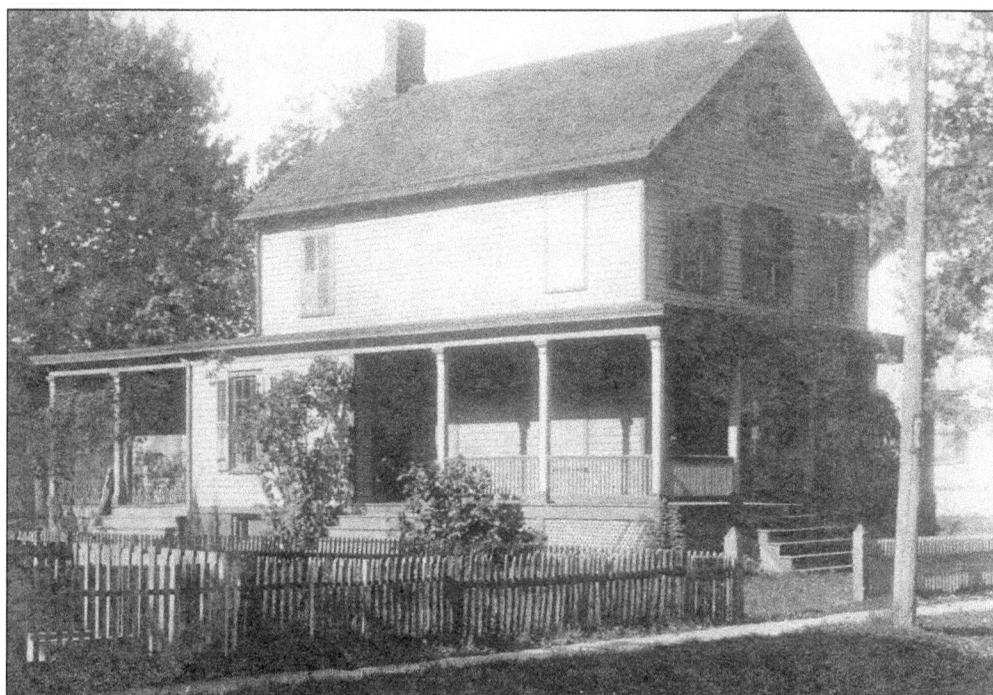

Next-door to the home where Robert Warren French was raised stood this home, pictured in 1910, at 148 Central Avenue. French and his wife purchased the house and raised their family here. It was common in those days to remain close to extended family.

Patrick Traynor immigrated from County Tyrone, Ireland, as a young boy. He was a self-made businessman who was also involved politically and civically. Traynor was vice president and a director of the Westfield National Bank, served as a member of the common council, and was not only a volunteer fireman for 18 years but served as the fire chief for a time. He lived in this classic home at 425 East Broad Street with his wife and five children. The property abutted Mindowaskin Park, and for a period of time, Traynor owned the pond, which he bought from the Clark family. This was the last home to occupy this land before the municipal building took over this space. This photograph was taken in 1940.

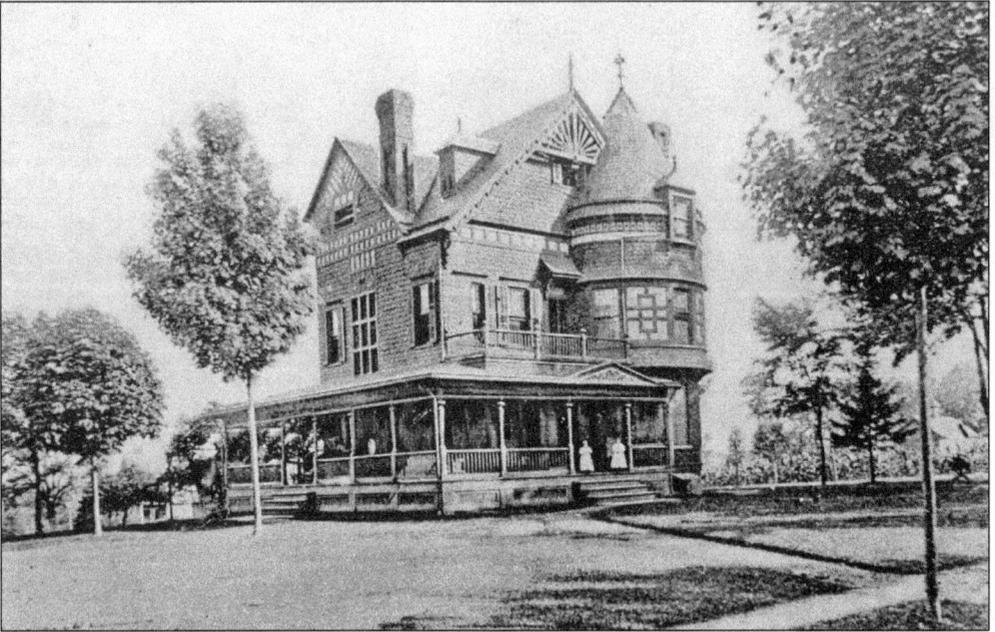

The home of John T. Lawrence, nicknamed "Lawville," dates back to 1887. It originally sat at the corner of Dudley Avenue and what is now Lawrence Avenue, named for the street's first resident. It was common practice to move homes from one location to another in the 19th century. Lawville was moved to 730 Lawrence Avenue, where it was the first home on that street. The above photograph was taken around 1893, before it was transplanted. Pictured below is Lawville some time after it was transplanted.

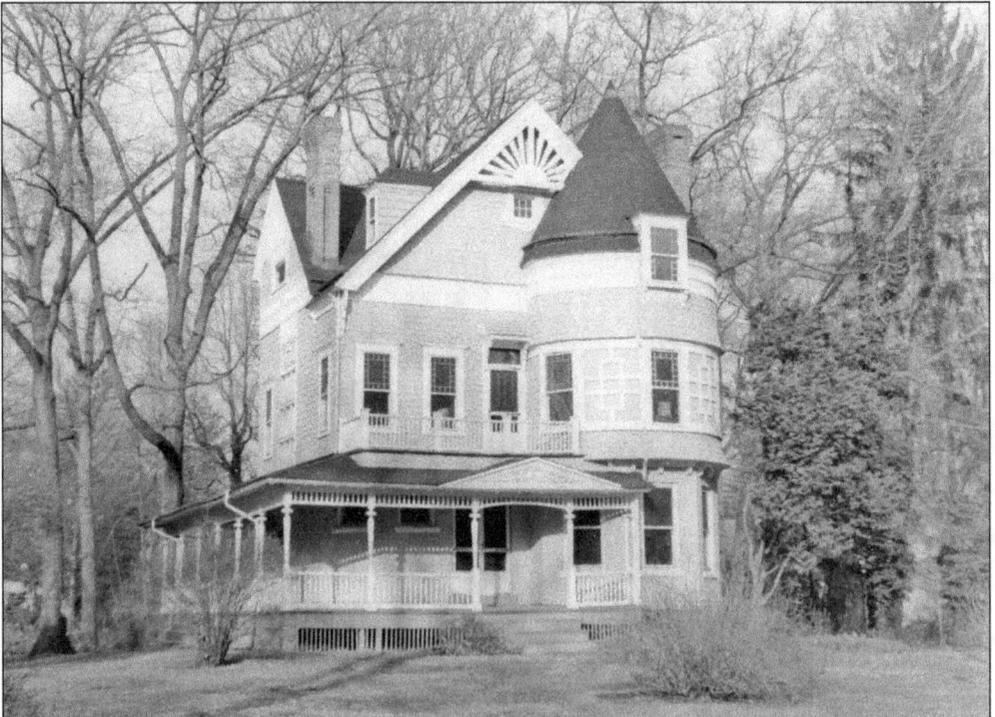

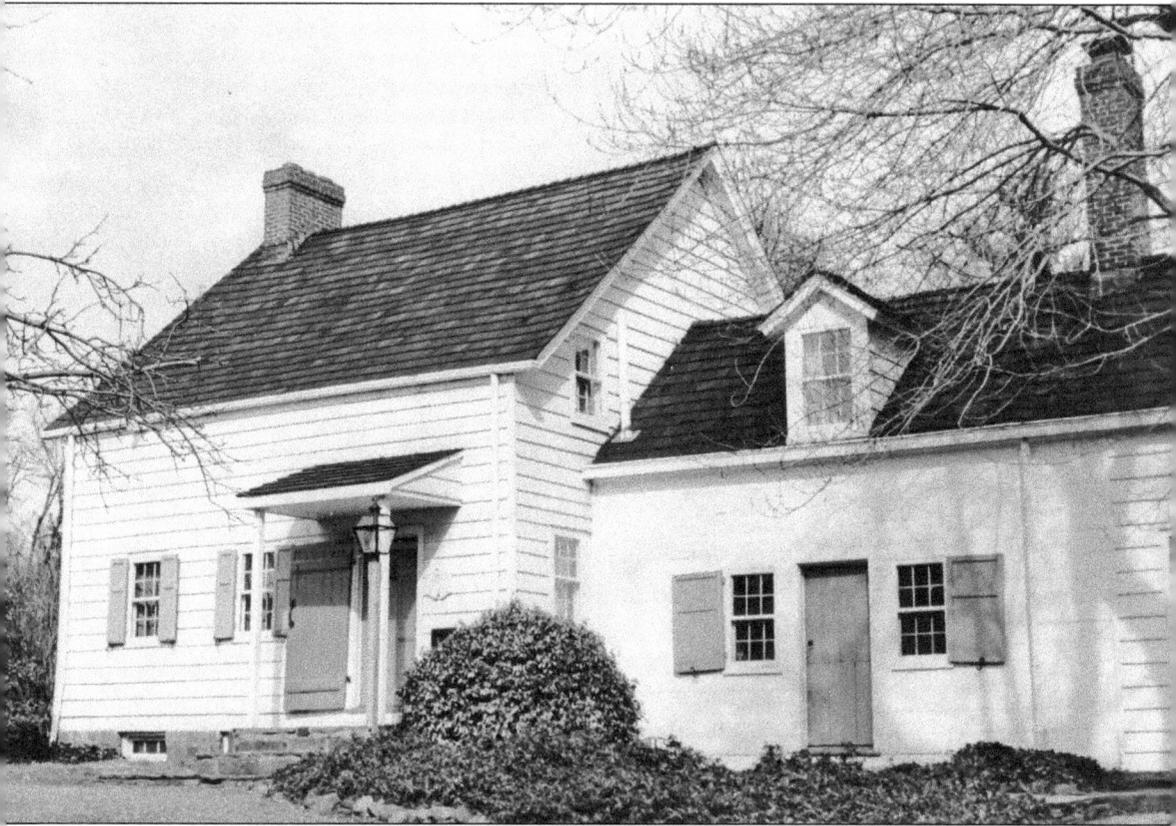

Named for its two pre-Revolutionary owners, the Miller-Cory house still sits at 614 Mountain Avenue, known in the mid-18th century as the road to the mountains. Although both the Millers and the Corys were rural farmers, they were savvy in an urban way, as the West Fields lay at a crossroads of Colonial America. Situated along the main route between New York and Philadelphia then, like today, the town was influenced by its location between these two major cities. Built in 1740, it is known that all three sections were completed before Samuel Miller's death, as they are mentioned in his will. The home has been certified as a historic site, listed on both the New Jersey and National Registers of Historical Places. The Miller-Cory House is also a nationally recognized living museum where exhibitions of Colonial life in the 18th and early 19th centuries are performed for visitors.

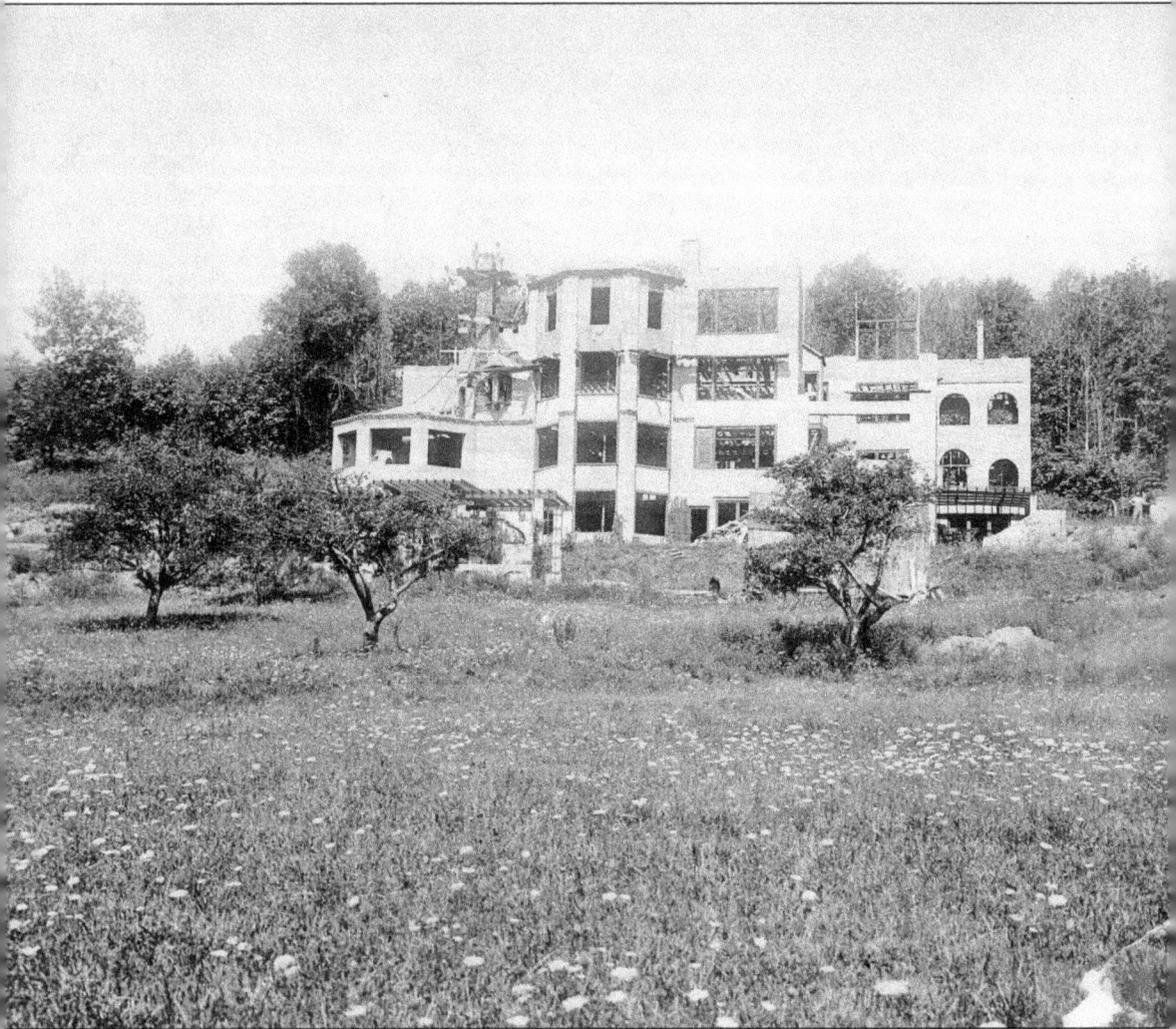

Alfred E. Pearsall began building his dream home, Pot Luck Castle, in the early 20th century. This photograph was taken in 1917, while it was still under construction. It was probably the largest single-family home in the area at the time. The Pearsalls owned several successful businesses, among them a large real estate company at the corner of East Broad Street and Prospect Street, which perished in a fire. Pearsall died in 1919, never having the opportunity to see the majestic castle completed.

Two

EARLY DOWNTOWN

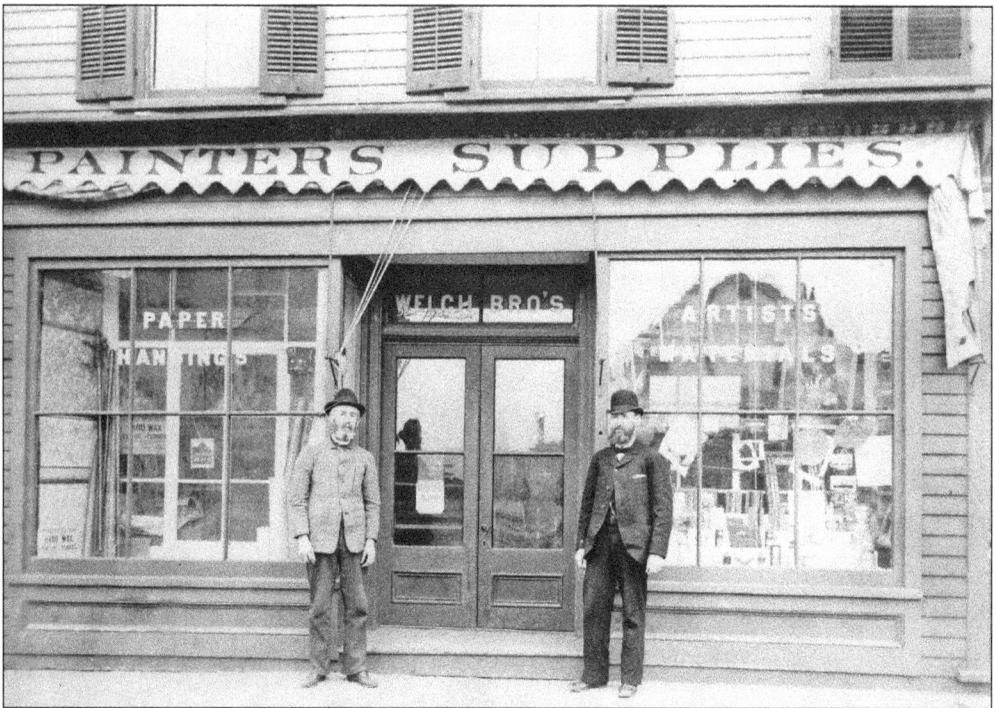

The Welch Paint and Wallpaper Store was established by brothers William S. (right) and Littleton F. Welch (left) in 1868. For over 100 years, the store serviced the community with not only home and office painting and wallpaper supplies but artist supplies as well. This locally famous photograph of the two men standing in front of their store at 214 East Broad Street was taken around 1890.

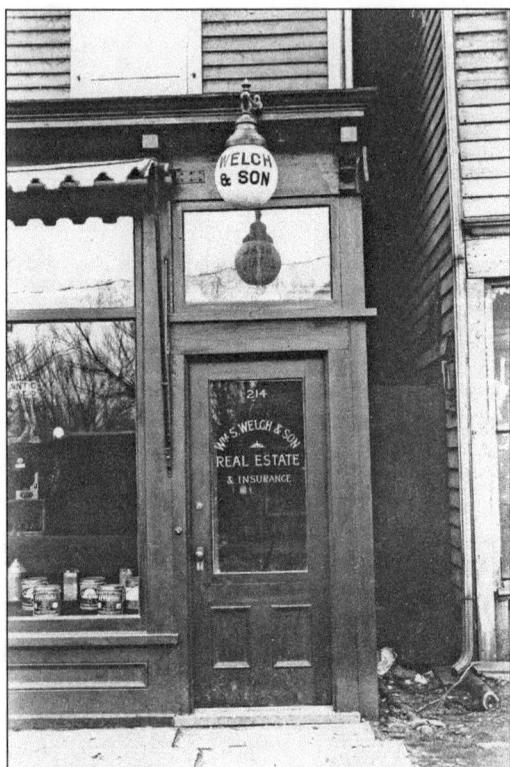

Upstairs at 214 East Broad Street, William S. Welch ran a successful insurance company with his son Herbert R. Welch. In the 1930s, Herbert was the company vice president. The photograph of him below was taken some time in the early 20th century.

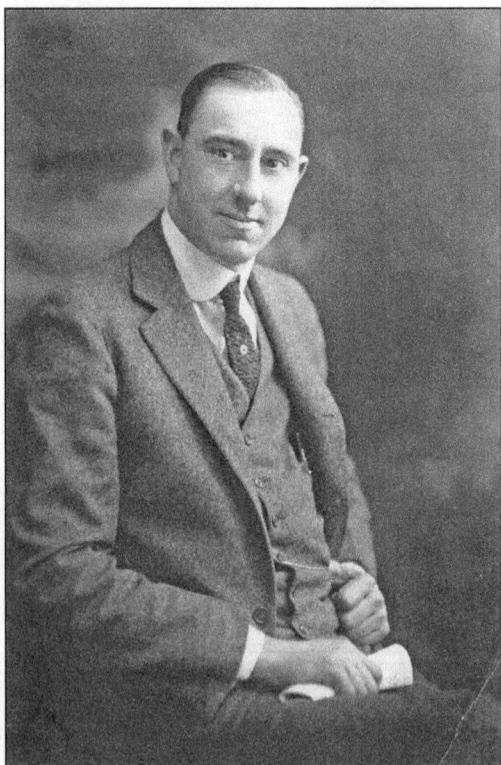

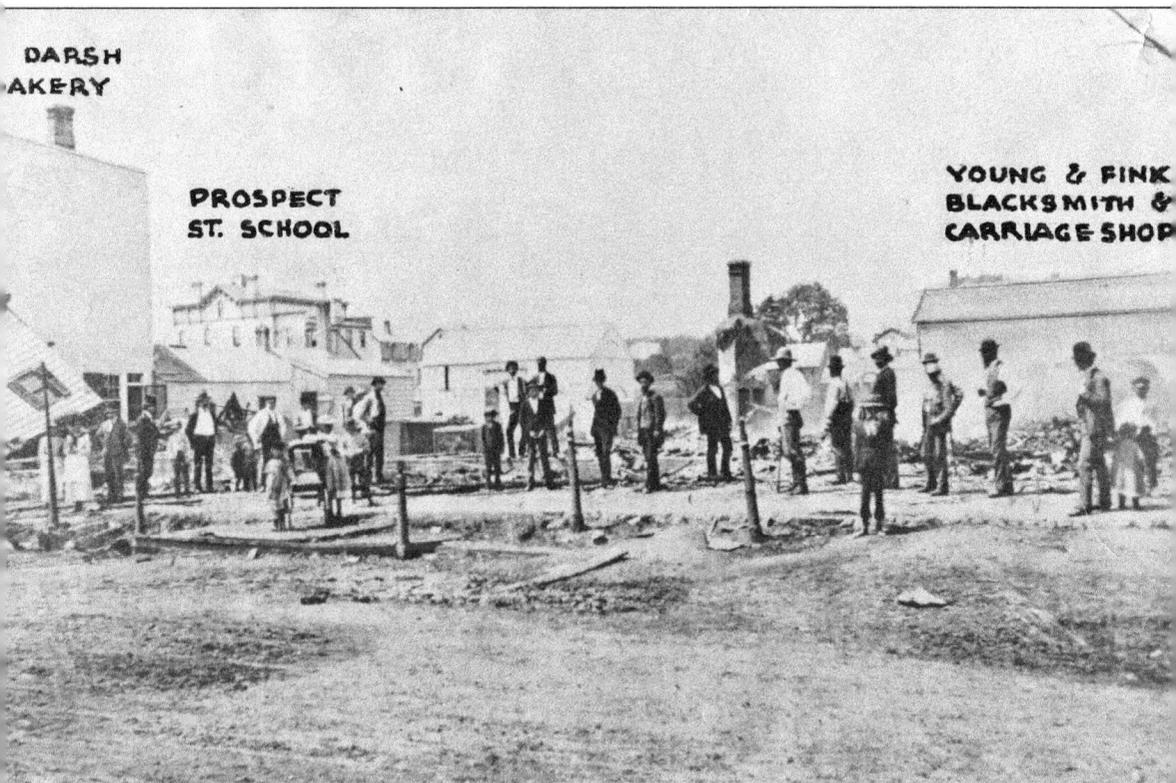

DARSH
AKERY

PROSPECT
ST. SCHOOL

YOUNG & FINK
BLACKSMITH &
CARRIAGE SHOP

On August 4, 1874, Westfield suffered one of its most destructive conflagrations. Pictured is the north side of Broad Street immediately after the fire. Much of Broad Street and a part of North Avenue were destroyed, encompassing much of the downtown area. It was this devastating fire that prompted the citizens to organize the Westfield Fire Department.

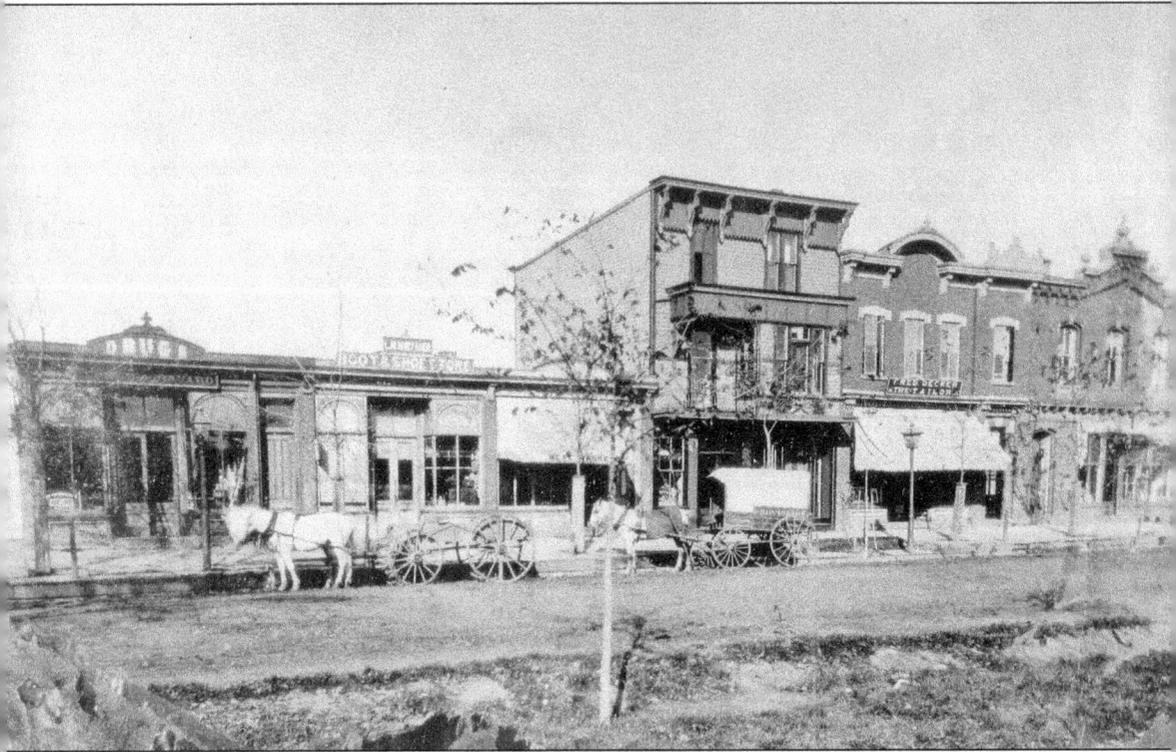

After the big fire, local businesspeople got busy rebuilding the downtown. This photograph of the north side of East Broad Street between Prospect and Elm Streets was taken in 1880. Horse-drawn carts are lined up in front of these stores: (from left to right) Bayard Drug Store (later Dorvall's), Whittaker's Boot Shop, Schooner's Meat Market, Decker's Tailor Shop and Post Office, and Pierson's General Store.

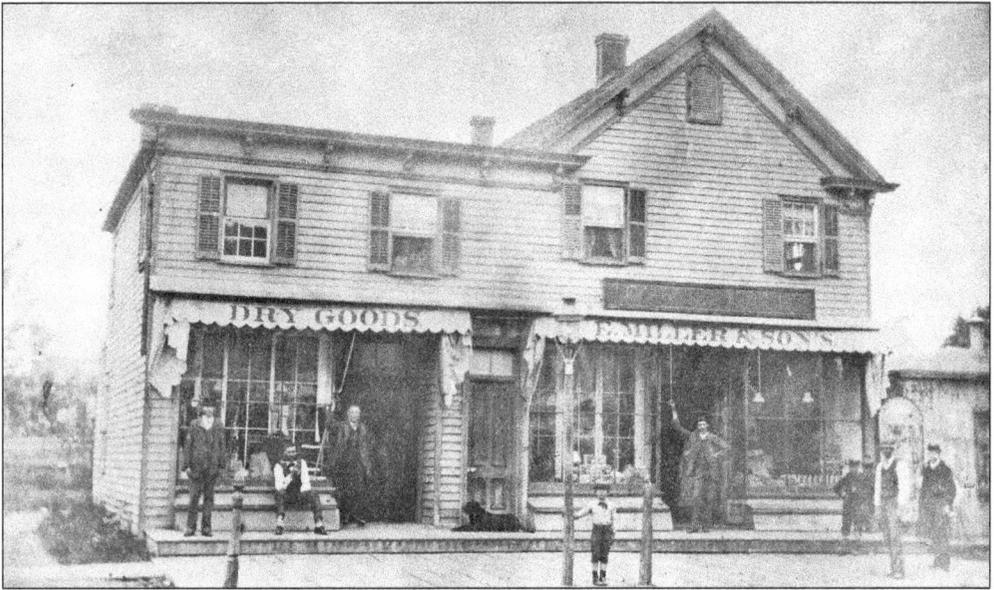

After the addition on the left side of Erastus Miller and Son's dry goods store was added, the Millers referred to their late-19th-century shop as a department store. The establishment was regarded as Westfield's most modern business, while its owner, Erastus Miller, was thought of as a leading merchant. It became the unofficial Democratic headquarters. At the time, Broad Street was a quagmire in the winter and a cloud of dust in the summer. The introduction of kerosene lamplights and wooden sidewalks gave Westfield a reputation as a contemporary town in 1878. In this photograph are, from left to right, unidentified, Charles Wittke (who owns the business across the street), Daniel Miller (Erastus's son), one of the Herter boys, and four unidentified individuals.

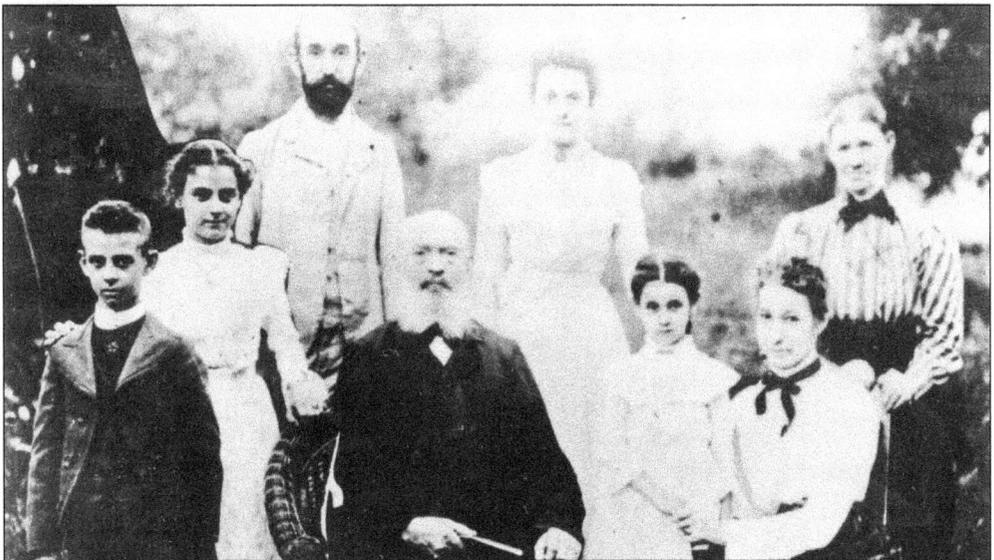

The Wittke family is pictured some time in the early 20th century. In this image are, from left to right, Edward W. Wittke; Emma Wittke; Charles Frederick William (C. F. W.) Wittke, proprietor of the popular news store and father of Edward, Emma, Anna, and Flora; Samuel August Wittke, Charles's father; Anna Wittke; Flora Wittke; Pauline Wittke, C. F. W.'s sister; and Louisa Erber, the housekeeper.

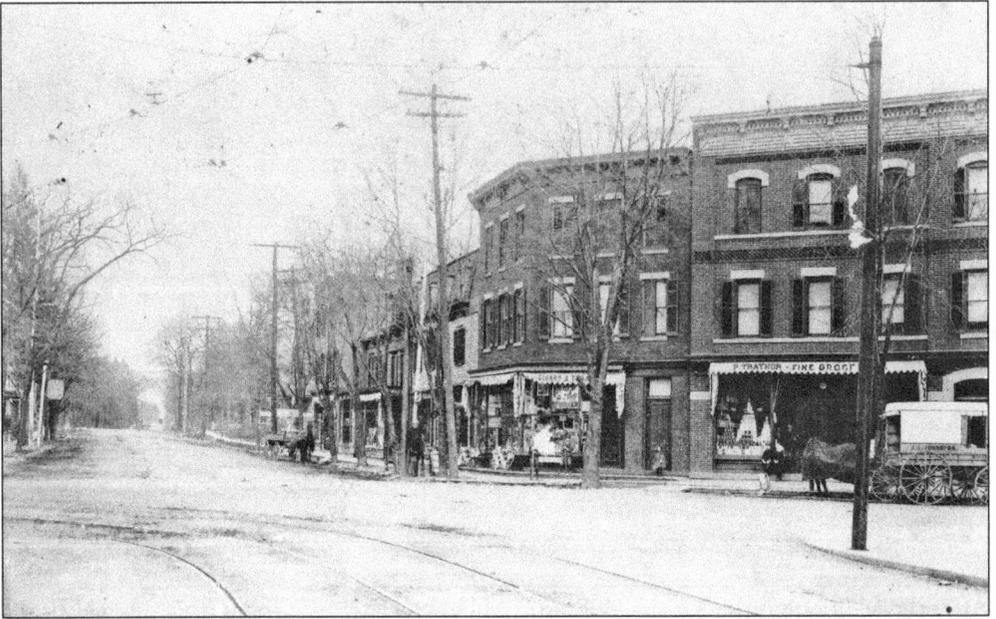

For many years, Wittke's corner store stood as a pillar of the community. Known as Wittke's Corner, the news store on the southeast corner of Broad and Elm Streets sold newspapers, stationery, cigarettes, books, toys, and more. The family maintained a long legacy in this town. Patrick Traynor's grocery store and delivery truck can be seen to the right.

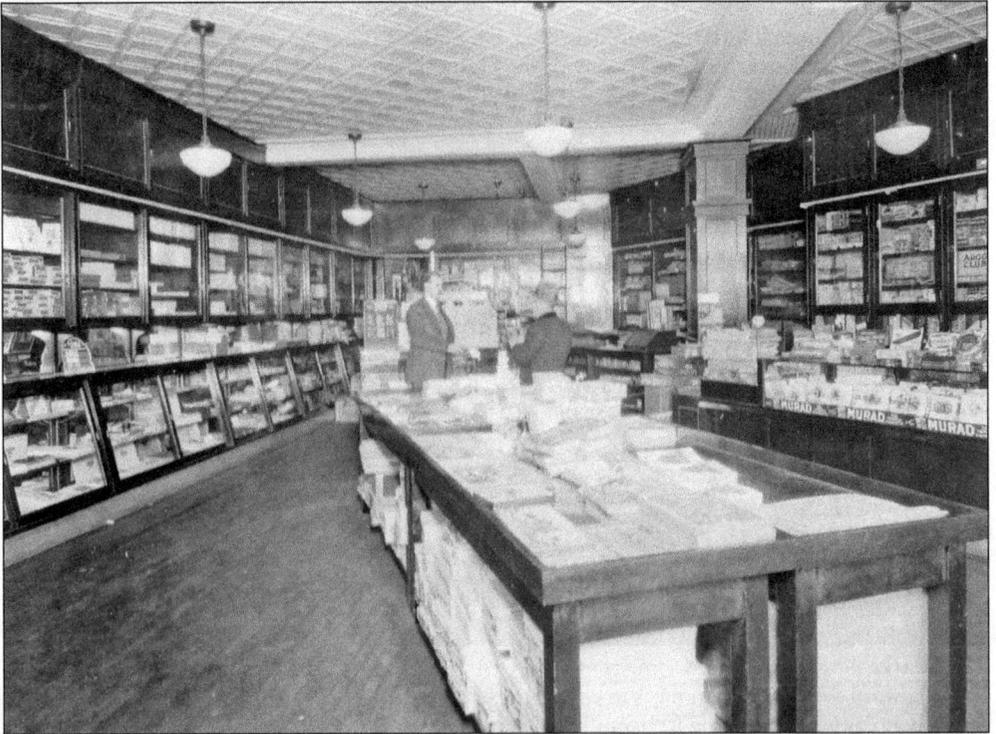

Pictured is the interior of Edward W. Wittke's stationery store some time during the 1930s. Edward was the son of CFW Wittke.

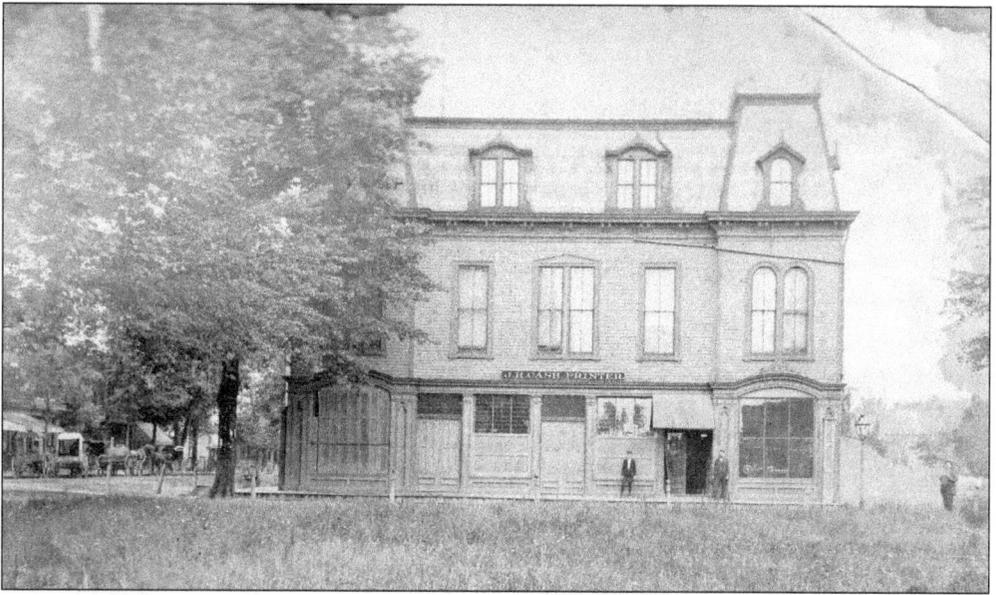

Lyceum Hall was the first home to Westfield's current newspaper, the *Westfield Leader*. John Cash, the paper's founder, is standing to the right of the doorway of the building, located on the southeast corner of East Broad Street and Prospect Street. The Congregational Sunday school held classes for a few years on the third floor of this building before moving to its newly constructed church on Elmer Street in 1882. Lyceum Hall was one of many buildings lost in the great fire of 1892.

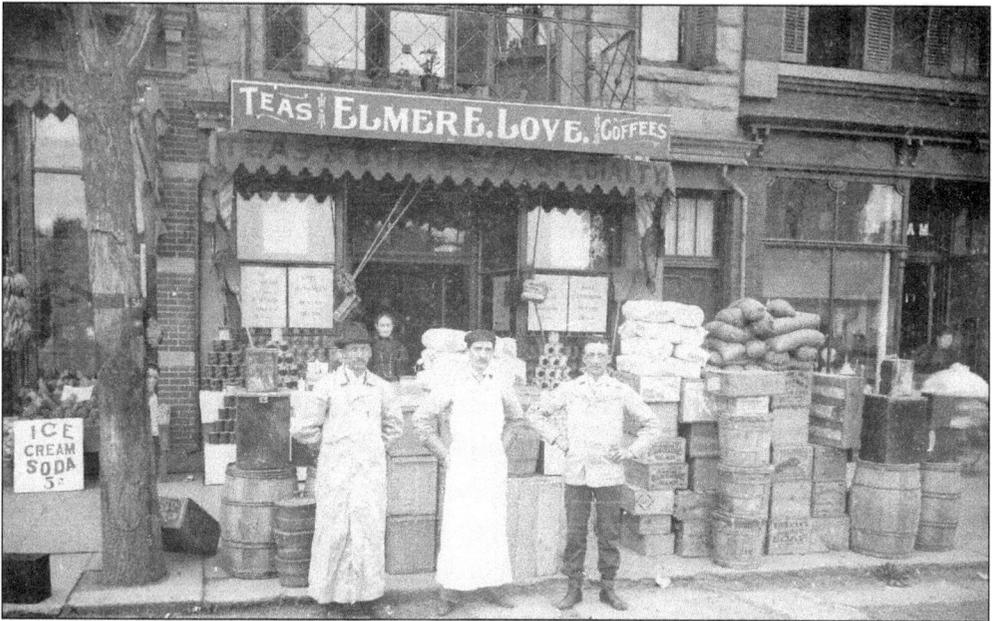

Elmer E. Love (left), grocer; Edgar Fitch (center), chief clerk; and Love's brother Clarence pose in front of Love's store on Broad Street some time between 1895 and 1900. In 1910, the addresses in Westfield were changed to coordinate the through streets. This photograph was taken at 109 East Broad Street before the change was made. The building was the site of a near tragedy in 1901, when a fire broke out in the upstairs apartment. Fortunately, fire officials arrived quickly enough to ensure that no one was injured. (Courtesy of Charlie Bussing.)

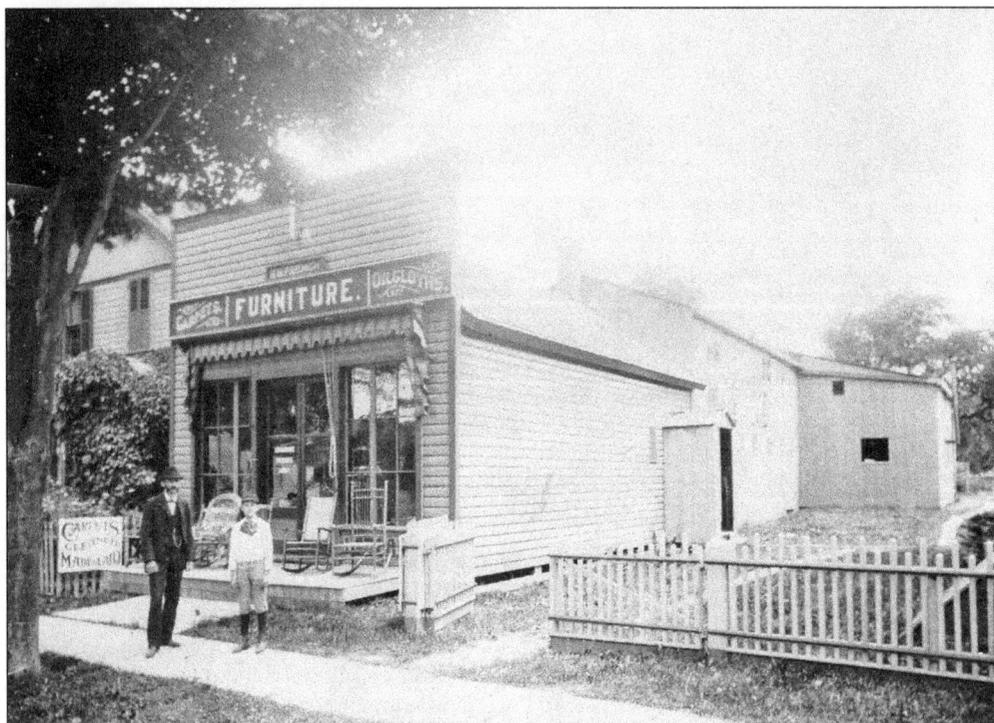

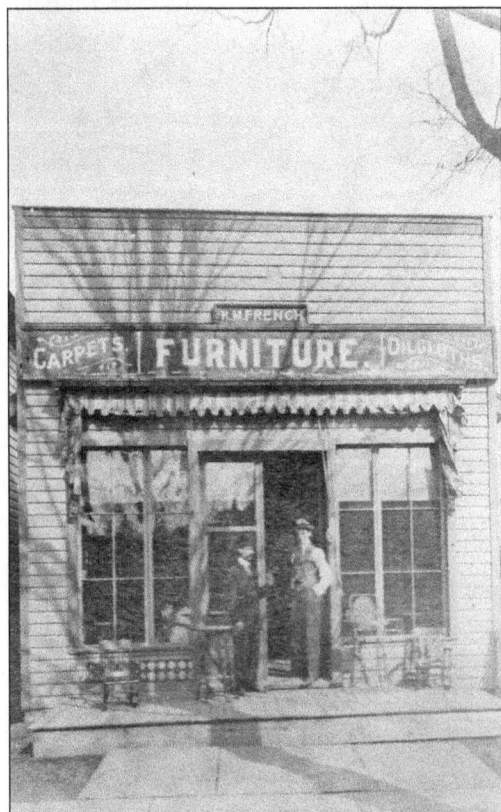

Posing in front of the family furniture store at the far southwest end of Elm Street in 1894 are Robert Merton French (left) and his son, Robert Warren French. The business was begun in 1891 in a smaller space on East Broad Street, and like so many downtown businesses of this era, it was lost to fire. Four months after the store burned down, French put up this building on Elm Street. Many thought the move here to be daring and risky, as Elm Street was not considered part of the downtown business district. The iconic store prospered here for many years. In the early 1900s, father and son pose again in the doorway of the store; again father is on the left.

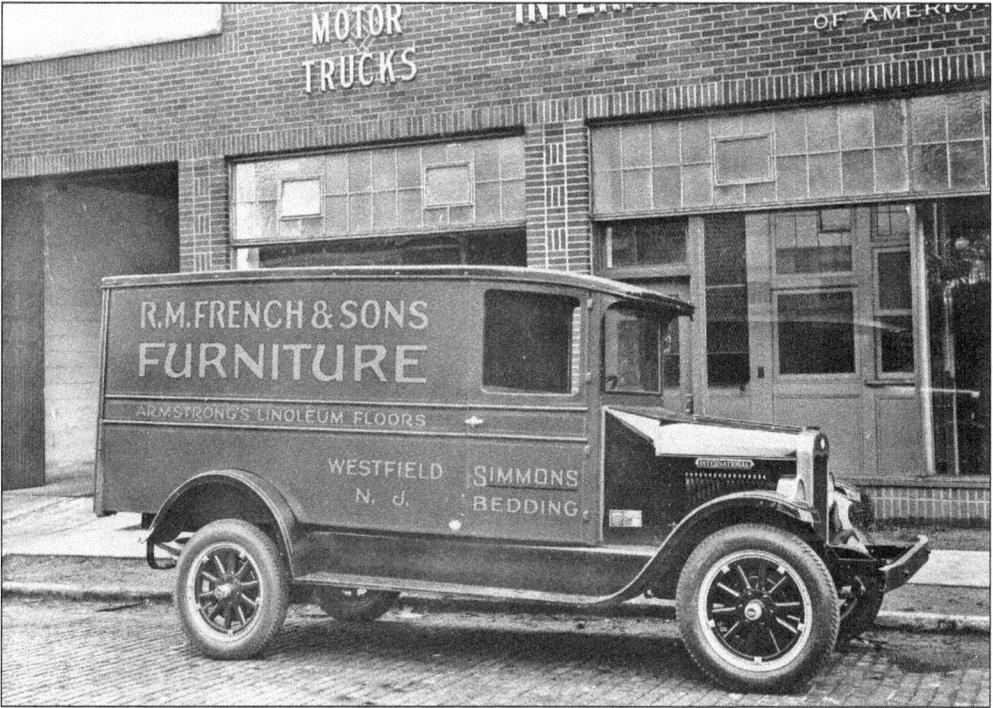

The French Furniture delivery truck is parked in front of an automobile service business. Interestingly, the linoleum and mattress brands that French's carried in the early 20th century remain in existence today. The expanded store is shown below some time in the 1920s. Today, Elm Street lies in the center of Westfield's busy downtown section. Traffic lights of this sort disappeared in the 1960s.

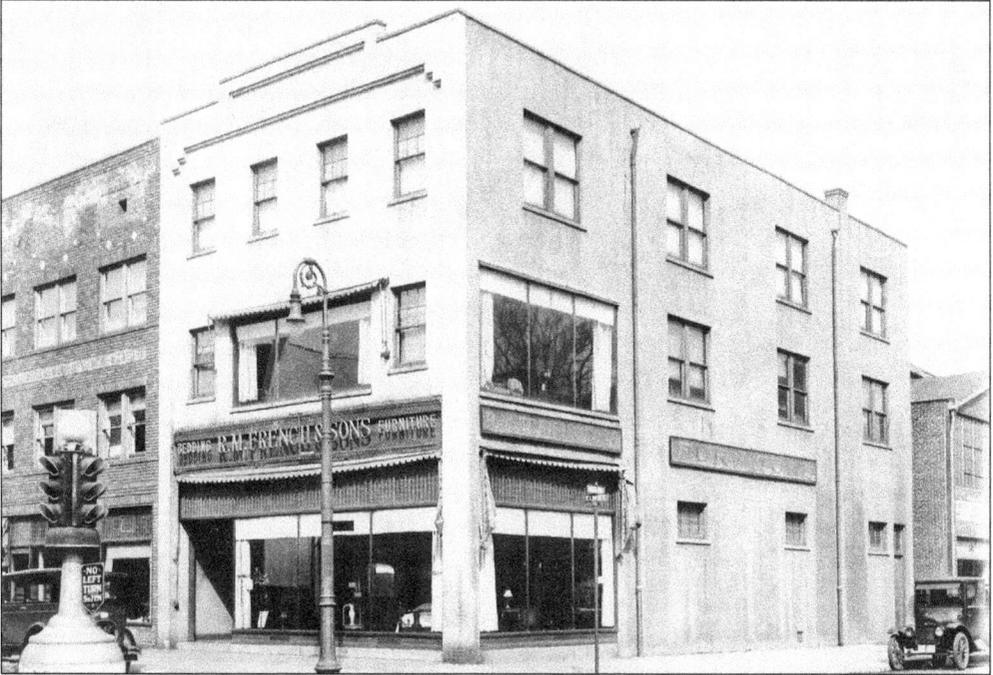

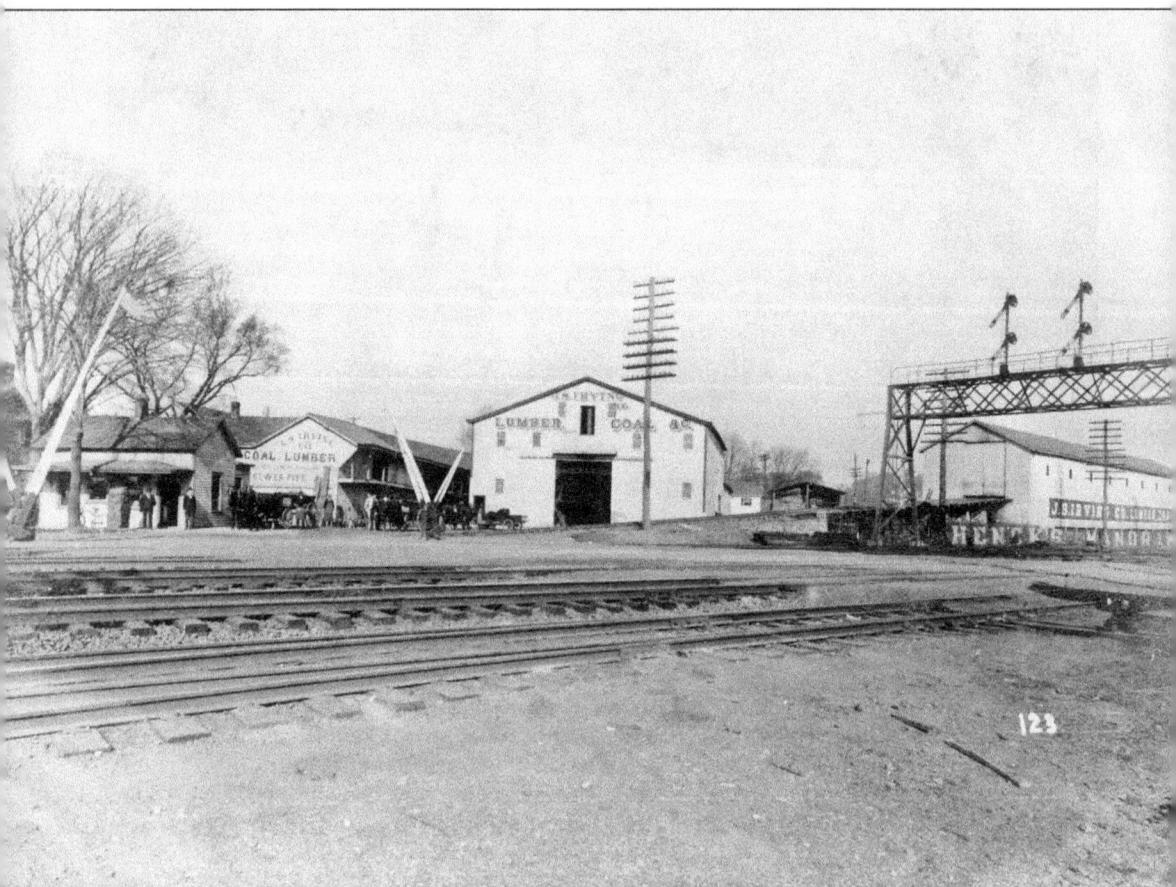

J. S. Irving Lumber and Coal was the first major business of its kind in town. It opened in 1867 on Central Avenue between the railroad tracks and North Avenue. After World War II, the company relocated to the more modern Tuttle Plant when that plant closed due to bad economic times. Irving's two sons joined him in the business and eventually took over. With the rapid growth of real estate, it is safe to say that this lumberyard supplied the majority of lumber to the homes built in Westfield. J. S. Irving's coal and lumber business was the longest-running concern in Westfield's history, staying in business for more than 100 years. It was not only the oldest lumberyard in Westfield but also the oldest between Elizabeth and Plainfield. It closed in the 1970s. For years, it stood as a welcoming landmark to commuters on the Central Jersey Railroad.

John Stiles Irving was born in Somerset County, New Jersey, in 1838. When he was a young man, he moved to Westfield, where he purchased the lumberyard belonging to C. Moffett. Irving's name is one of the few that is closely associated with the transformation of Westfield from a rural farming village to a large and prosperous township. He lived to be almost 83 and remained actively involved in his business as well as in community affairs almost until the end of his life. Not only was he instrumental in organizing the Westfield Building and Loan Association, but he also served as its president for 30 years. Irving was also involved in organizing the Westfield Trust Company and the Fairview Cemetery Association, of which he was president for many years as well.

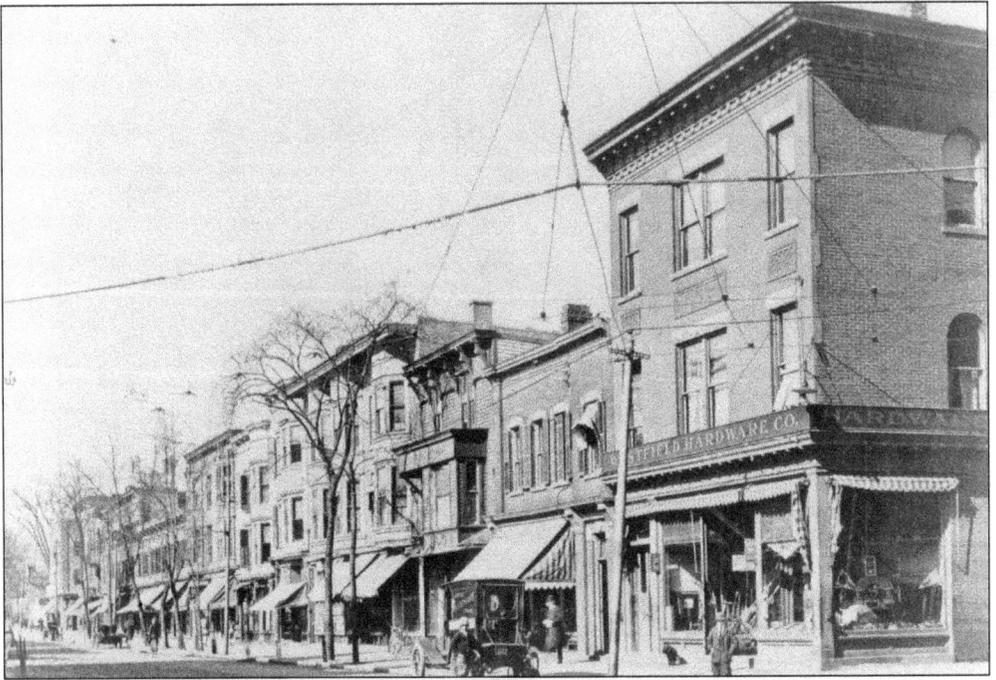

The charm and quaintness of old downtown Westfield is vividly portrayed in this *c.* 1919 photograph. These were the days when electric and telephone service wires attached to buildings and poles draped across streets and through the town. Canopied entrances adorned the fronts of practically all the shops to help keep the hot sun out of the store, as these were also the days before air-conditioning.

The slogan "Through service, we grow" proved true for the Berse brothers—Leo, Dave, and Ralph. After only a few years, their booming business relocated from 221 North Avenue to larger quarters at 443 North Avenue.

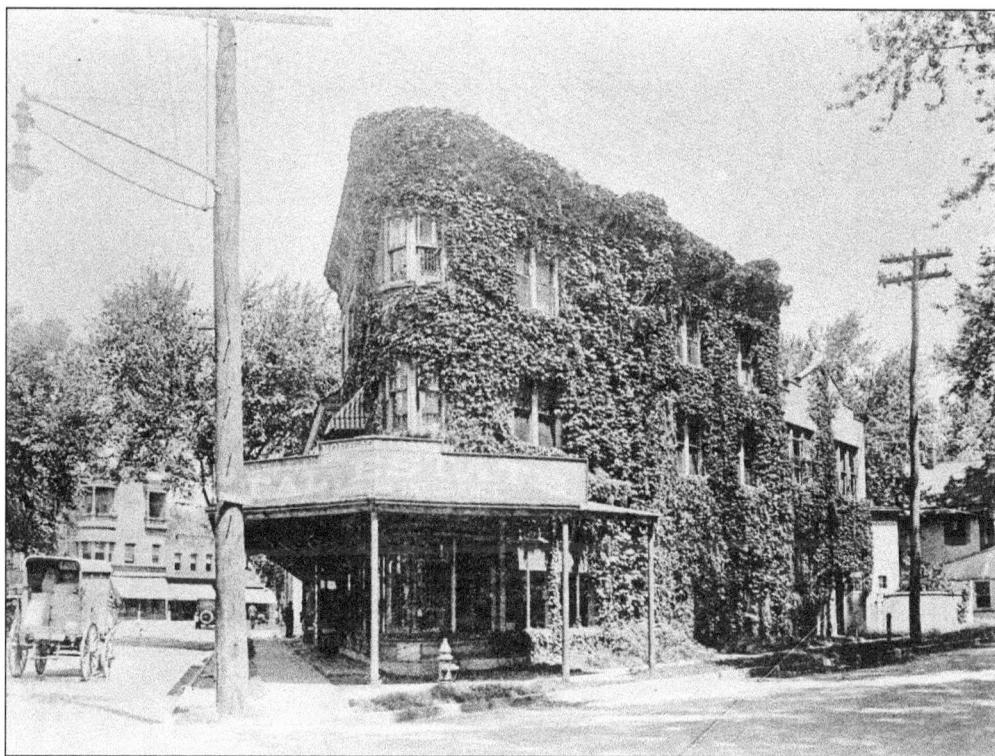

The landmark Flatiron building is located just about dead center of the town on the corner of Elm and Quimby Streets. At the time of the photograph above, it was covered in ivy. The first business housed in the building was a funeral home. Until the 1990s, the structure was home to real estate offices, having several different owners through the years. At right, E. S. F. Randolf is standing in front of the building that housed his real estate office some time in the 1930s. At the time of this photograph, Randolf was in the process of planning the section known as the Westfield Gardens. He developed several other neighborhoods and streets, including Tremont and South Euclid Avenues. Walter J. Lee, publisher of the *Leader*, built his home on the latter.

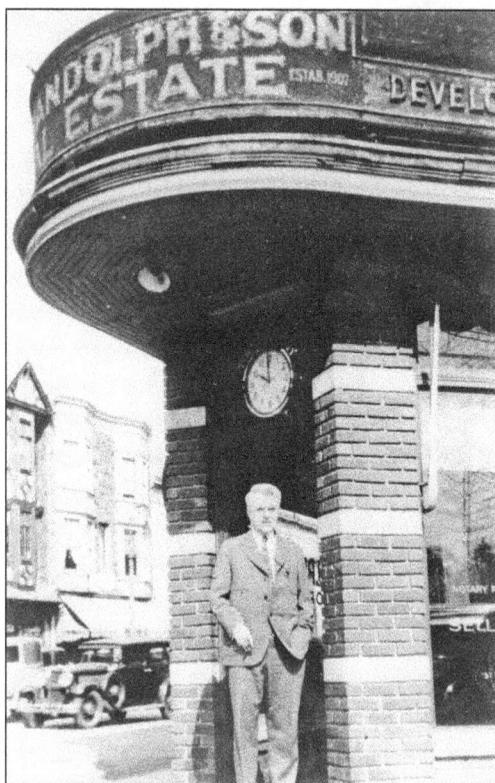

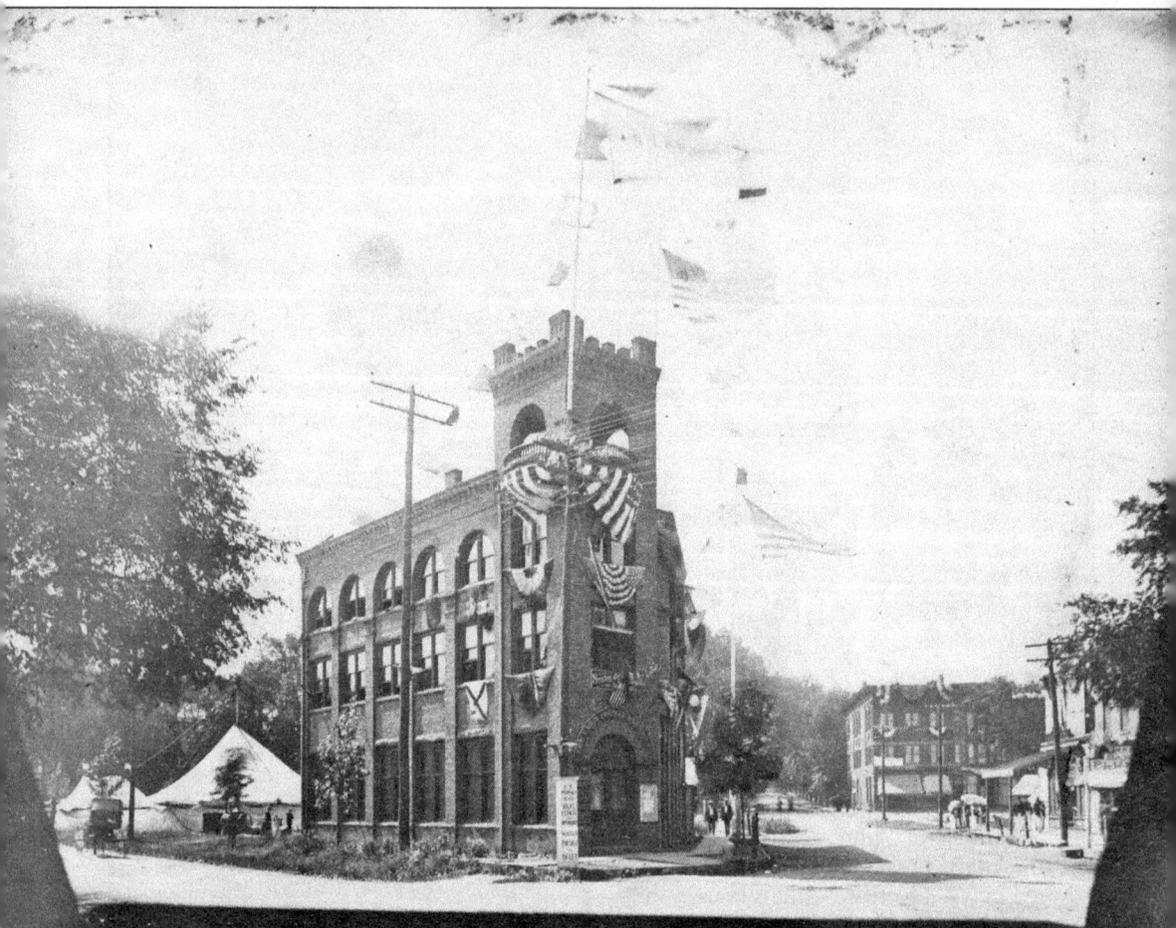

The Pearsall building was built in 1894 by Alfred E. Pearsall to house the local newspaper, the *Union County Standard*, and to replace the original location in the Ferris Building, which also perished in the great fire of 1892. Additionally, the newer building housed C. E Pearsall's real estate and insurance business and at one time was used as a social club.

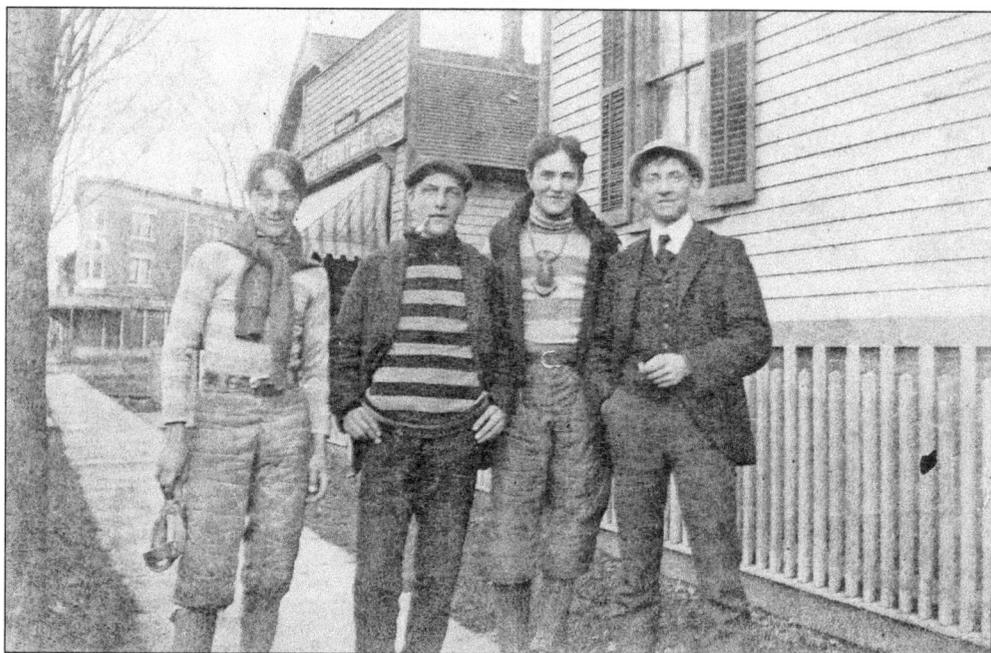

These four young men strike a pose on Elm Street in 1898. From left to right are Harry Hale, Cliff Everett, Sam Voight, and Eugene Brown. Their garb is reflective of 19th-century style. Although knickers and caps disappeared long ago, striped sweaters and sports jackets have remained fashionable. The landmark Flatiron building can be seen in the far background.

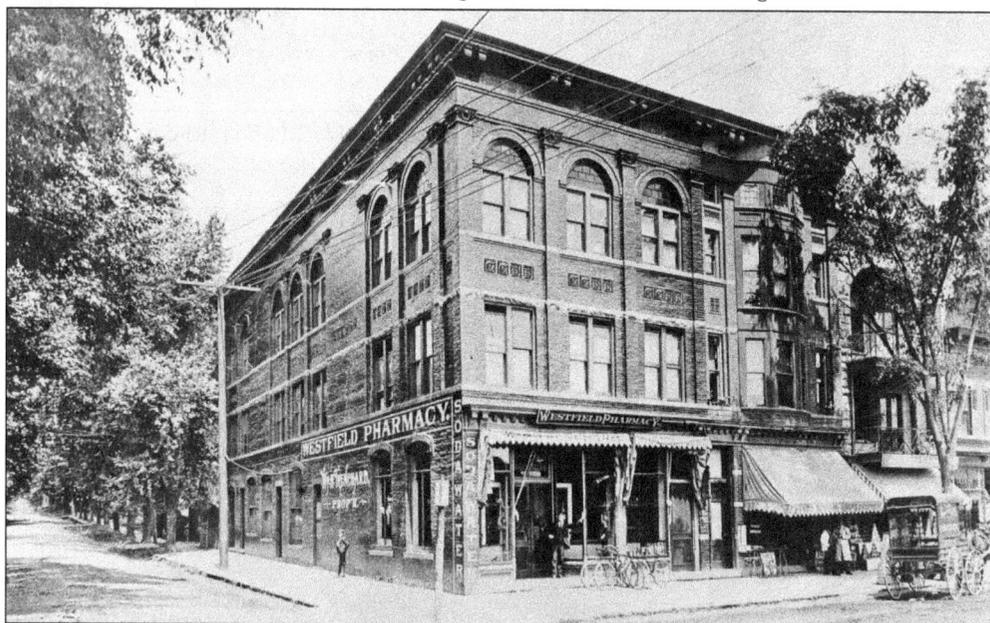

In 1889, the first telephone used in Westfield was a pay phone at the tailor shop of Fred Decker that was served by a Plainfield exchange. In 1900, a switchboard was placed in William Trenchard's drugstore. The first telephone numbers were only three digits. Townspeople mostly were not very interested in what they regarded as an experiment. The home to the town's first switchboard is seen here in the early 1900s.

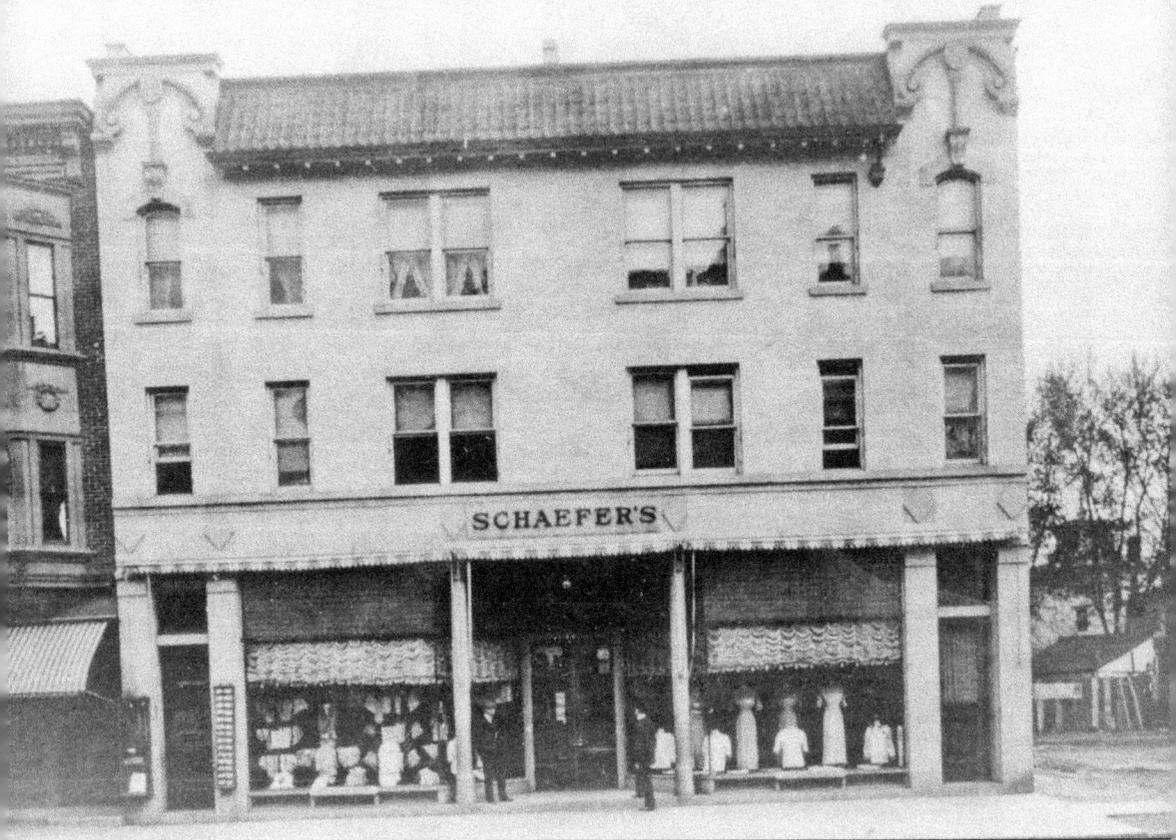

When this photograph was taken in 1912, Schaefer's was considered an up-to-date department store providing quality merchandise and attentive service to its customers.

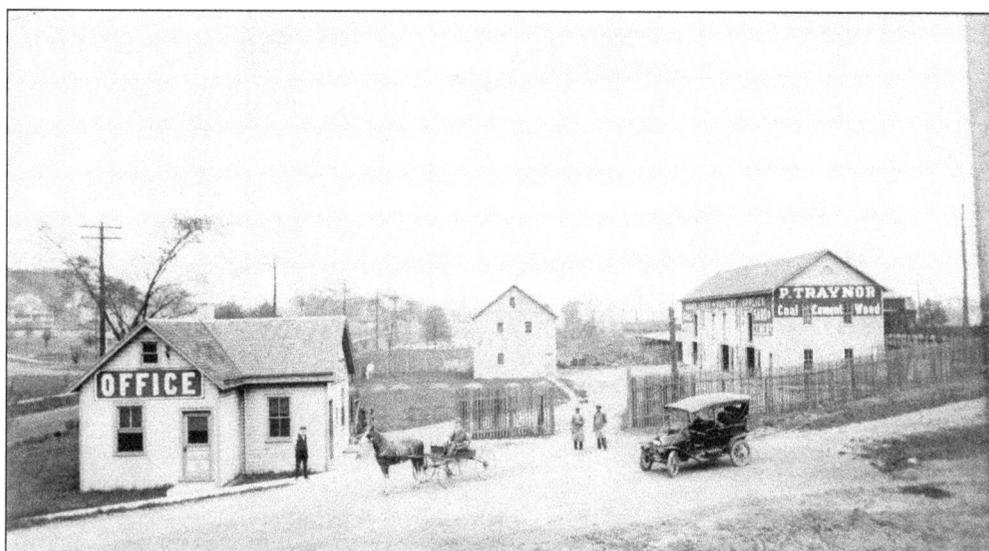

Another significant establishment was Patrick Traynor's Feed and Building Supply. Feed and coal businesses were successful in the late 19th and early 20th centuries, as demand was high for these commodities. Traynor's successful operation stood at the corner of North Avenue and Elmer Street for many years. Traynor and his shop were pillars of the community in the 1920s.

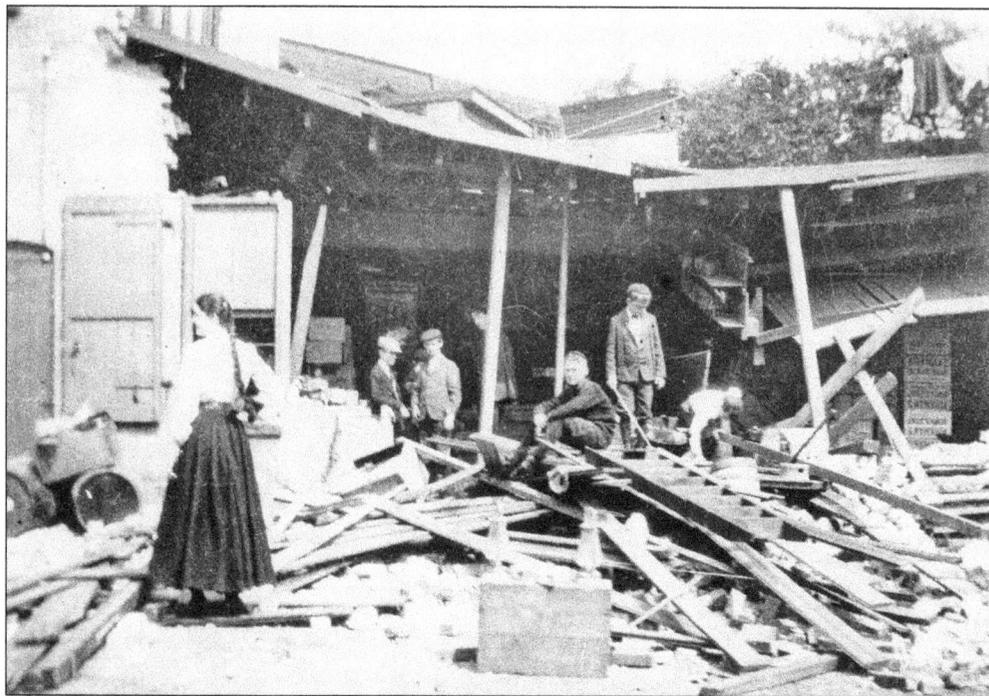

A terrible explosion occurred at Traynor's shop in the early 20th century. An employee went downstairs to retrieve a bag for some potatoes. Traynor produced his own gas on the premises for the gas lamps. Unwittingly, the employee lit a match, probably to provide some light, and blew out the entire side wall of the shop. There were no casualties as a result of this accident. However, as can be seen, the destruction was great. Unfortunately, the business was eventually lost to fire in the 1920s.

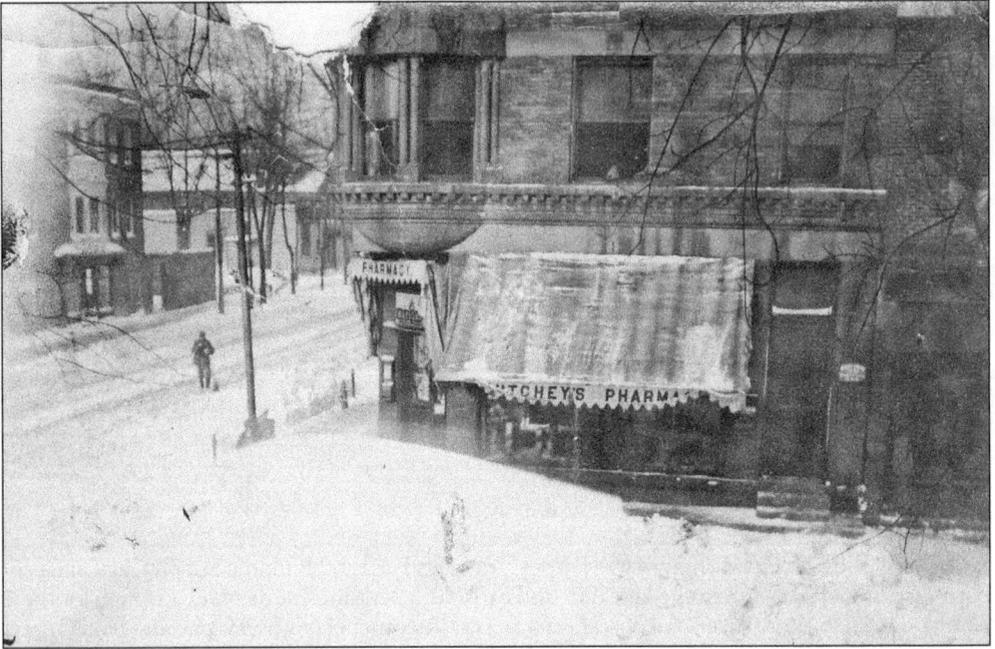

Frutchey's was more than a pharmacy in the early 20th century. It was the town meeting spot. Here, teens and young adults would assemble before their evening activities and sometimes again after. The shop carried everything from toiletries to doughnuts.

Assisting a customer is the proprietor of this 1900s haberdashery, Harold Gordon. The shop opened at 53 Elm Street in 1915, during an era when a man was not completely dressed unless he donned a hat. The store carried a full line of men's furnishings and provided tailoring services as well. "Get the Gordon Habit" was its slogan.

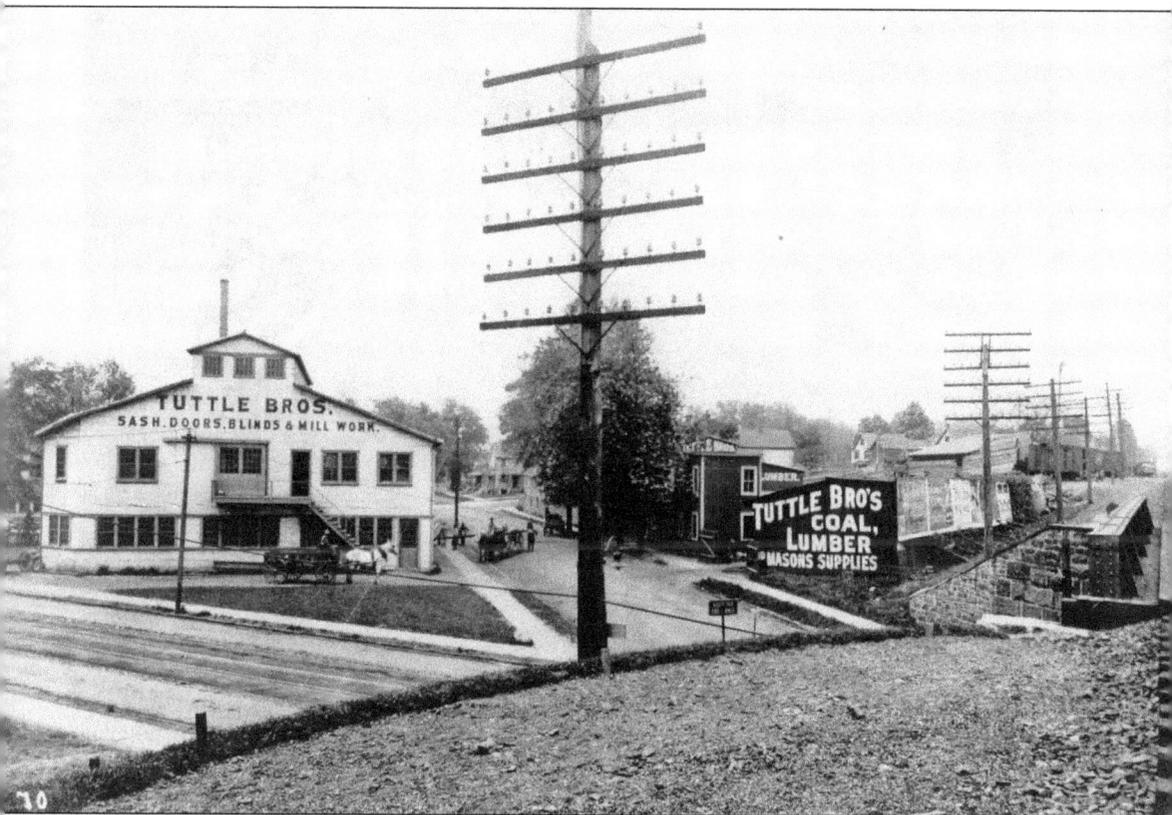

Tuttle Brothers was founded by brothers William and Lauren in the late 1800s. The coal, lumber, and building supply business, located at the corner of Westfield Avenue and Spring Street (now Watterson Street), was a major business, supplying the area with necessary products for many years. The brothers also opened a country store, which served as a general meeting place. It offered superior goods at reasonable prices and was the only place for miles around where farmers could buy staple goods. For 50 years, the brothers individually shared the office of postmaster. WIlliam was a Democrat, and Lauren was a Republican. When a Democrat was elected to office, William held the office of postmaster and Lauren ran the store. When a Republican was elected, they simply switched places. The Honorable William Tuttle (King Coal Tuttle) served as a congressman. He was appointed by President Wilson as the U.S. commissioner to the Panama-Pacific International Exposition in 1915. Tuttle Parkway, a two-block residential street, is named in memory of the brothers.

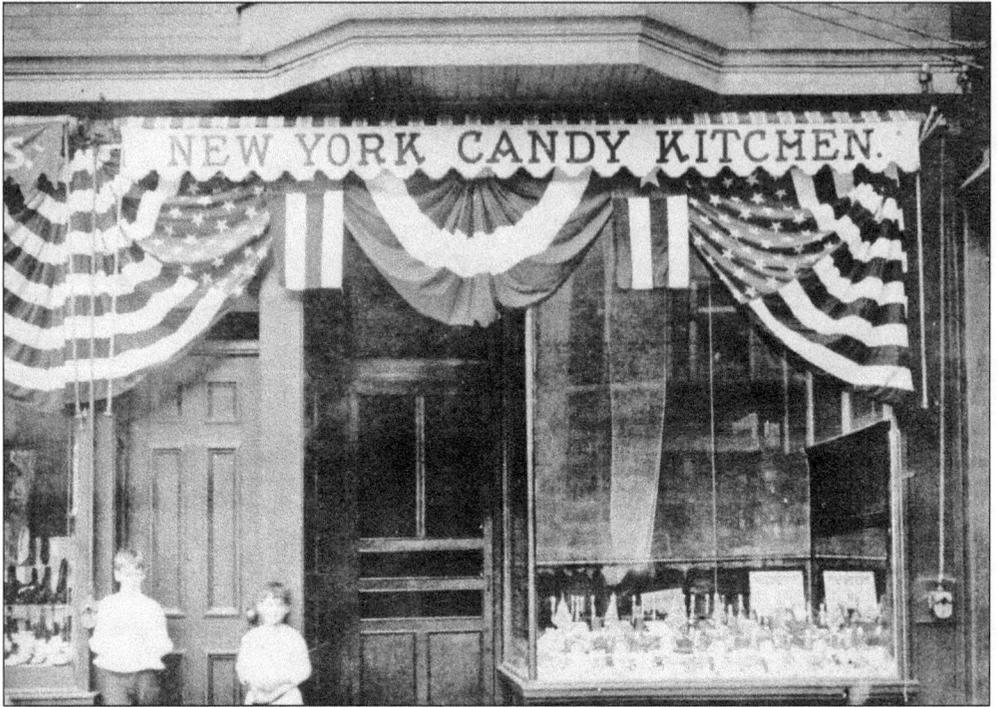

Vagelos and Mitchel, future owners and children of the family of the proprietors of the popular New York Candy Kitchen, are pictured here in front of the shop at 173 East Broad Street. The business was known for having the best ice cream in town.

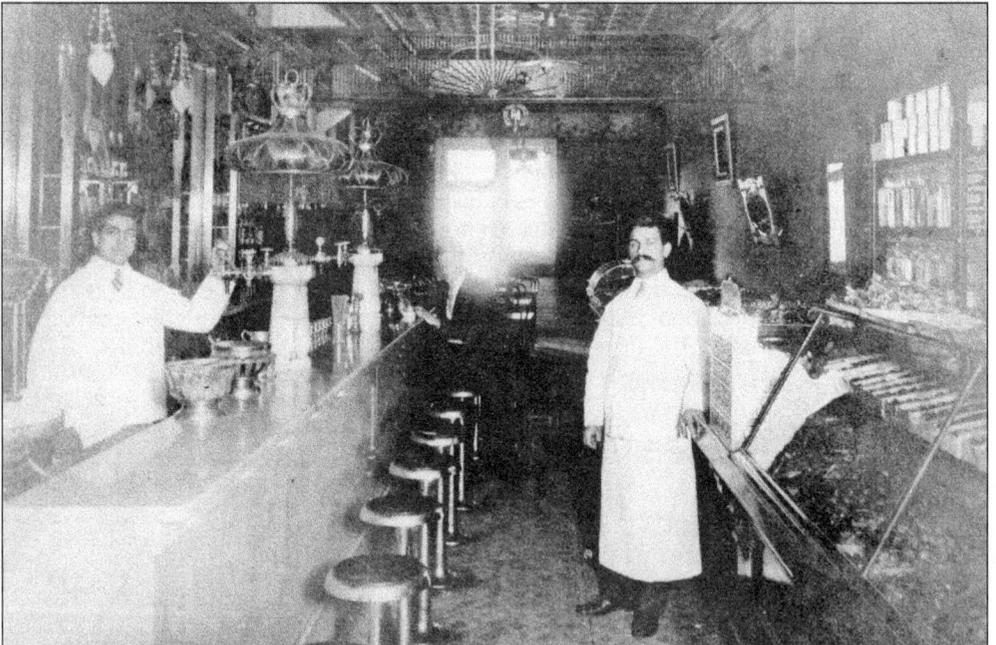

Years later and all grown up, Vagelos and Mitchel pose in their successful confectionery. The famous Meadowbrook sundae, a ball of ice cream covered with marshmallow whip and topped with a mixture of cocoa, was a local specialty and the shop's signature confection..

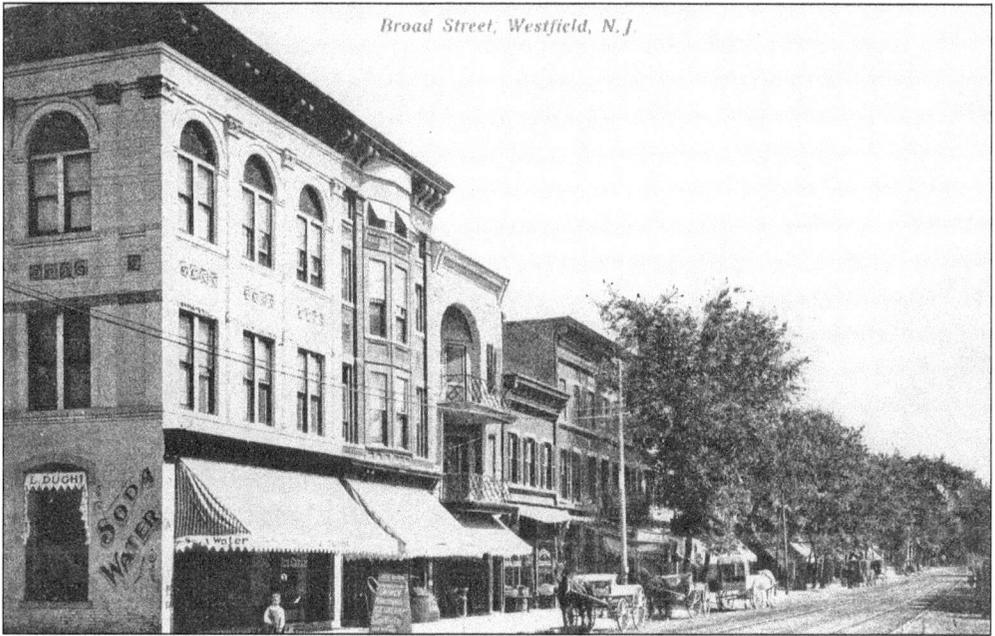

Trolley tracks that accommodated the Main Line Trolley, which began traversing the roads of Westfield in 1898, can be seen in this 1907 photograph of East Broad Street. Though horses and buggies are no longer seen along this street, many of these buildings still stand today.

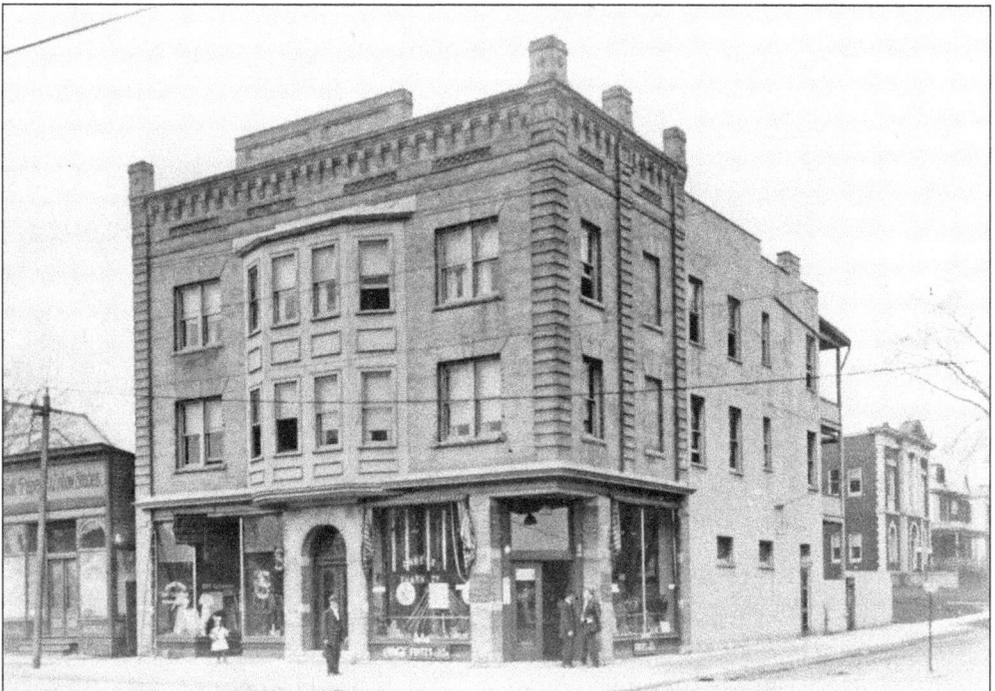

This structure remains at the corner of Prospect and East Broad Streets. Today it is home to a tailor shop, a boutique shop, and a take-out restaurant. In this 1912 photograph, the old Municipal Building can clearly be seen in the background.

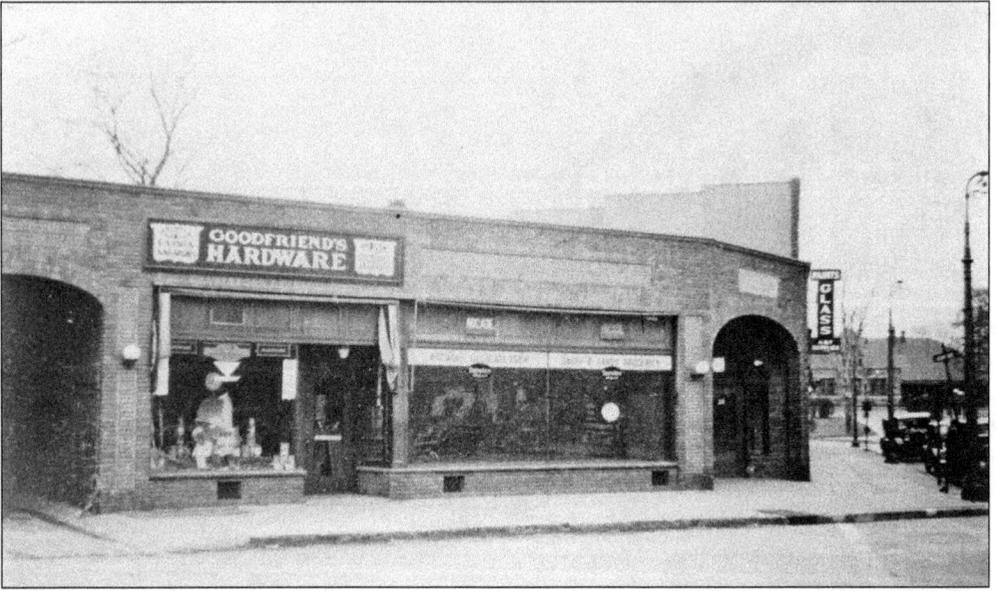

After Goodfriends Hardware, a thriving retail establishment on Quimby Street, closed its doors, another mom-and-pop store, Taylor's Hardware, served this community for many years and through several owners until a large retail chain took over. The north-side train station is in the background.

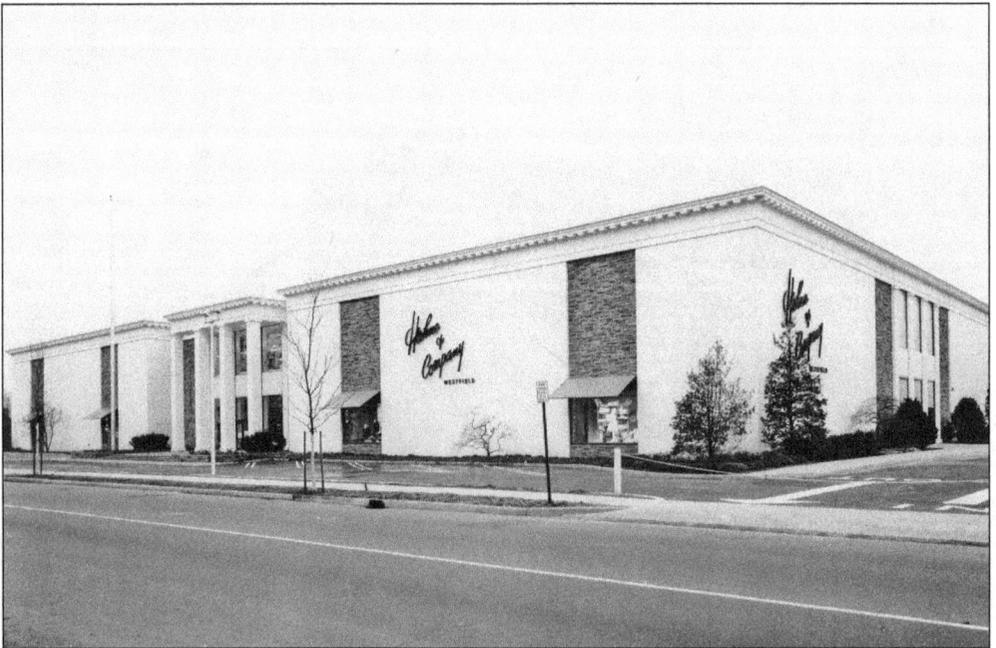

Hahne's Department Store opened in Newark in 1858. The first business was begun as a specialty store by Julius Hahne, but by the early 20th century, the retailer had grown into a full-line department store. Hahne and Company opened on North Avenue in Westfield in 1963 to become the first and only major department store in town. The company suffered some difficult times. In 1988, the location was taken over by Lord and Taylor, which remains the only department store in town.

Three

TRANSPORTATION

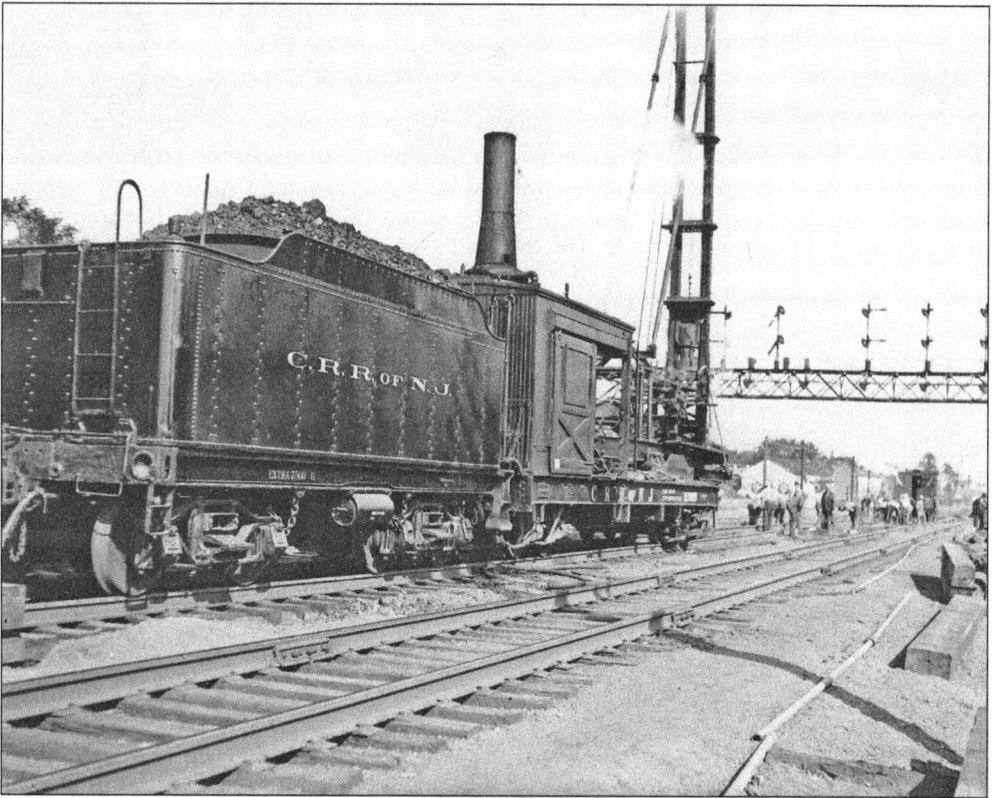

Although rail service came to Westfield as early as 1838, it was not until the early 20th century, when the Central Railroad of New Jersey began providing direct service to Jersey City, that growth took off. From Jersey City, commuters took a ferry into New York City, making New York suddenly very close. Commerce and business opportunities abounded for the once-small farming village. Pictured is the Central Railroad train, the third oldest railway in the United States, stopped at the Westfield depot some time around 1899. In those days, trains were powered by steam locomotives. In 1925, diesel-electric locomotives were developed, but it was not until the 1940s that they actually began to replace the steam engines.

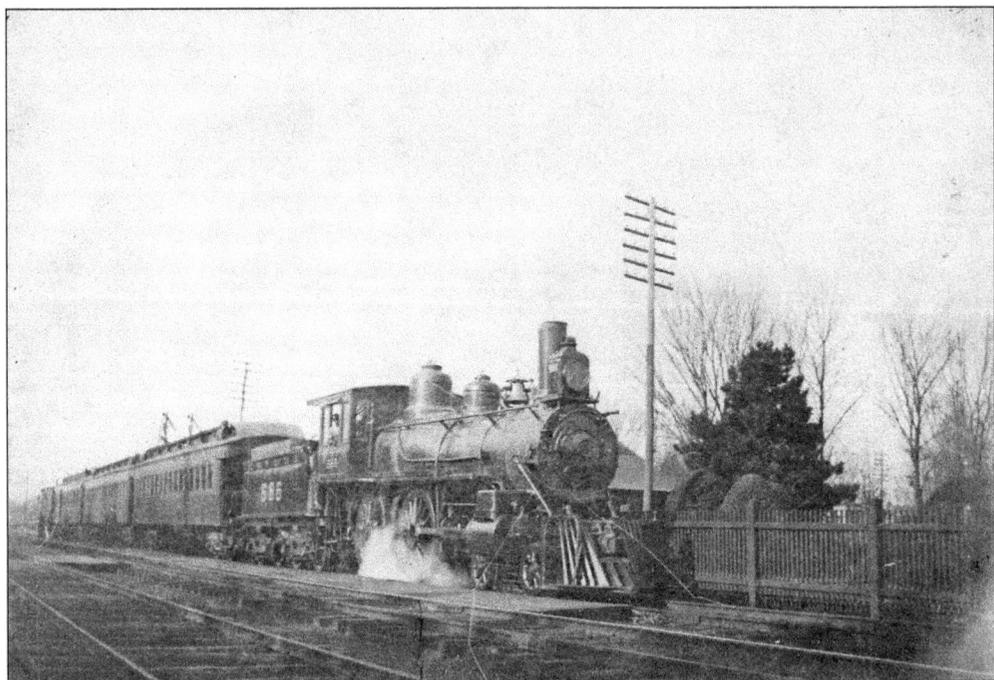

Known as the world's greatest train by railroad buffs, the *Limited Express* was an upscale passenger train that travelled at a speed of approximately 60 miles per hour. The train made long excursions between major cities. The train is pictured passing through Westfield's station on one such journey.

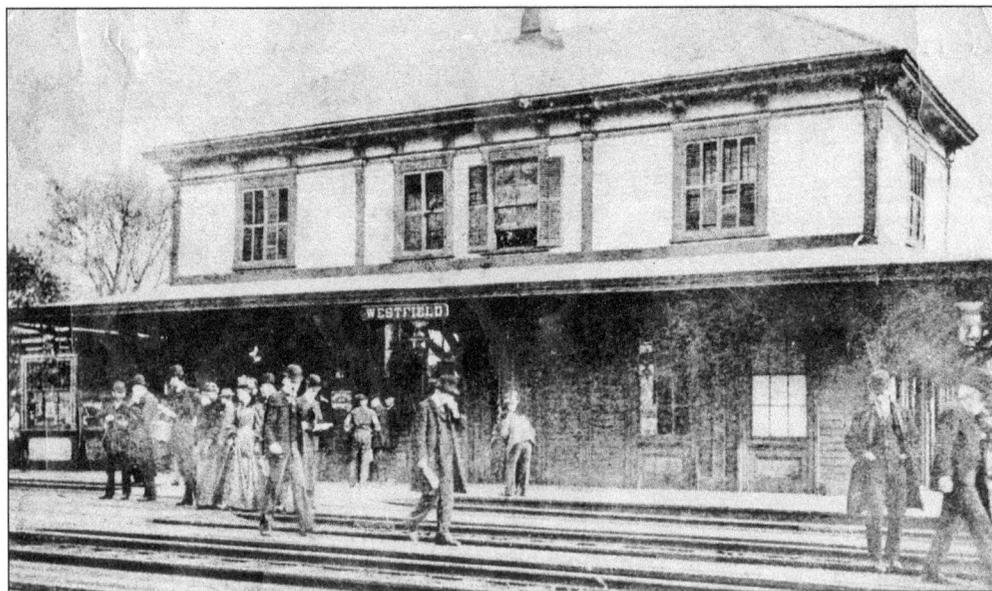

The first passenger depot on the current North Avenue was built in the 1860s. On September 9, 1891, auctioneer J. M. C. Marsh sold it to a man named Hart for $500. Hart moved the depot a few hundred yards up Elm Street. He raised it, built a first floor, and sold the structure to realtor Walter J. Lee in 1910. It then became the home of the *Westfield Leader* until it was destroyed by fire in 1976. This photograph was taken in 1890.

This black and gold sign was one of several that hung in the train station on both the north and south sides. This particular one was salvaged by Charles Ross, a baggage master and porter for the Central Railroad of New Jersey. It hangs in the Westfield Historical Society's museum archives.

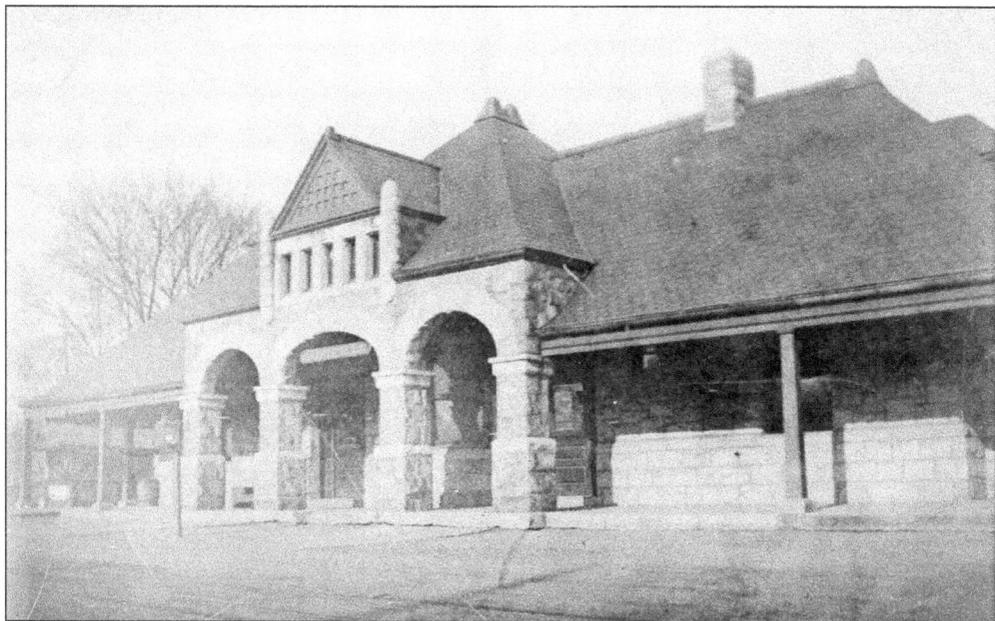

Two buildings, one on the north side and one on the south side connected by a tunnel walkway, make up the train station. Pictured is the current north building, which was constructed in 1892, before the platform was added. The westbound tracks are accessed through this building, while the eastbound tracks are accessed through the auxiliary south-side depot.

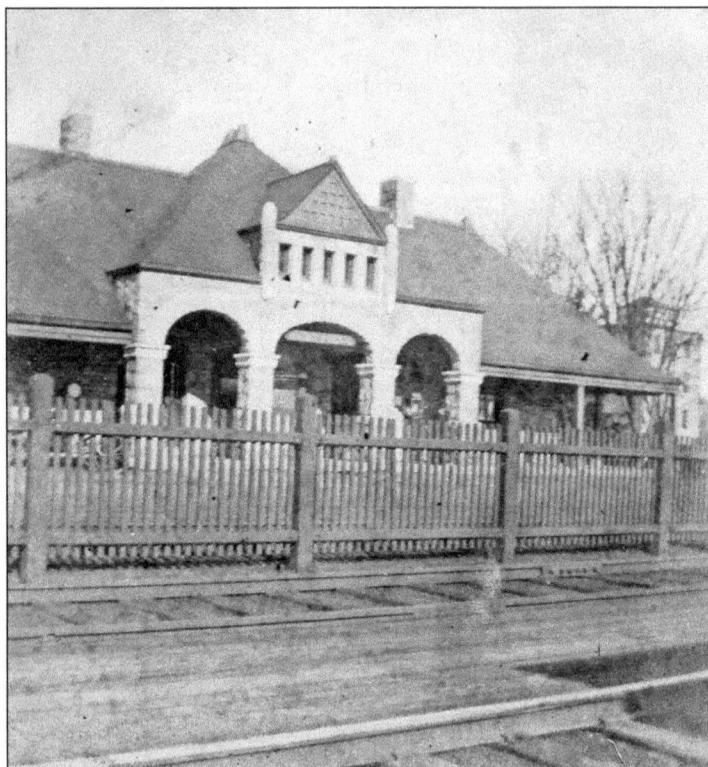

The current north-side depot is pictured here after a fence was added for safety purposes. Below is an image of the snow-covered north-side depot taken during the winter of 1899. This shot was taken from the second floor of Robert M. French's furniture store on the corner of Elm Street and North Avenue.

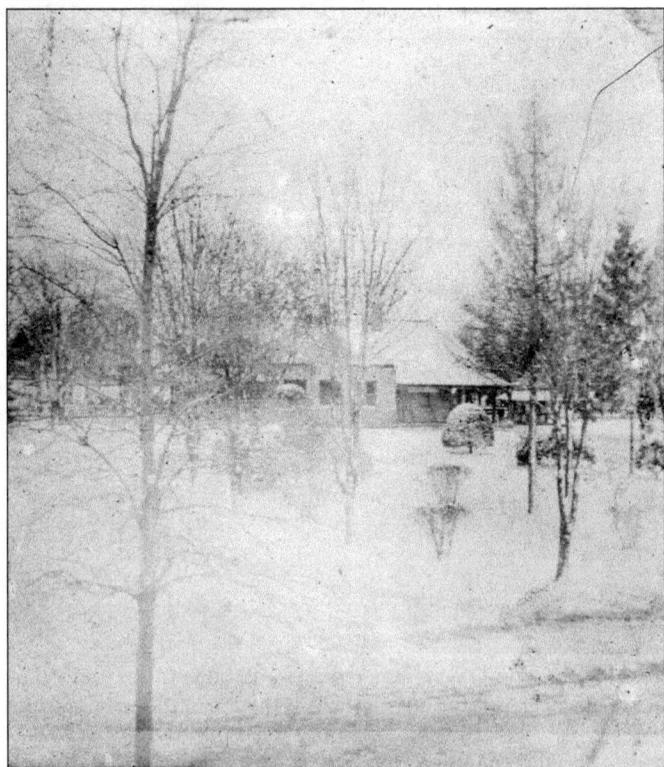

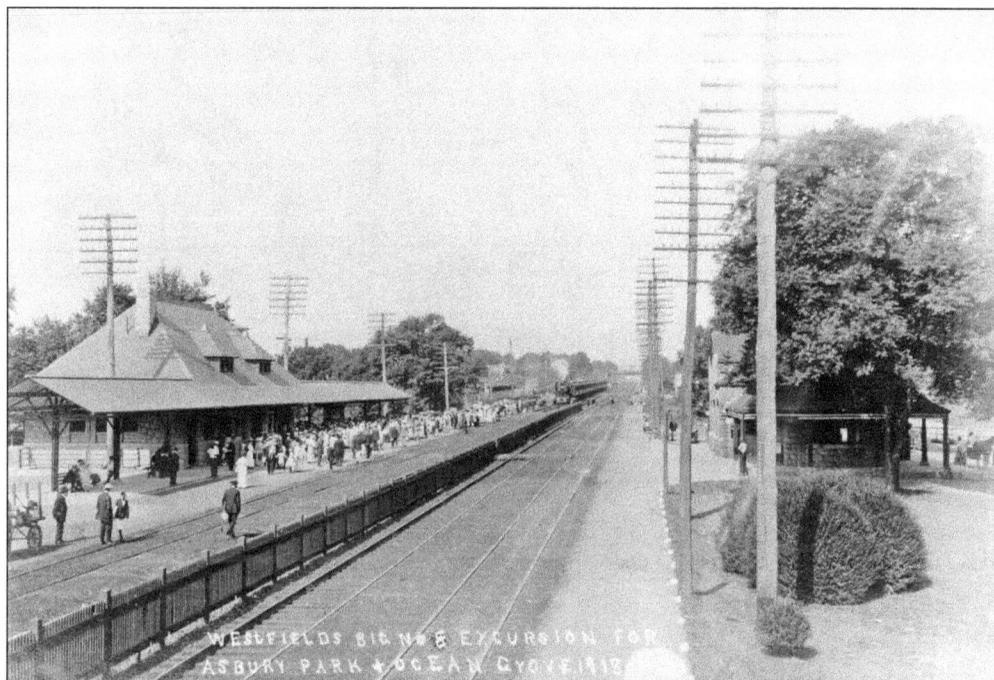

In the early 1900s, the Methodist church sponsored excursions to Asbury Park and Ocean Grove on the Jersey Shore. These trips, which took place three or four times per season, were always well-advertised and well-attended, as local swimming spots were few. The outings drew much excitement from crowds of all ages. Typically, picnic lunches of boiled-egg sandwiches were packed for these fun-filled days. Pictured, although difficult to see, is the Central Railroad train pulling into the station. Usually two white flags adorned the locomotive to help identify its destination.

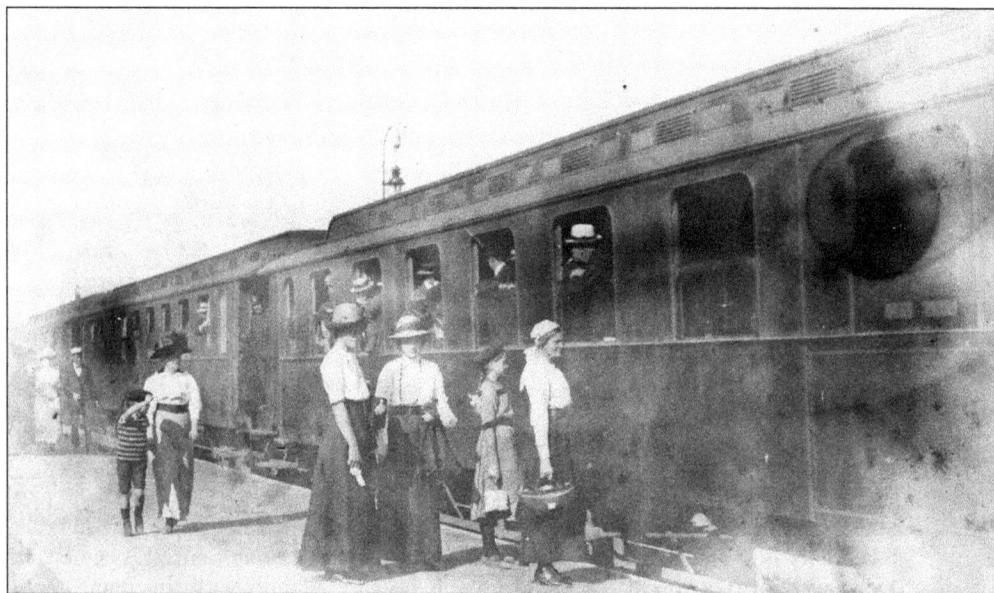

This is another shot of a train stopped at the Westfield depot. This 1914 photograph shows the fashion of the day. Long skirts for the ladies and hats for the men, women, and children were a part of an unwritten dress code.

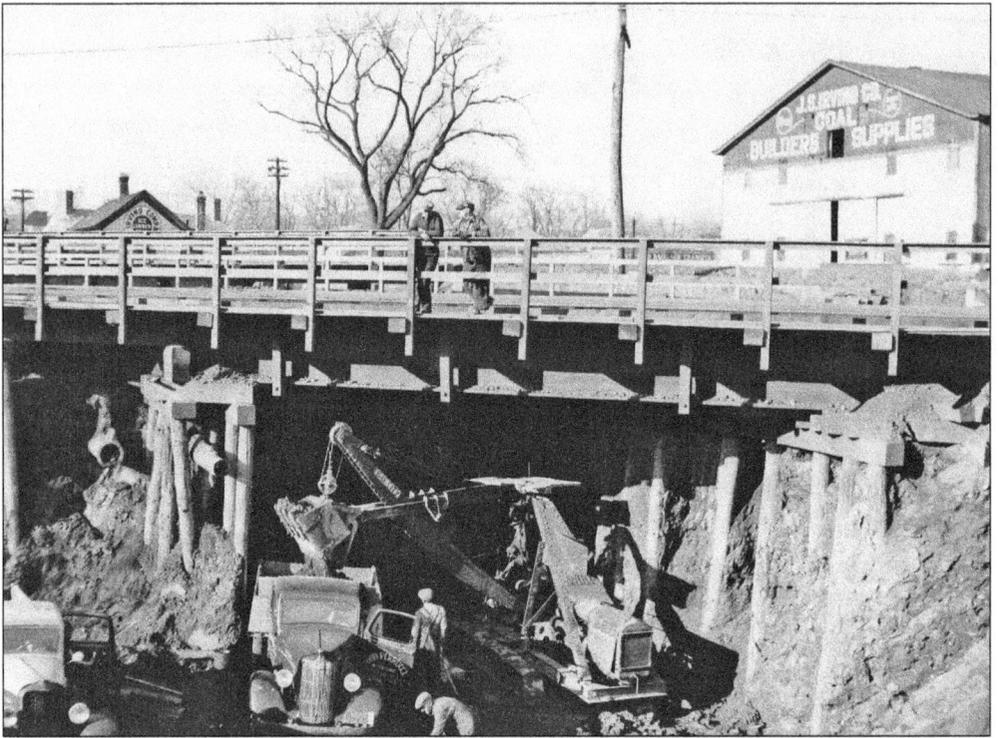

Construction of the train overpass is shown here. The land was not only excavated to raise the tracks but a portion of East Broad Street was leveled in order to complete the project. J. S. Irving Lumber and Coal can be seen in the background.

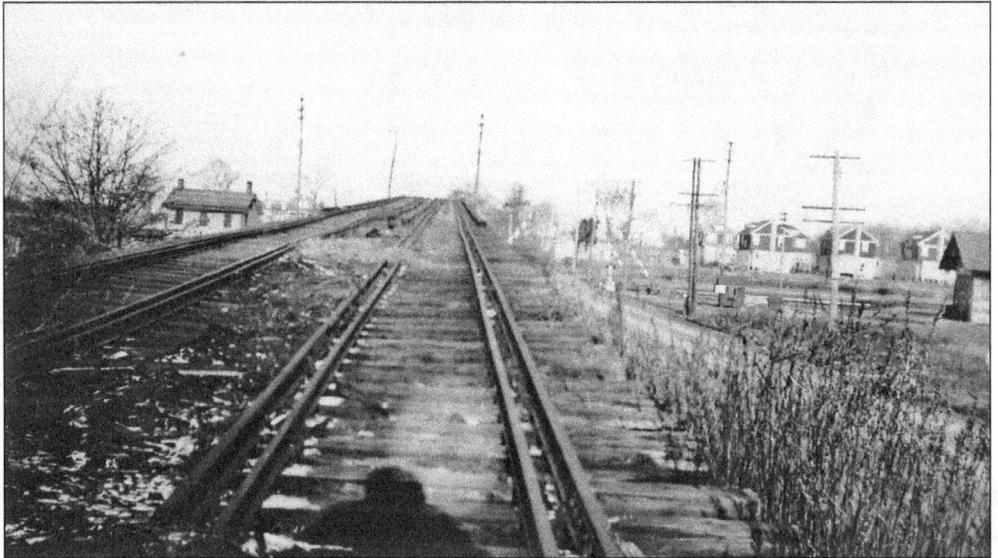

Pictured in February 1933 are the Lehigh Valley train tracks that ran along Central Avenue. The neighborhood was known as the Picton section simply because a family with this name, along with one other family, the Scudders, owned the only large farm in the area. This section is no longer called Picton. The little station stood near the tracks. It is possible that the small structure in the left background is that depot.

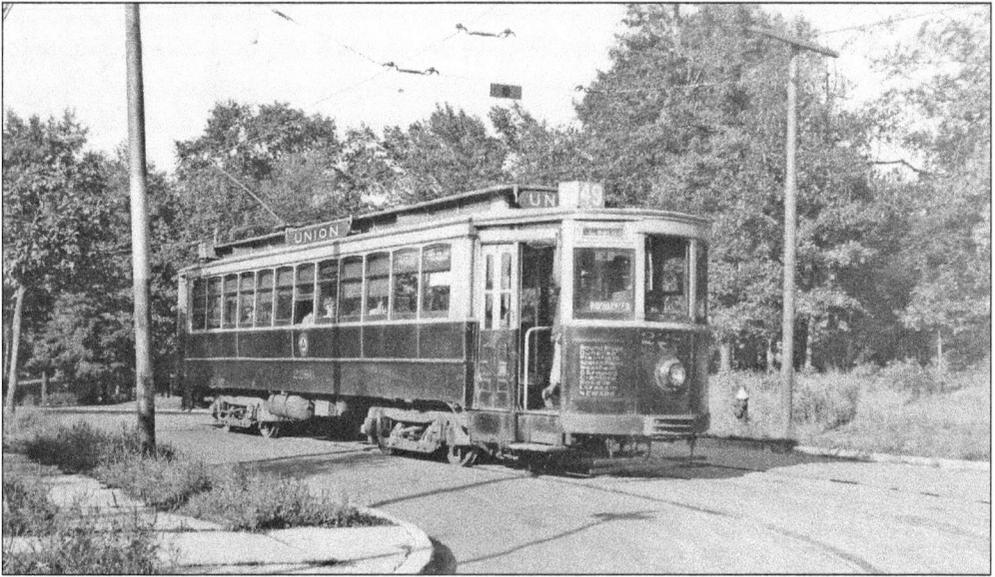

Trolley no. 49 is about to turn the corner of Brightwood Avenue onto Prospect Street heading south into downtown in September 1935. It is one of this car's last trips, as trolleys were replaced that year with electric buses. Below, trolley car (or street railway to purists) no. 1906 makes its way along the main line between Elizabeth and Bound Brook. In 1935, this route disappeared.

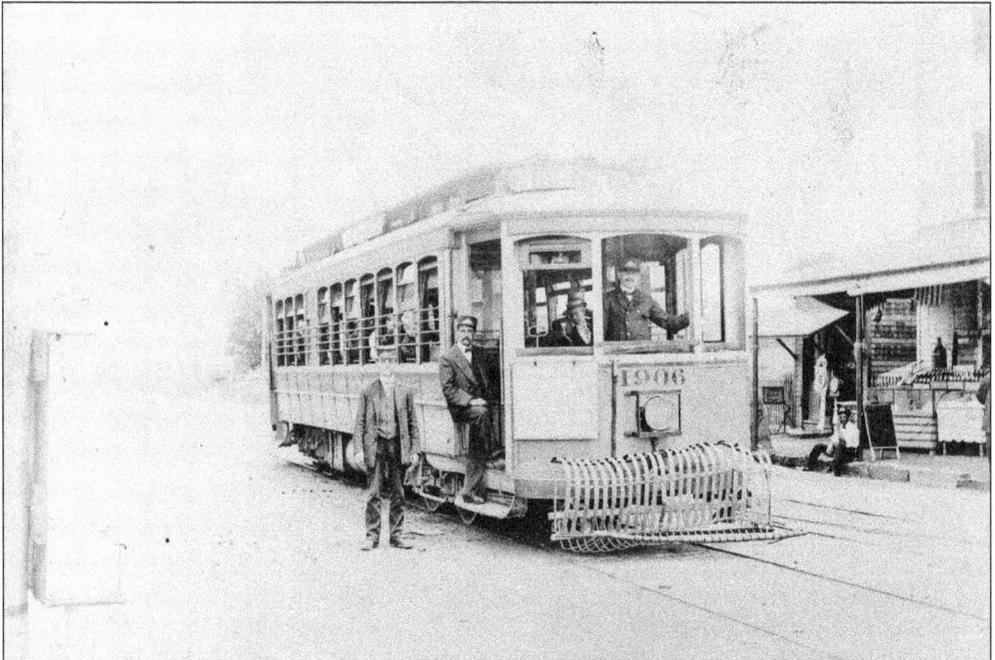

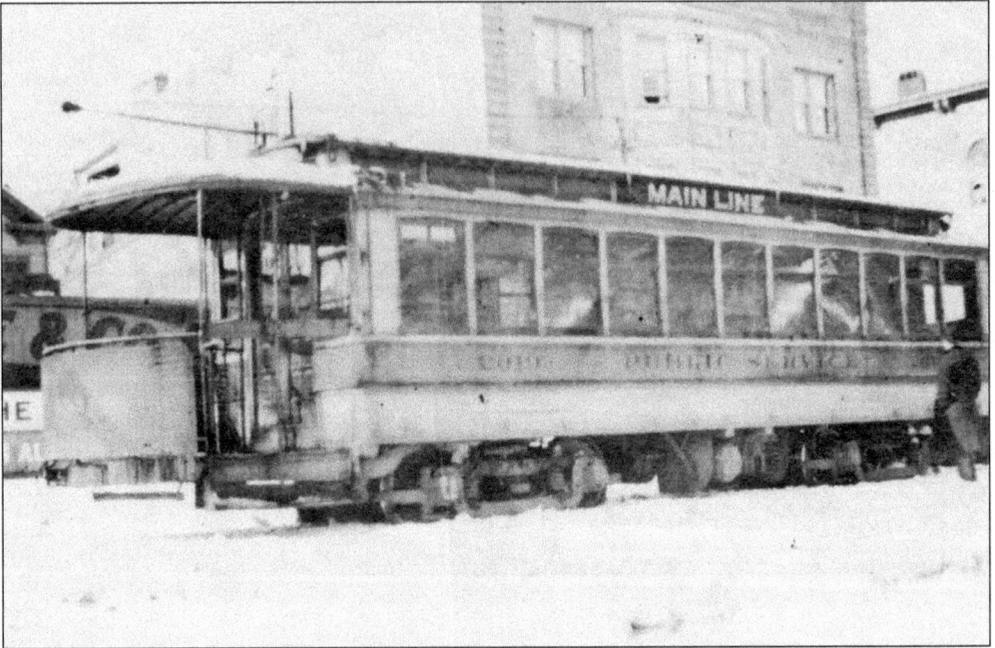

Here the Main Line trolley is stuck in the blizzard of March 1914. The snowstorm was the most destructive the town had endured since the blizzard of 1888, which also struck in March. Trolley service was stopped, and most of the telephone poles and electric wires were downed. With winds gusting at 50 miles per hour, no one left home, and even Sunday masses were cancelled.

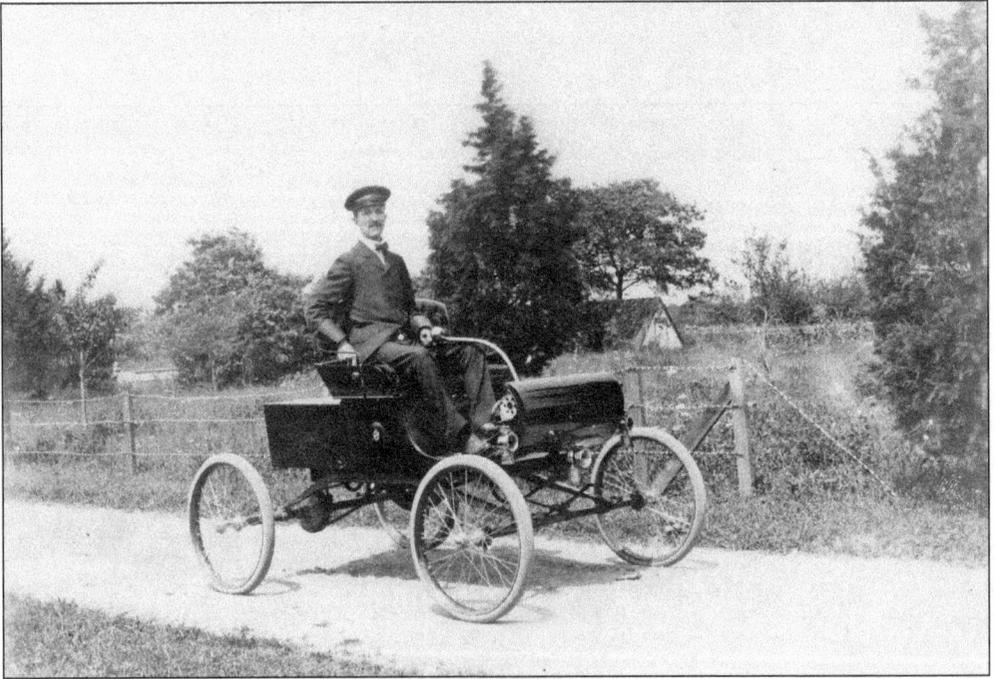

Milton H. Phillips, who resided on prestigious Dudley Avenue, owned the first gasoline-powered automobile in Westfield. This picture was taken somewhere on Long Island. Henry Ford's Model T became an offshoot of this 1902 vehicle and the new popular means of transportation by 1908.

In the late 19th and early 20th centuries, travel by horse along the dirt roads of Westfield was also a common form of transportation. Pictured is Milton H. Phillips's horse at Albert Decker's stable on North Avenue at the corner of Prospect Street.

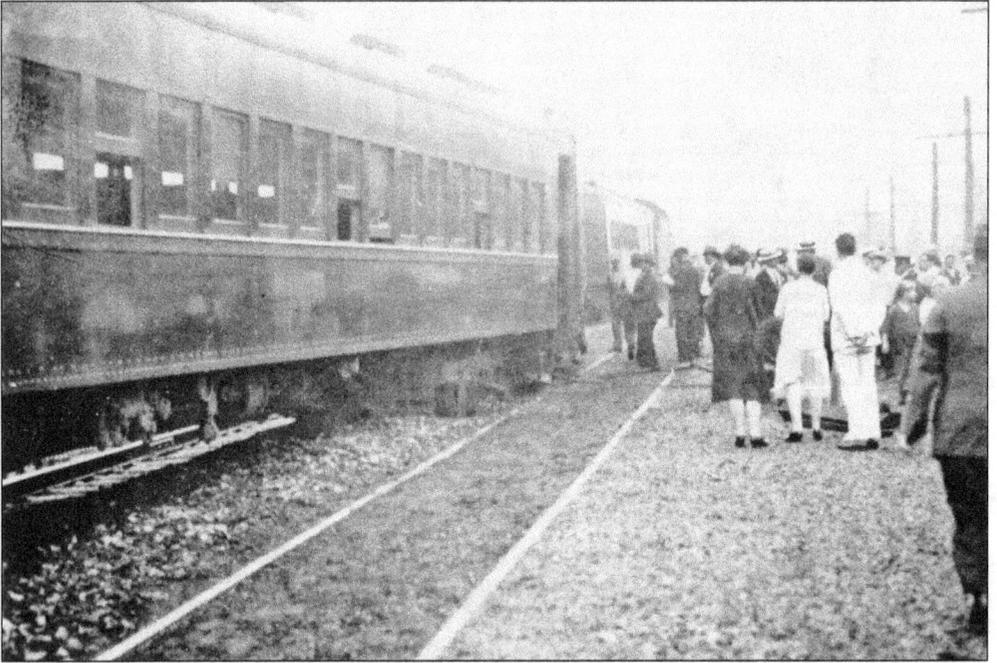

This 1930s photograph of local residents boarding the train reflects the change in fashions, particularly for women. By the 1930s, travel by train was on the rise, reflecting the increase in suburban commuters.

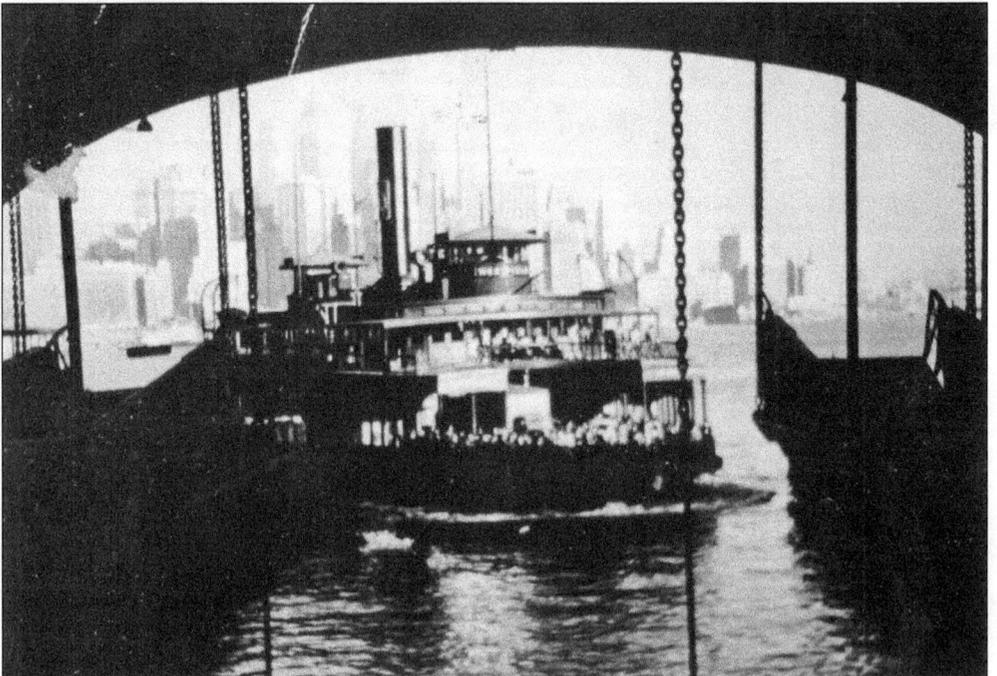

In this 1950s photograph, the large number of commuters aboard the ferry headed back to Westfield from New York City clearly indicates the continued growth and rise in population Westfield enjoyed in this era.

Four

HOUSES OF WORSHIP

If there is one landmark that could be called the heart and soul of Westfield, it would be the Presbyterian church. It was around this church, organized by early English settlers, that the village of Westfield sprang up. It is believed that two men, James Badgley (see page 13) and Peter Wilcox, may have been the leaders in spearheading the effort in organizing this first church. The first building was constructed of logs in 1727 and stood on Elizabethtown Road (now Benson Place) until 1735. The first pastor to serve the congregation was Nathaniel Hubbel. Rev. Benjamin Woodruff served as pastor for 44 years. His term of service lasted from 1759 until 1803, when he passed away. His remains as well as his wife's are buried in the vestibule of the current church. Pictured is the present stately church, which was erected in 1861. It is the third frame building to be constructed on or near this site.

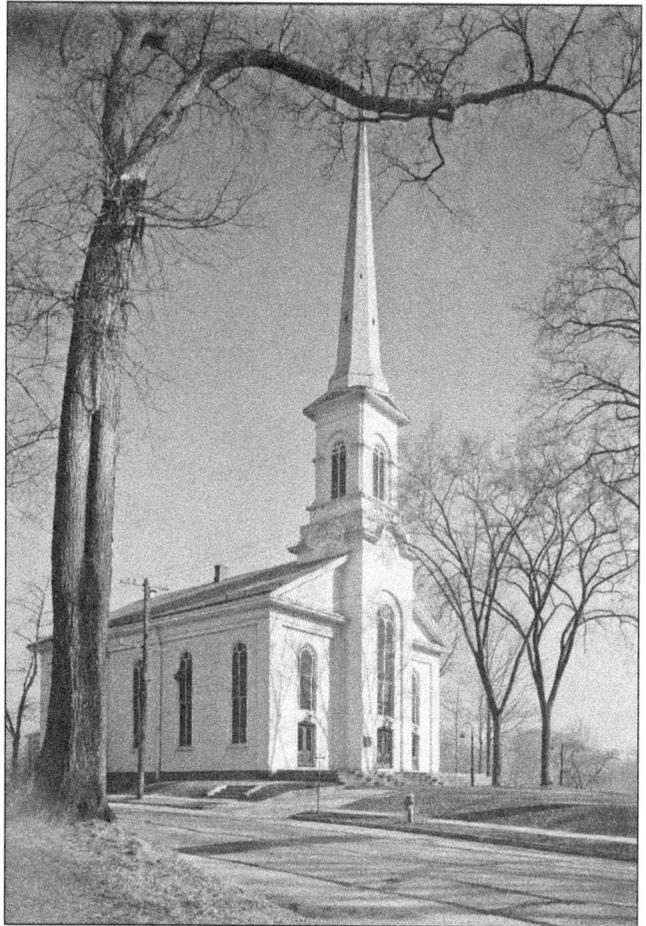

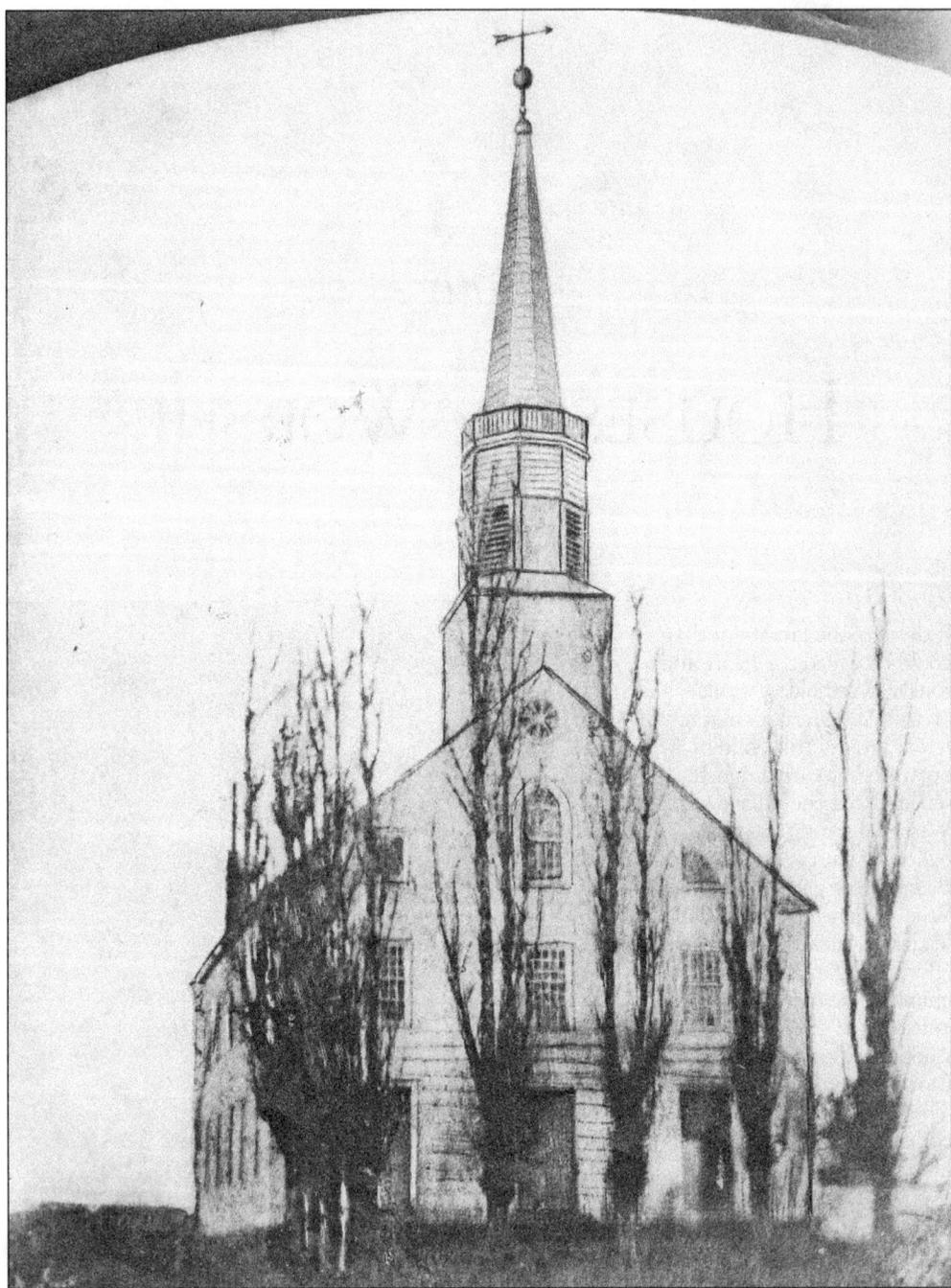

Pictured is the third church building (1803–1861), the second frame structure built on Mountain Avenue near the corner of East Broad Street. It was constructed behind the second church, which had been, in turn, the first frame structure (1735–1803). The structure kept moving further up Mountain Avenue so the existing church could continue services while the newer one was being constructed.

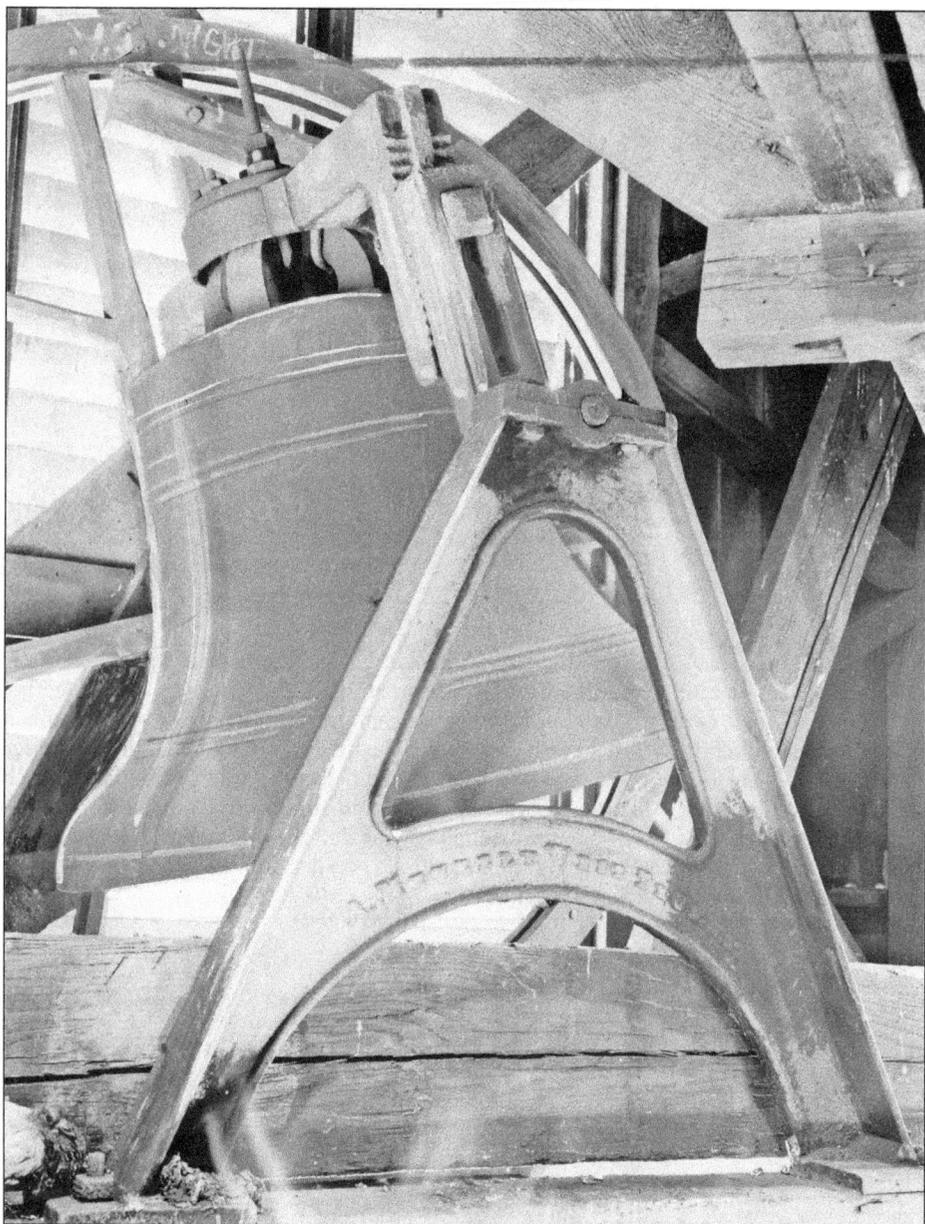

Before a steeple was built, the bell hung from a large apple tree. The bell warned the town of the invasion of British troops in 1780, ruining the Redcoats' plan for a secret attack. This angered the British to the point that they stole the bell, threw it from the church, and it carried to Staten Island, New York. This loss of a warning signal enabled the enemy to be more successful in raiding parties than they would have been otherwise. William Clark, a captured Westfield soldier, heard and recognized the bell while he was being detained in the Sugar House Prison in New York along with his brother Azariah and a comrade, Noah Miller. Due to his efforts after the war, the sacrificed bell was returned to Westfield. The sexton, "Sambo," was so excited about its return that he rang it too long and cracked it. This bell was cast in 1847 and contains some of the metal from the history-making original bell. The original bell, cast in 1758, bore the name of the church and hung in the bell tower during the Revolutionary War.

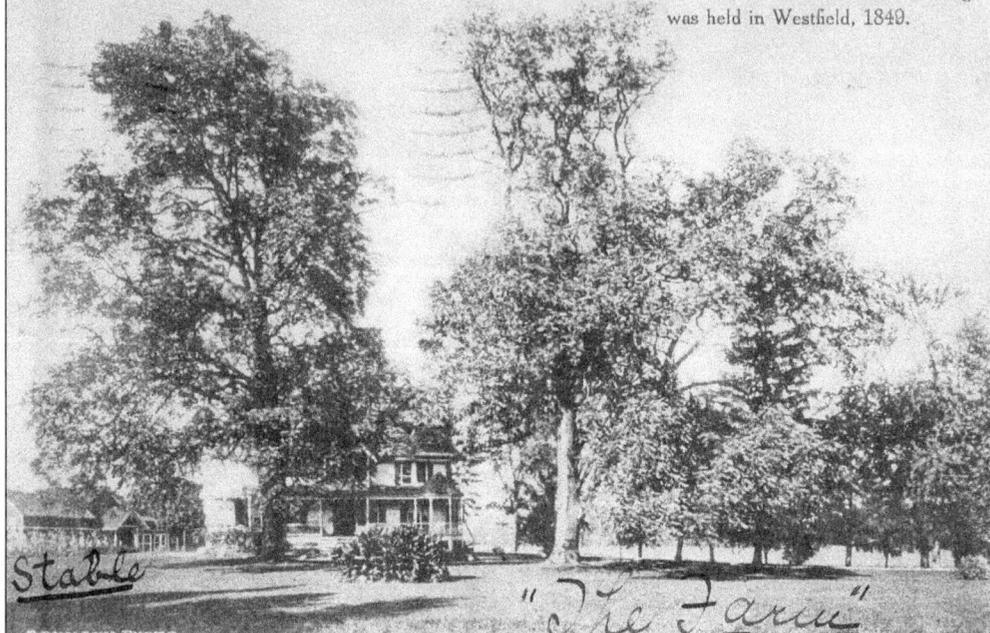

Broad and Chestnut Streets. WESTFIELD, N. J. Under these trees the first Methodist meeting was held in Westfield, 1849.

Stable "The Farm"

It was under theses walnut trees, on a Sunday afternoon, that the first Methodist meeting in town was held in 1849. Led by Cornelius Leverage, the group was formed of former members of the Presbyterian Church in Westfield who objected to the theology of John Calvin and preferred the doctrines of John Wesley. Leverage had been a member of the Old Methodist Church in Plainfield but lived in Westfield on the corner of East Broad and North Chestnut Streets in the old David Baker home. The worshippers convened here during the summer of 1849. At this time in Westfield's history, there were only five streets, and the population was 2,100. This photograph was taken in 1750. (Courtesy of Karl Baumann.)

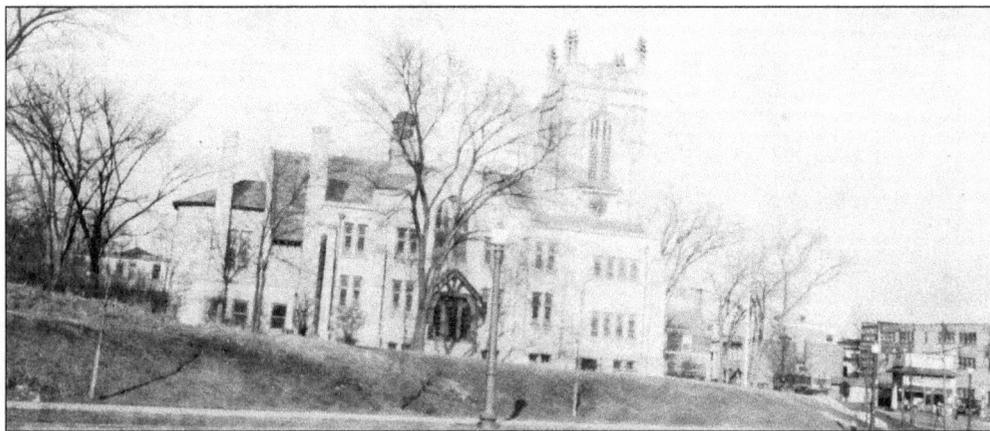

In 1852, a small saltbox-shaped building was constructed near the location of the current Methodist church on East Broad Street and North Avenue. James Ferris led the fund-raising campaign to build the new church. Ferris was a religious man and an active member of the church for 50 years. He served as precentor of the choir, superintendent of the Sunday school, and a member of the board of trustees. He was one of the town's largest landowners and, like many other influential citizens, has a street named in his memory. Ferris Place runs directly behind the First Methodist Church.

70

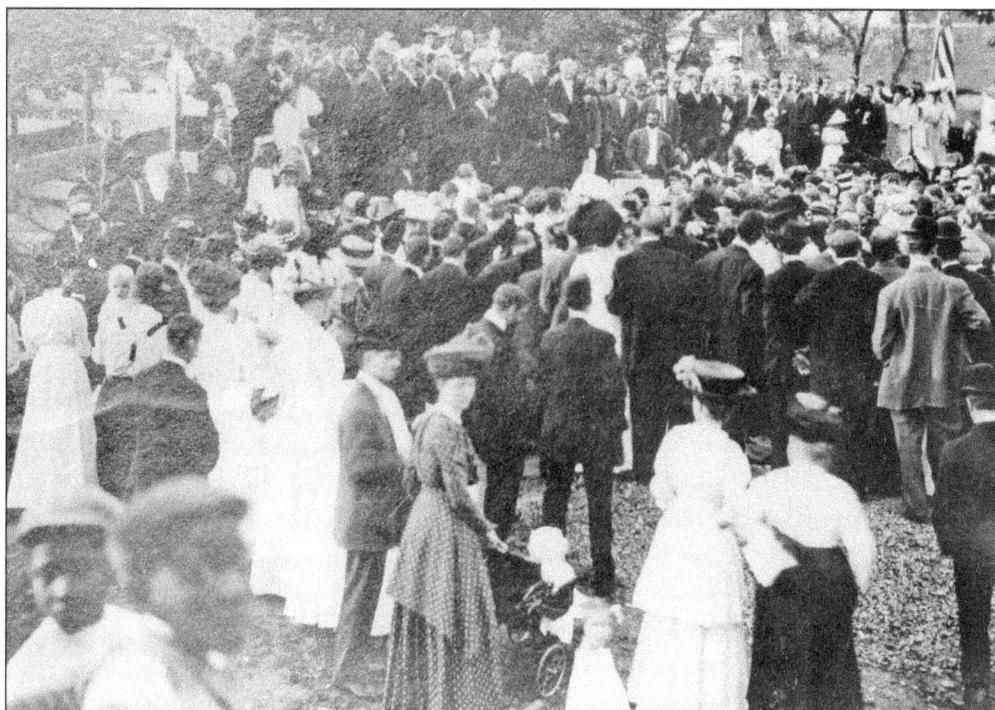

In 1910, a large cornerstone-laying ceremony took place at the site across from the Plaza on North Avenue and Broad Street. As evidenced in the photograph, the event drew a big audience.

The Old Baptist Church was built in 1867 at a cost of $5,000. It was founded by 34 local Central Railroad of New Jersey commuters. While waiting for the train, these passengers discovered their mutual Baptist religious beliefs and began meeting at each other's homes. One of the organizers, Rev. Joseph Greaves, became the first pastor, serving the congregation for six years without compensation. His son, Richard Greaves, was an important contributor in detailing the genealogical history in Westfield.

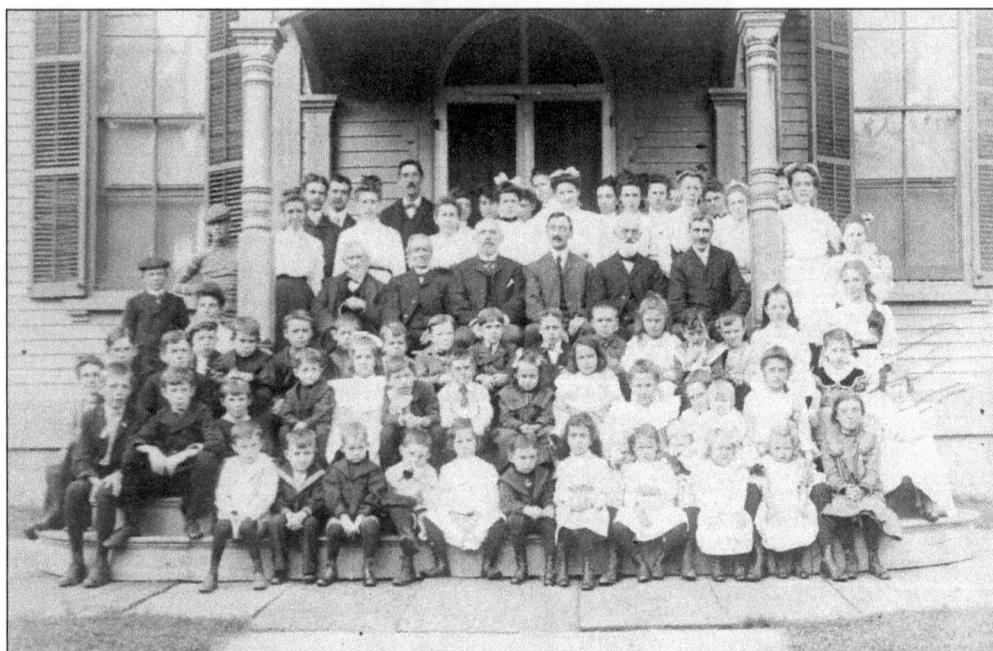

At the time of construction, Elm Street, where the church was built, did not exist. The farm owners agreed to lay a new street extending from Broad Street through to Dudley Avenue to make the new house of worship more accessible. Pictured on the front steps is a Sunday school class from the late 19th century.

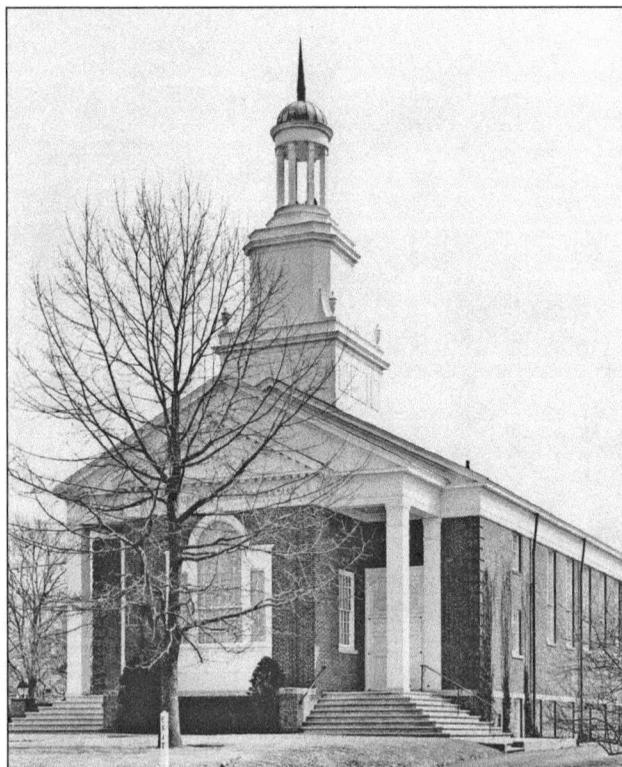

In 1879, under the tutelage of Mary Baker Eddy, the Christian Science Association was formed. Three years later, the First Church of Christ Scientist was organized in Boston. Westfield organized its own branch 40 years after that through the efforts of 12 founders, most of whom belonged to the Christian Science church in Cranford. In 1921, they purchased a home at 422 East Broad Street, renovated it, and began holding services and meetings there. In 1941, the house was demolished to make way for this handsome brick-and-frame structure designed by architect Ray O. Peck. For many years, the church enjoyed worshipping here. In 2005, the Westfield Area Y bought and remodeled the property. This building is used for youth and teen programs.

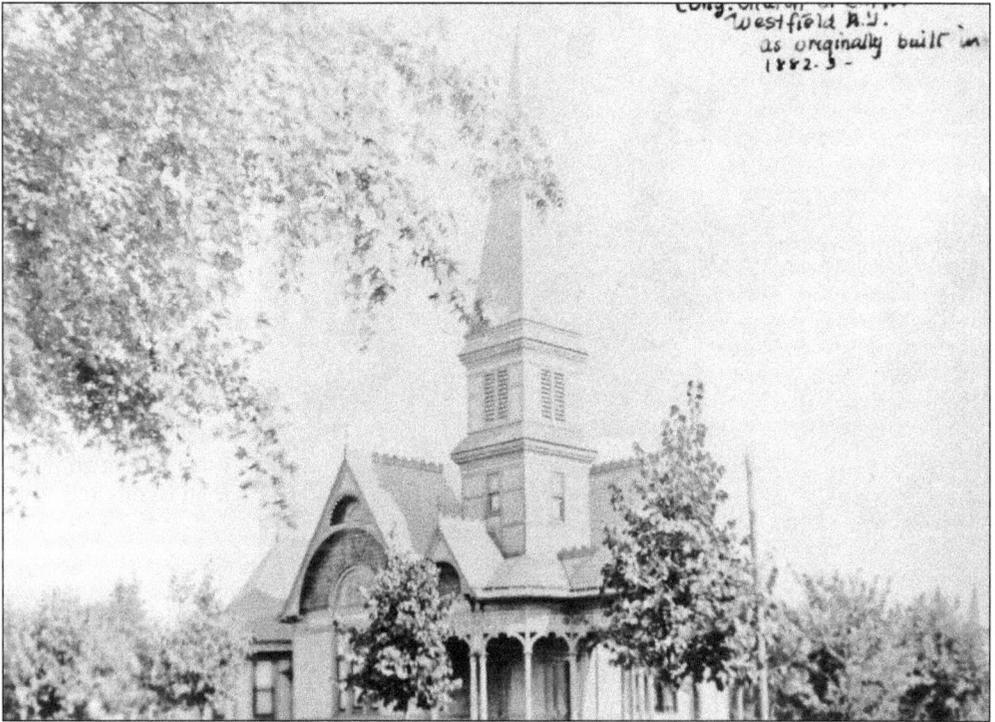

Cong. Church of S???
Westfield N.Y.
as originally built in
1882-3 -

The First Congregational Church is pictured here at it looked in the 19th century. The Queen Anne–style church was built on Elmer Street to accommodate the worshippers, who were holding regular services in Aeolian Hall. The hall was destroyed by fire. In 1882, the year the church was dedicated, the membership consisted of 70 congregants. Since then, the building has been added to several times.

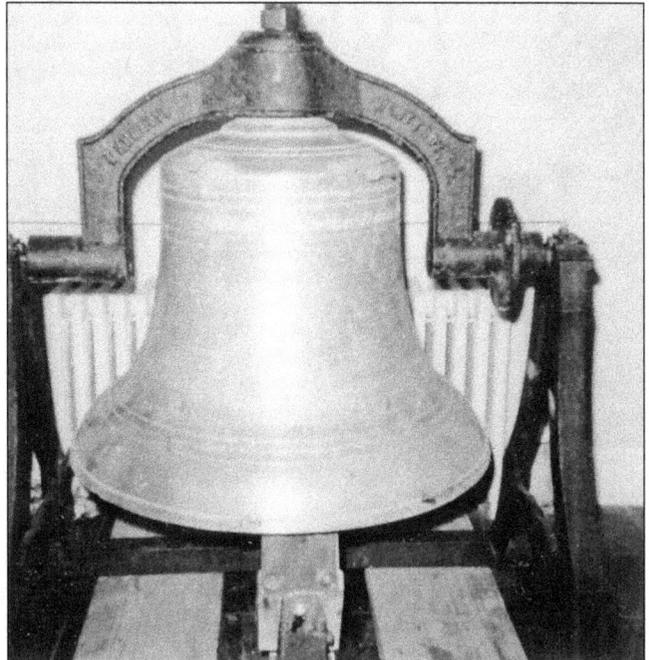

A tower with a spire was a part of the original First Congregational Church, but a bell had never been installed due to a lack of funds. For many years, the tower stood empty. By the early 1920s, weather had rotted and ruined that part of the structure. Finally, in 1952, a new tower was built, but again, no bell was installed due to financial reasons. It was not until 1980, when the Congregational church in Maplewood closed its doors, that the church finally acquired a bell.

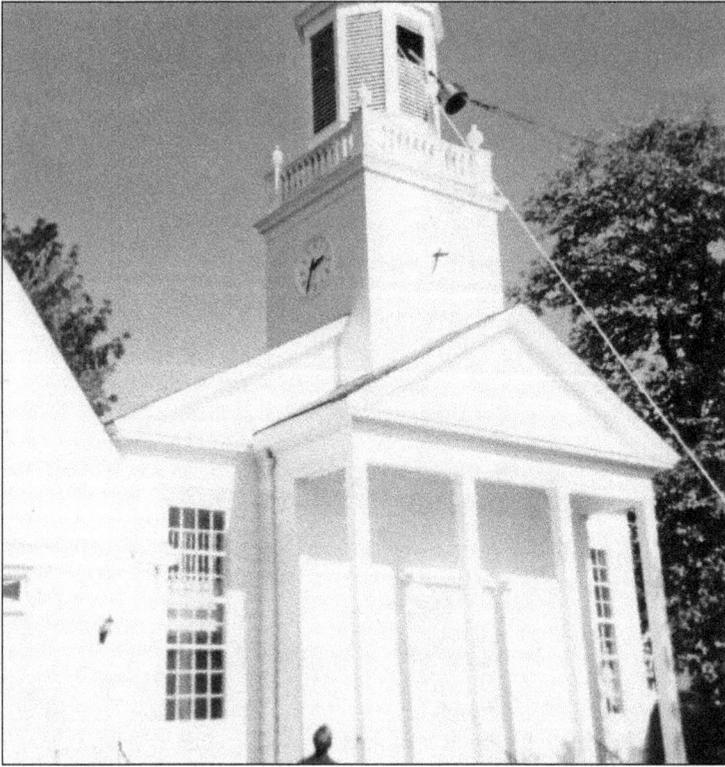

After 99 years without a church bell, the tower would now house a beautifully cast model. This photograph shows the installation of the long-awaited bell. This is how the church currently looks. Through the years, several additions and alterations were made, so the church is barely recognizable from its original look.

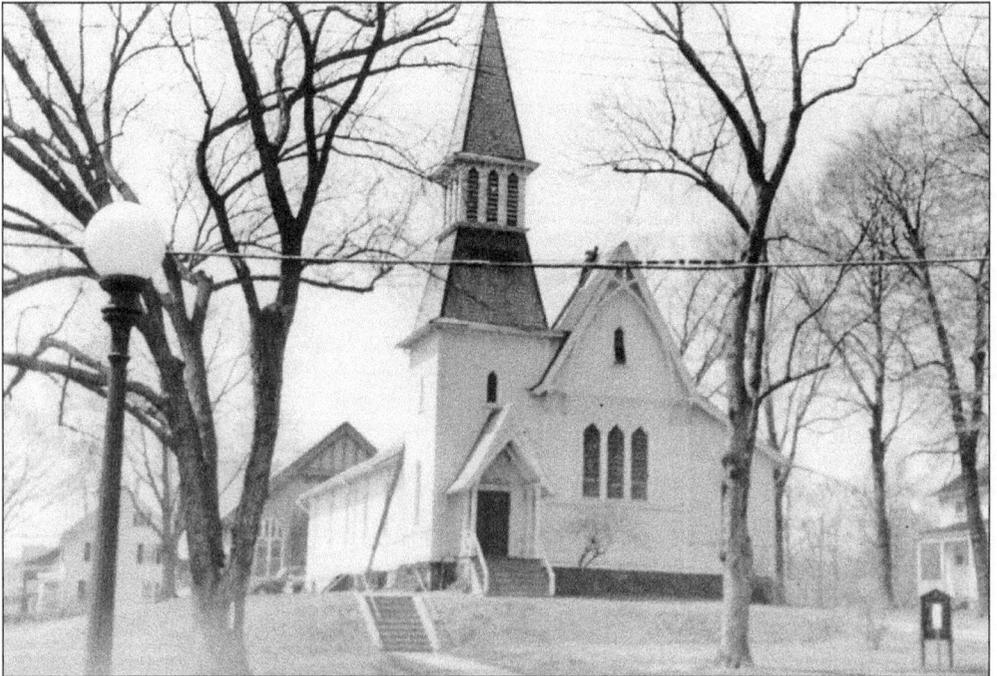

The Grace Episcopal Church had been organized in 1867. In 1874, this sanctuary was built, but the parish struggled for 20 years. Finally, in 1894, it disbanded. St. Paul's took over the building and enlarged it two years later.

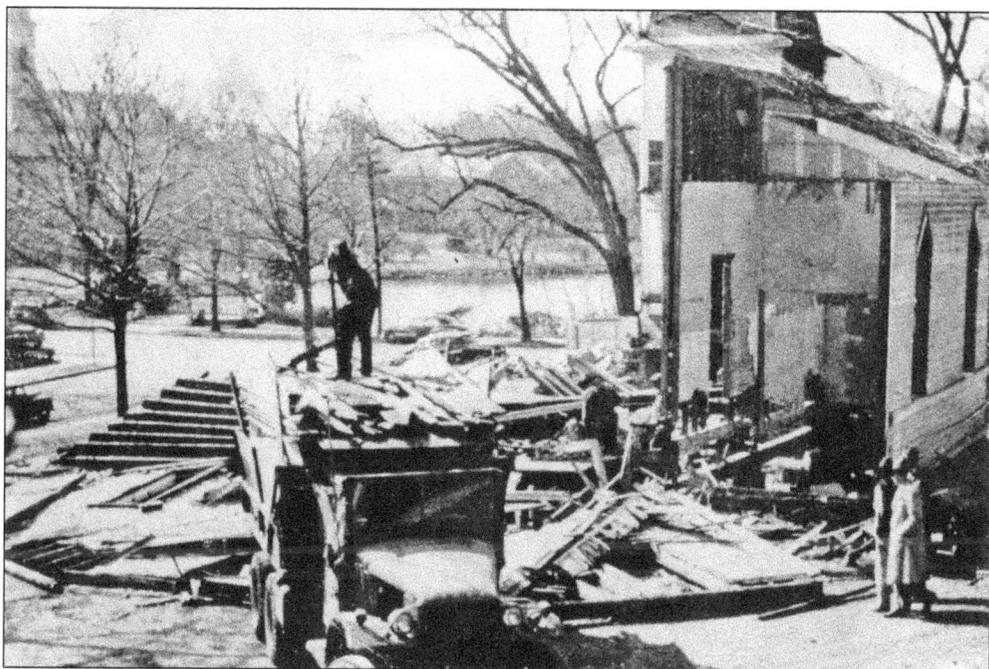

The old church at the corner of East Broad Street and St. Paul's Street was demolished in 1952.

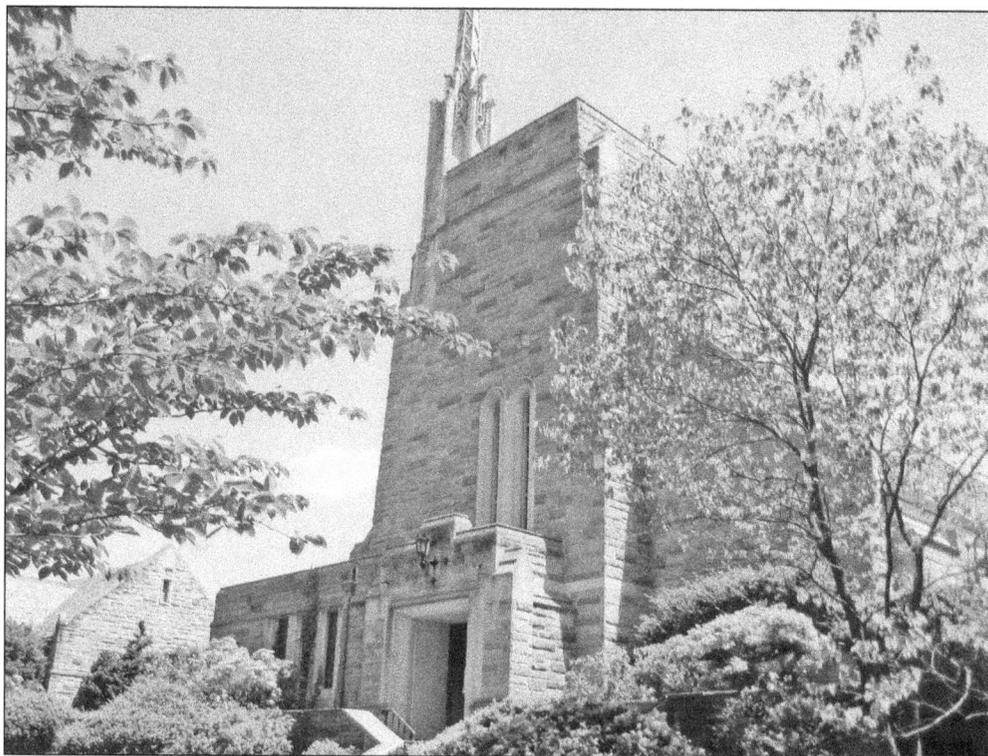

A new Country Gothic–style church was constructed on the same site. The architectural style is reminiscent of the Episcopal English heritage. The church, which sits across the street from Mindowaskin Park, remains today.

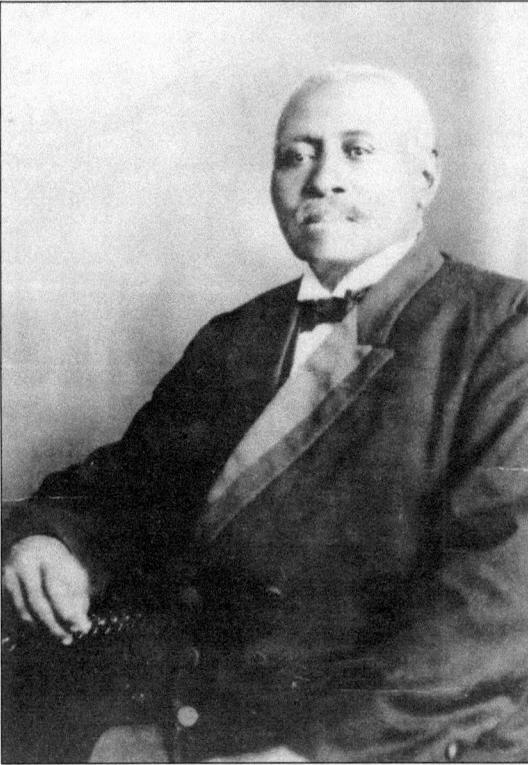

Rev. William Drew Robeson (1845–1918) was the pastor of St. Luke's African Methodist Episcopal (A.M.E.) Zion Church from 1907 to 1910. He was born a plantation slave in North Carolina. At age 15, he was a passenger on the Underground Railroad. The widowed reverend moved to Westfield with his youngest child, Paul Robeson, when the Witherspoon Presbyterian Church in Princeton removed him after 20 years of service. Westfield is proud to have had the famous Paul Robeson as a member of this community, even if only for a brief period of his life.

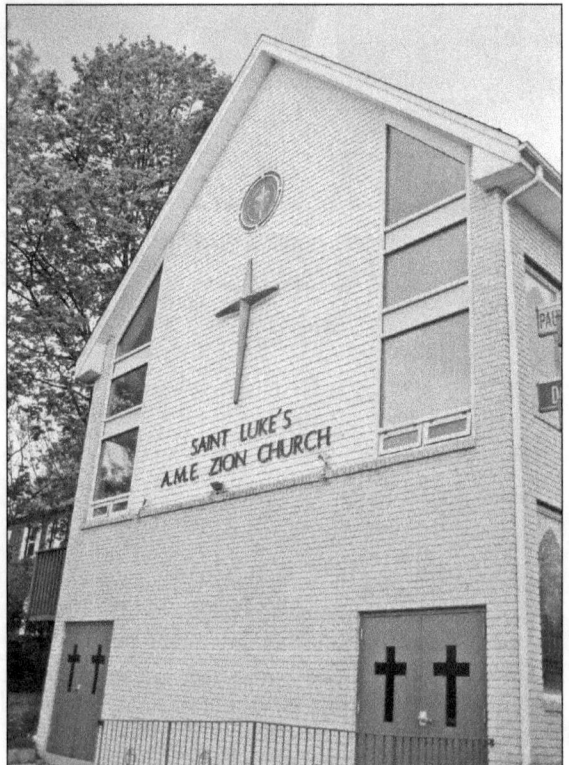

In September 1872, a tract of land was purchased for $115. During Robeson's short pastorate, the church on the corner of Downer Street and Osborn Avenue was erected.

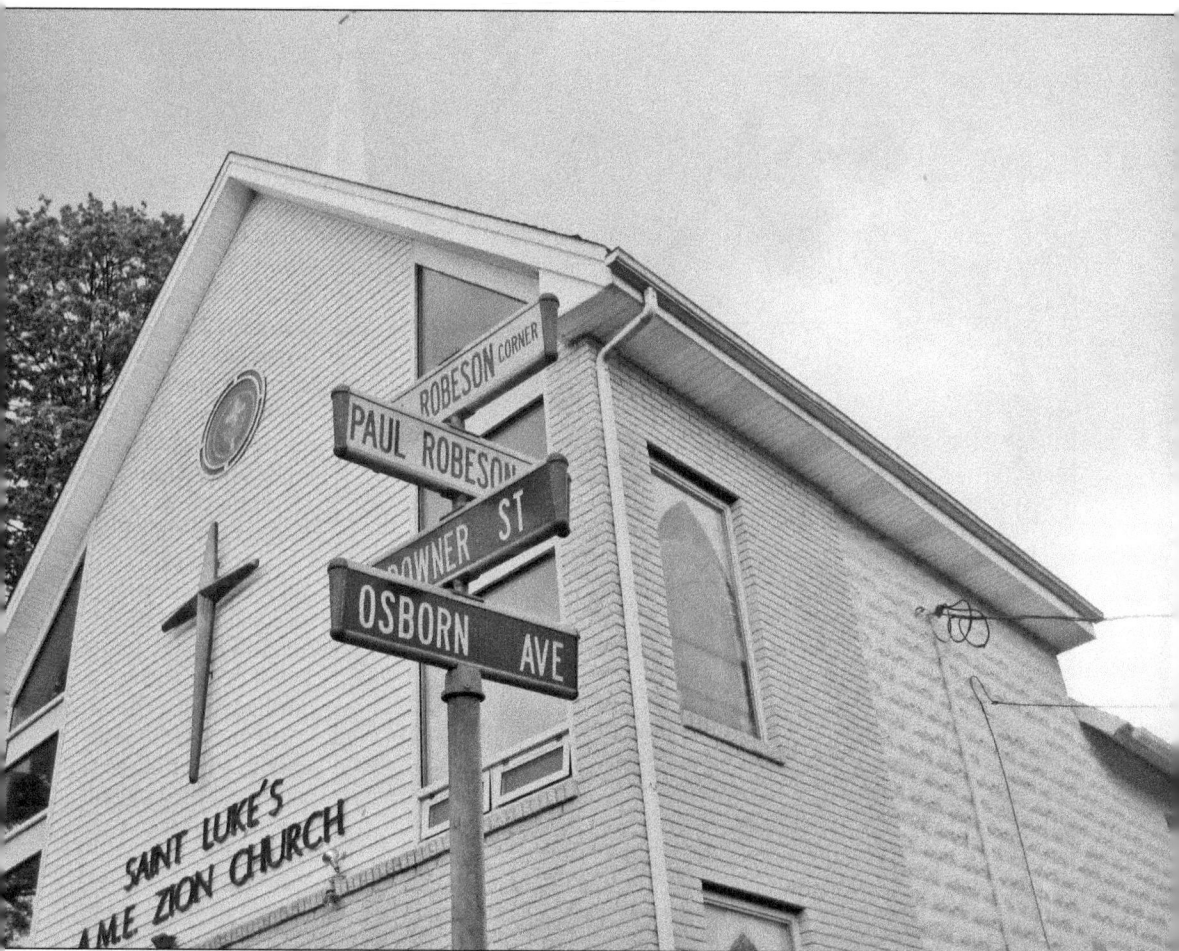

The corner of Downer Street, named for founding father Samuel Downer Jr., and Osborn Avenue, named for Downer's son-in-law and longtime physician Dr. Corra Osborn, has recently been designated as Paul Robeson Corner in honor of the reverend's famous son. Paul Robeson grew up to become a renowned scholar, successful athlete, actor, concert singer, and more. As a child growing up in Westfield, Paul played basketball for a local team.

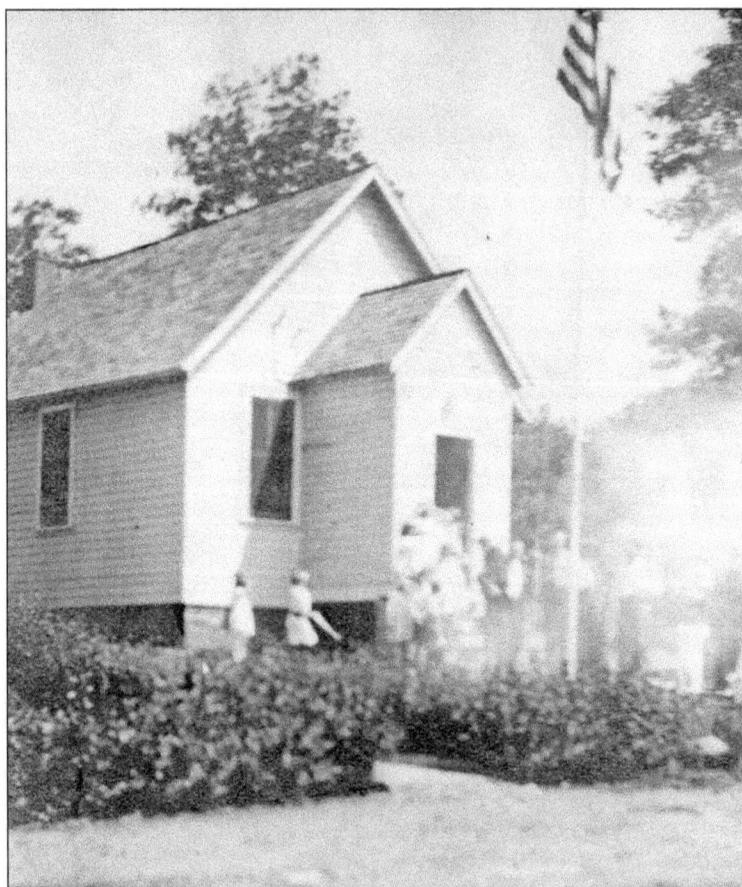

The Madison Avenue Chapel opened as a Sunday school on December 16, 1912. Two years later, in 1914, it was incorporated as an interdenominational church comprised of Methodists, Baptists, Congregationalists, and Presbyterians. The church was nicknamed the "Big Woods Chapel," after the section of town where it made its home. In 1924, it became affiliated with the Presbyterian Church. Below, the children of the Sunday school assemble near the chapel for this 1918 photograph.

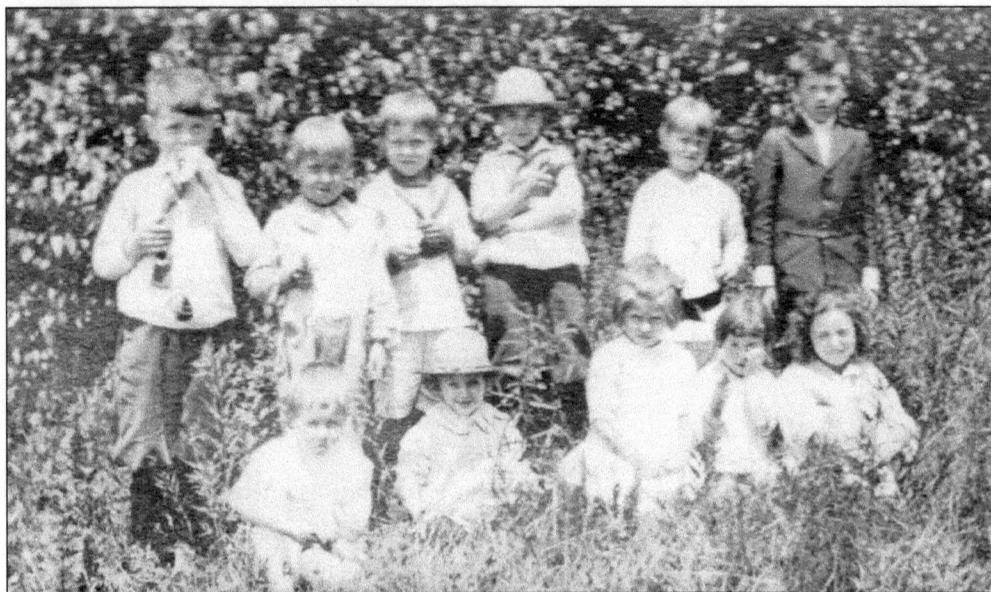

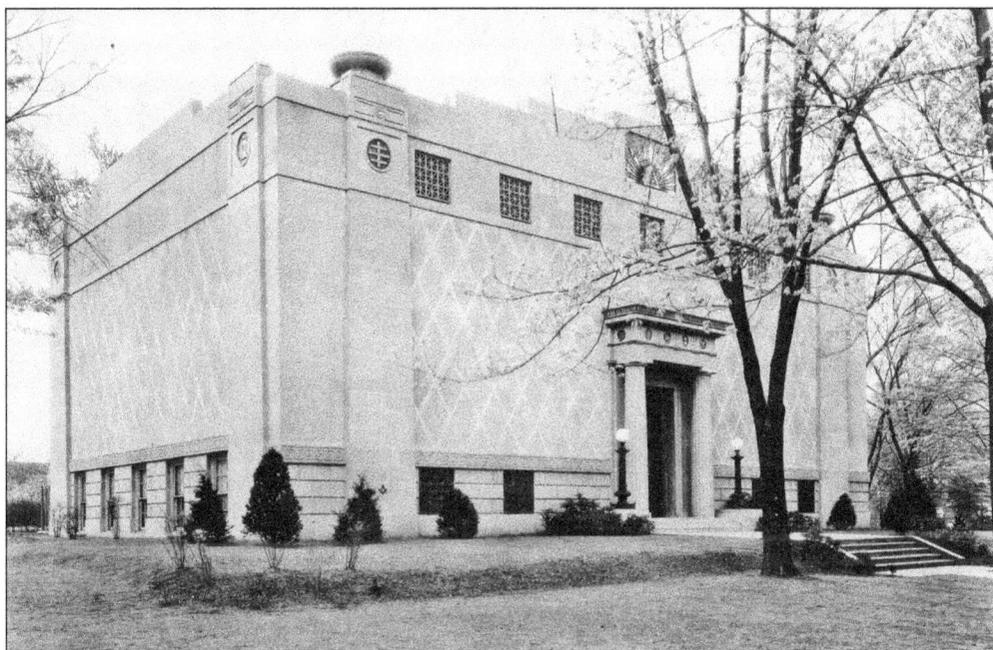

The Masonic Temple (Atlas Lodge 125) replaced the first Lincoln School. Accordingly, the street's name was changed from Academy Place to Temple Place. The cornerstone was laid on October 6, 1928. In 1974, the temple was torn down to make way for residential development, but the street name remains the same.

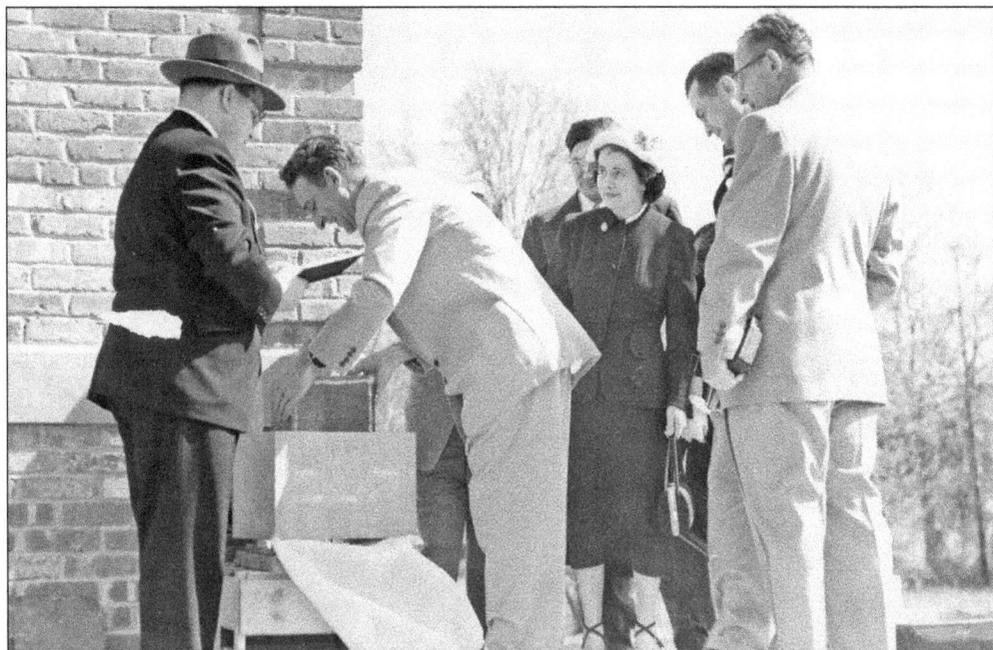

In February 1950, a committee of 42 families joined forces with the objective of building a synagogue in Westfield. By the end of 1950, a ground-breaking ceremony for Temple Emanu-El took place at 756 East Broad Street. Pictured is Rabbi Spicehandler (left) along with several of the temple's officers. (Courtesy of Stimpson Hubbard.)

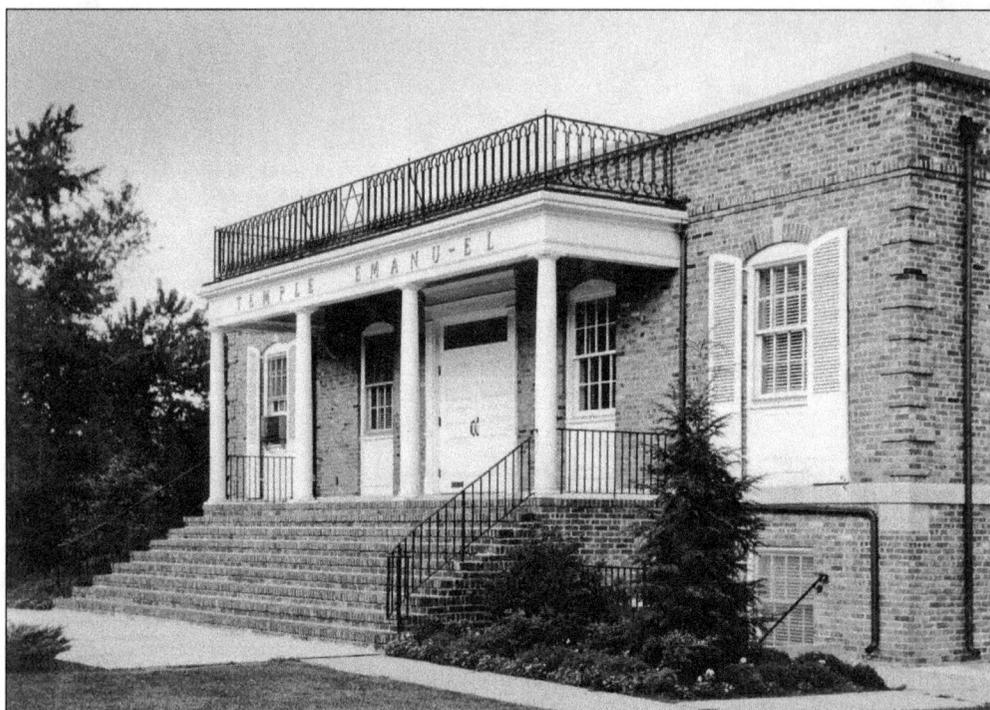

The completed building had a capacity of 150 congregants. By 1952, the membership had grown to 200. (Courtesy of Stimpson Hubbard.)

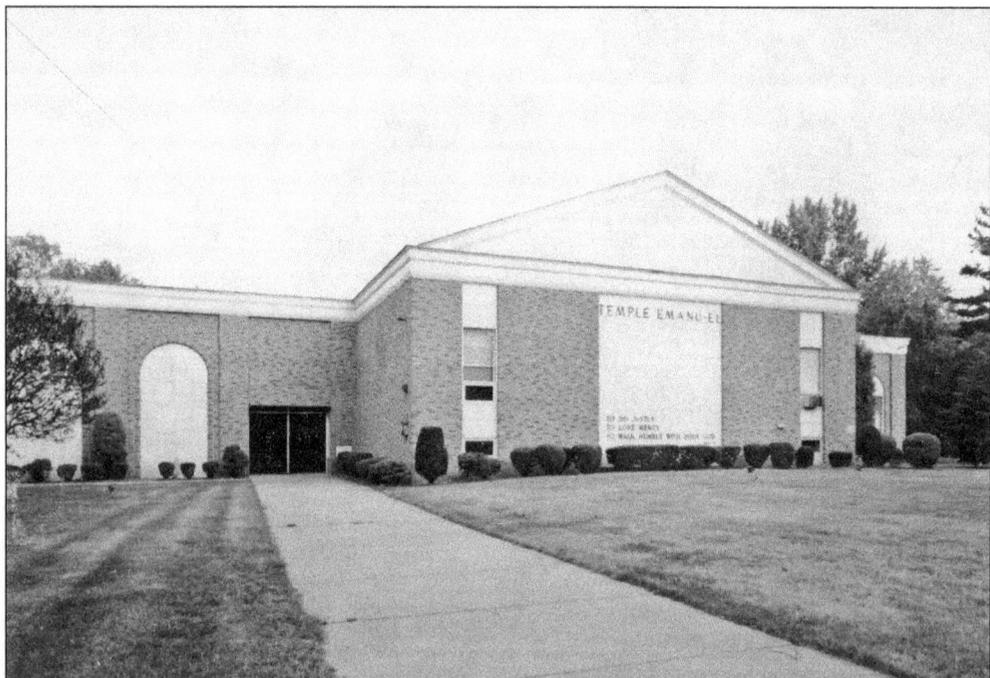

On April 25, 1965, ground was broken for an expansion. Above is the renovated temple with the new addition on the left and a school addition on the right, added in 1957. In 1966, Rabbi Charles Kroloff was installed. He led the congregation for over 35 years. (Courtesy of Stimpson Hubbard.)

Five

SCHOOLS

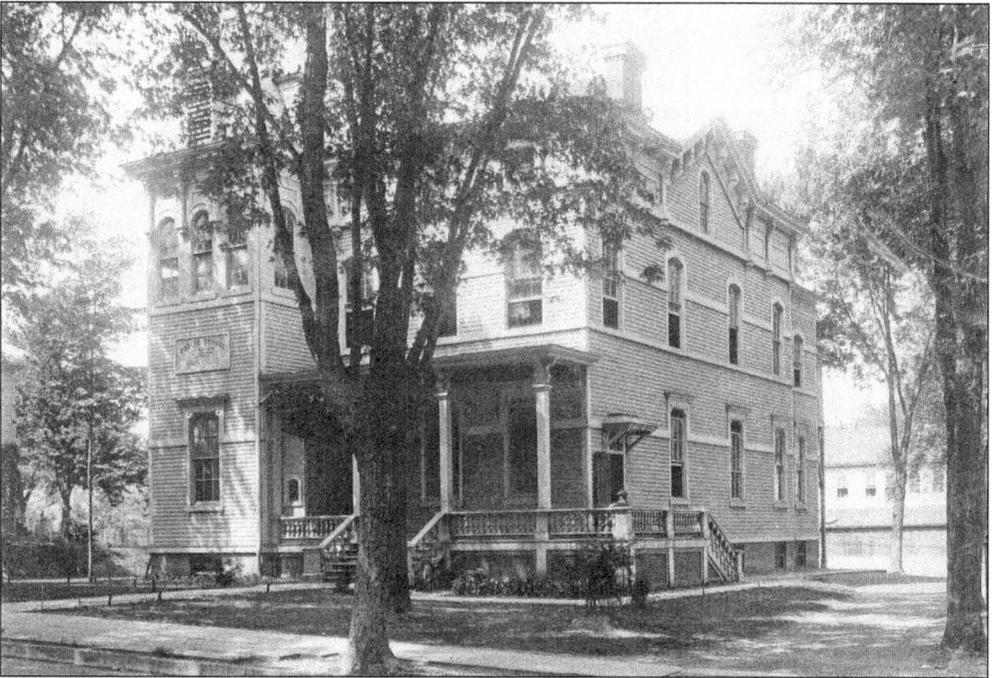

Three small schools preceded the old Prospect School, which was completed in 1869. Education was important to the early settlers. It is estimated that Westfield's first school was built some time around 1750, or about 30 years after the town's incorporation. The first schools were run by churches. The original town bell hung at the Prospect School, where it was used as a fire alarm and for special occasions.

Here the class of 1883 poses on the steps of the Prospect School. The beloved Elizabeth Stryker (fourth row, second from left) taught in the town for some 50 years. The popular schoolmaster (fourth row, far right) was affectionately called "Pop Demerest."

The Prospect School was built as more families moved from New York. The new, sophisticated settlers regarded education highly. This photograph of the entire school was taken around 1898. At the time, there were only four teachers.

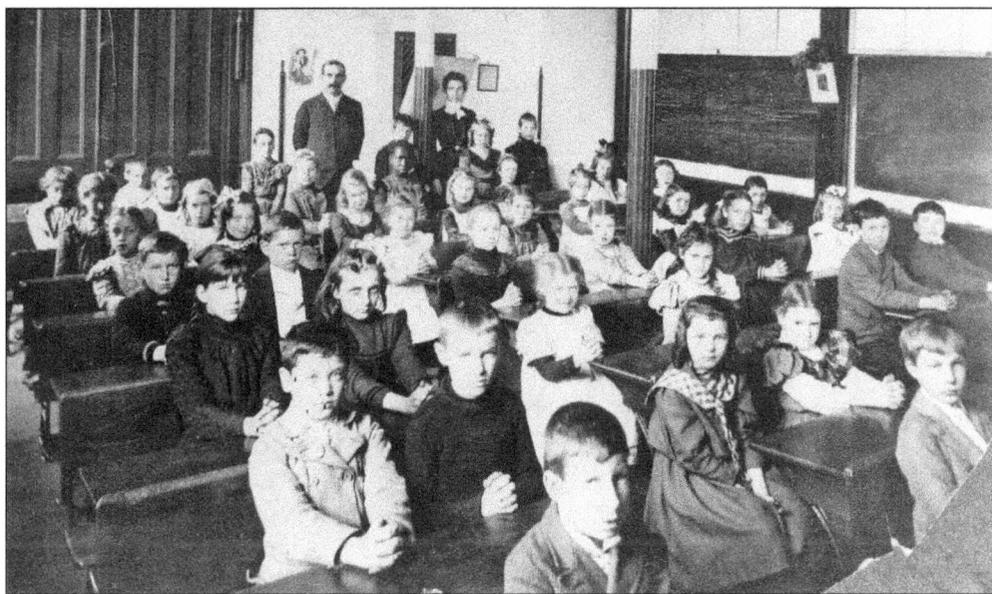

By 1903, the population in Westfield was growing at a rapid pace. Pictured is the third-grade class of the Prospect School, consisting of approximately 45 pupils, which is quite an increase from 1883.

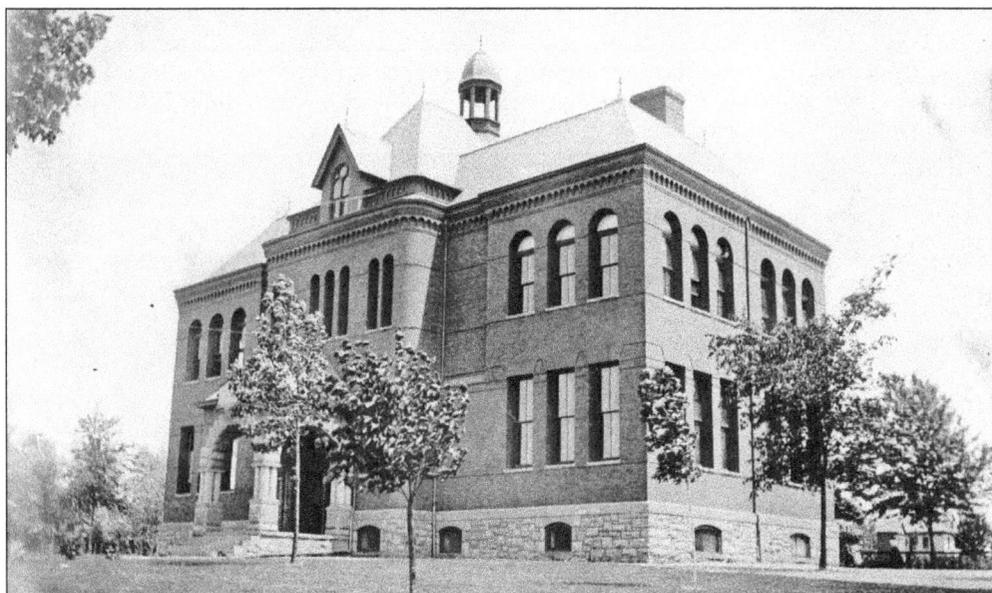

Westfield's first high school was erected in 1880, after much controversy amongst the residents. Some felt there was no need for a school of higher learning. What to name the school was also controversial. Some wanted to name the school in honor of a notable local citizen, while others thought it more appropriate to have a national figure. It was decided that all schools would be named in memory of U.S. presidents. Since then, there have been several exceptions to this policy. A flagpole that stood 140 feet high graced the front lawn of the old Lincoln School. At the time, it was the tallest in the state of New Jersey. On top of the pole stood a commanding weather vane, for which the high school's yearbook was named. Today, the high school is in a different location, and there is no weather vane perched on top of the flagpole, but the yearbook's name remains.

These 10 students make up the entire 1897 graduating class of the old Lincoln School. The institution was located on a street appropriately named Academy Place from 1890 until 1922. The building has been torn down.

The old Washington School, located on the southeast corner of Elm and Walnut Streets, was the site of the next high school. Pictured is the graduating class of 1910. Teddy Roosevelt campaigned for president in 1912 in front of this school. This building, too, has since been demolished.

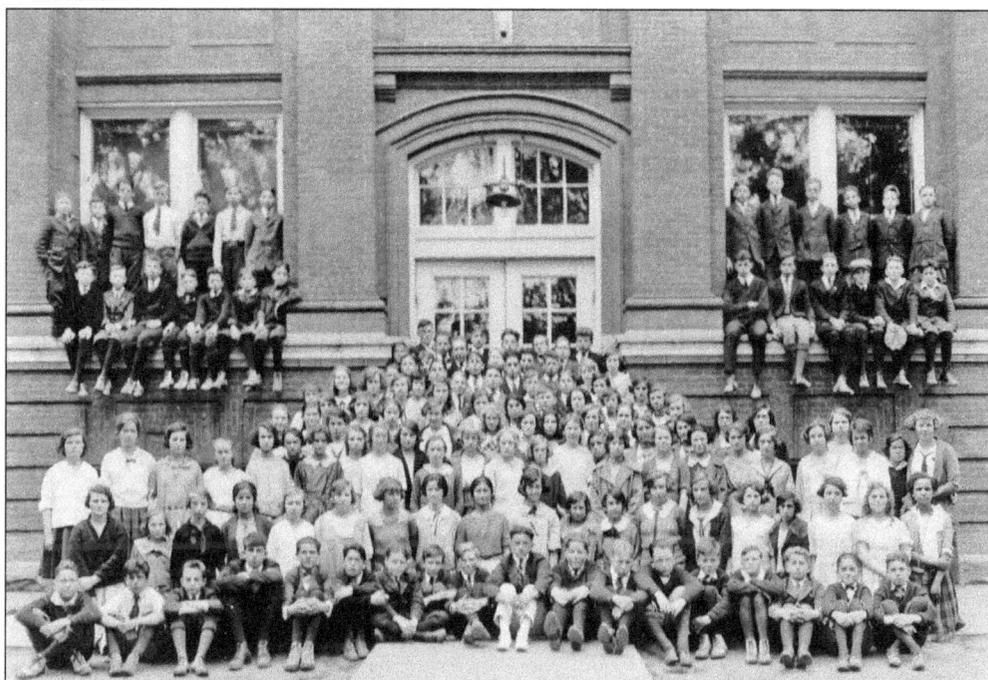

Pictured is the eighth-grade graduating class posing in front of the old Washington School in 1922. At this time, the school was used for all grades and as a spillover for the high school, which was located across the street at 302 Elm Street and connected by a carport.

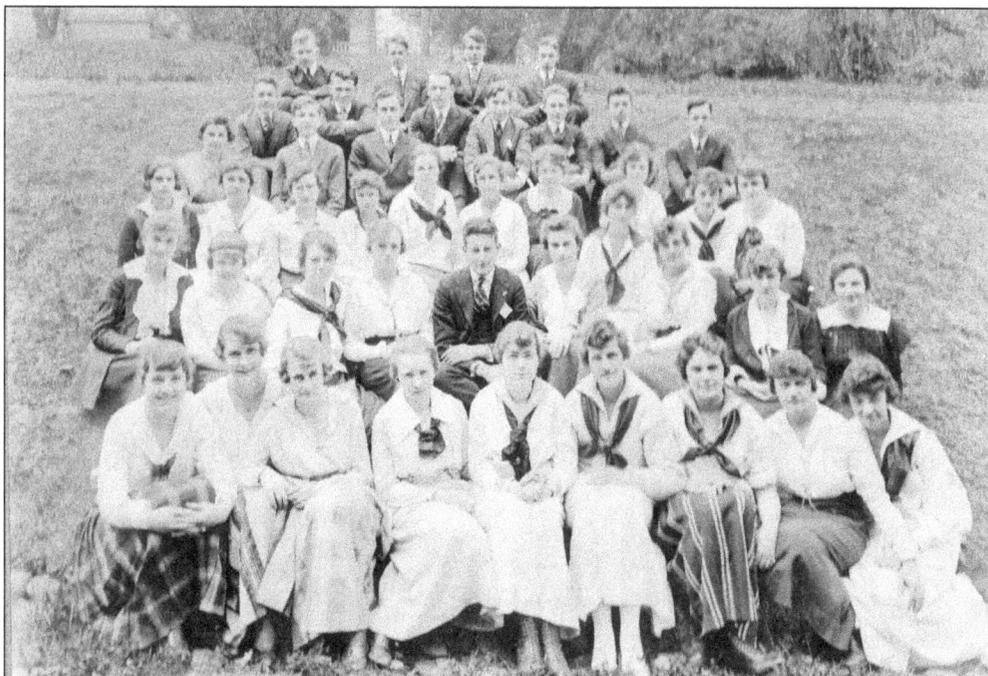

The graduating class of 1917 poses for this photograph on June 21, 1917. Seated in the center is the class president, Henry Carrington Stevens, who lost his life in World War I on September 13, 1918, just one year after this picture was taken.

This is a side view of the old Westfield High School, which was located at the 302 Elm Street on the corner of Walnut Street in 1919. Today this building houses the board of education. Below is a 1921 front and side view of the triangular building.

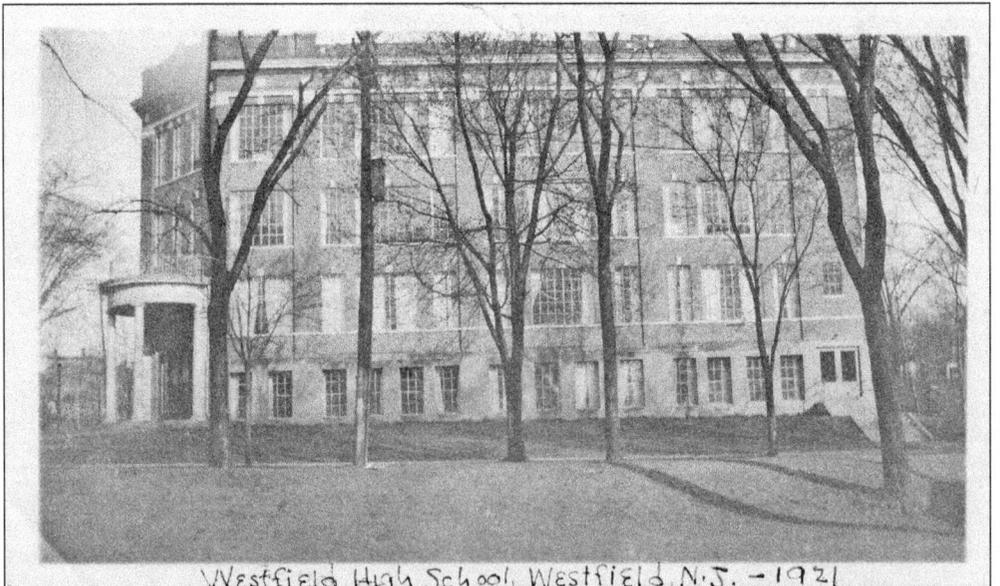

Westfield High School, Westfield, N·J. – 1921

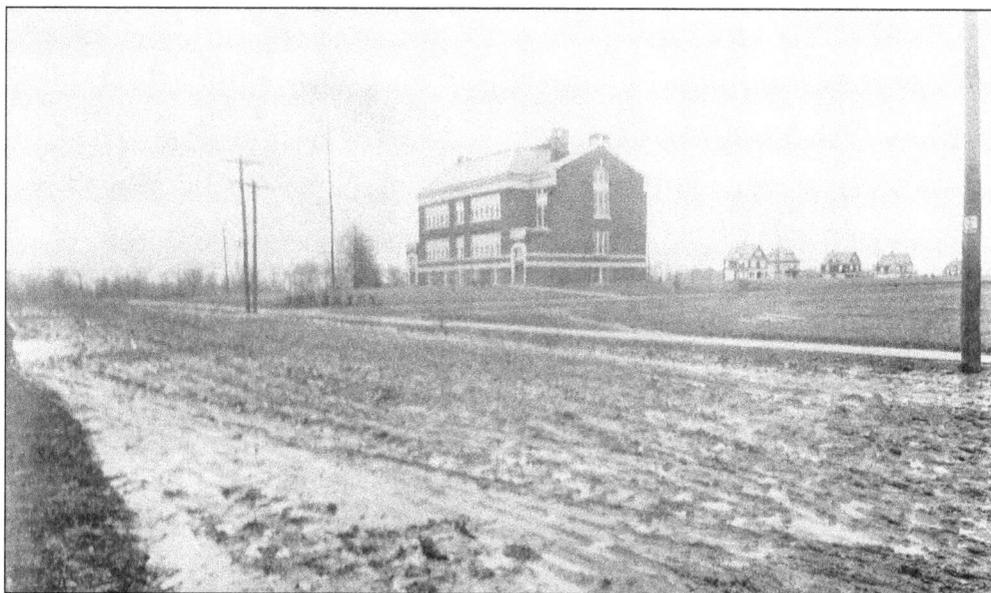

McKinley Elementary School, named for President McKinley, is one of the schools that followed the school-naming policy decided upon in 1880. Built in 1908 on the corner of First Street and Osborn Avenue, it preceded residential development in this area. Today, it is one of Westfield's six elementary schools located in the heart of a suburban neighborhood.

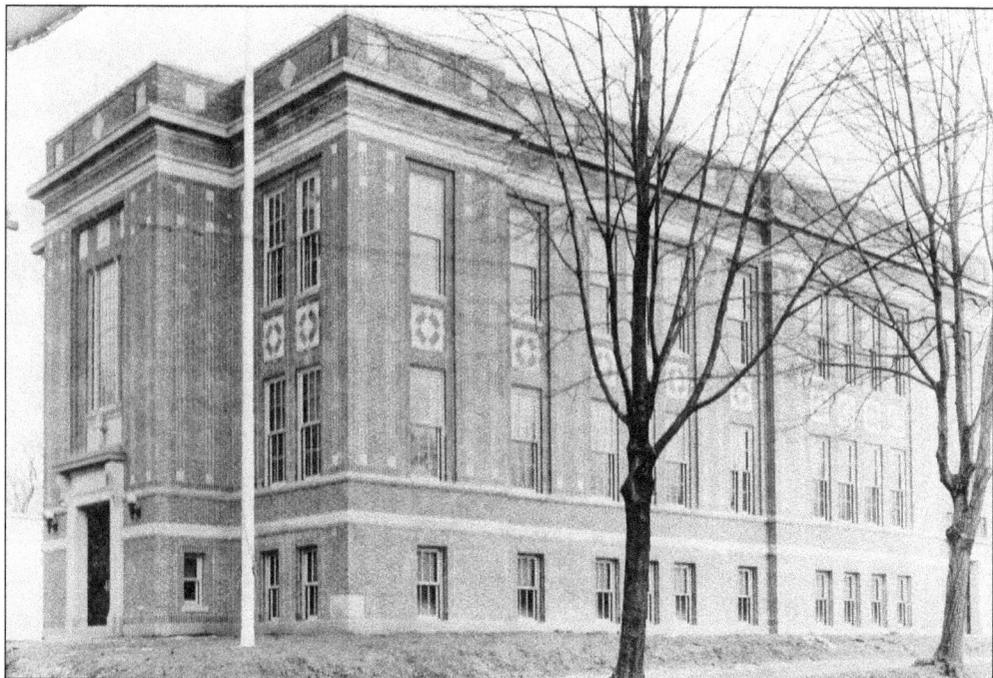

Holy Trinity School was built as an affiliate of Holy Trinity Church in 1916. It was constructed on First Street and New York Avenue (now Trinity Place). In 1976, Holy Trinity's high school closed, and the 60-year-old elementary school was sold and converted into residential condominiums. The high school was converted into an elementary school. Pictured is the building that was once the high school but today is the elementary school.

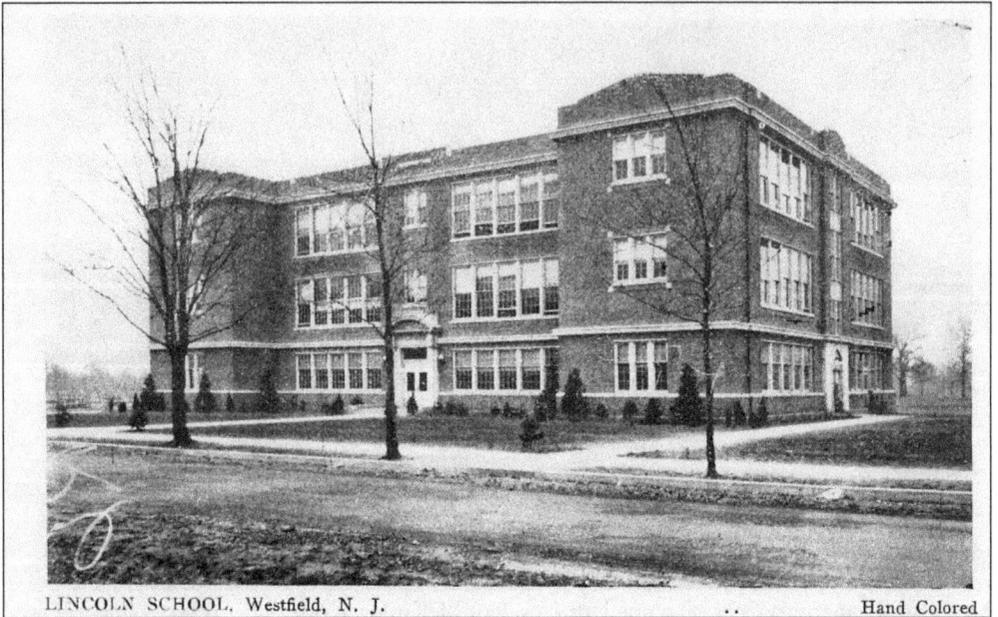

LINCOLN SCHOOL, Westfield, N. J. Hand Colored

The new Lincoln School opened in March 1922 and closed its doors in 1986. For many years, the building was used for other purposes. In September 2008, it reopened as the school for the town's entire kindergarten population, creating additional classroom space in the other schools.

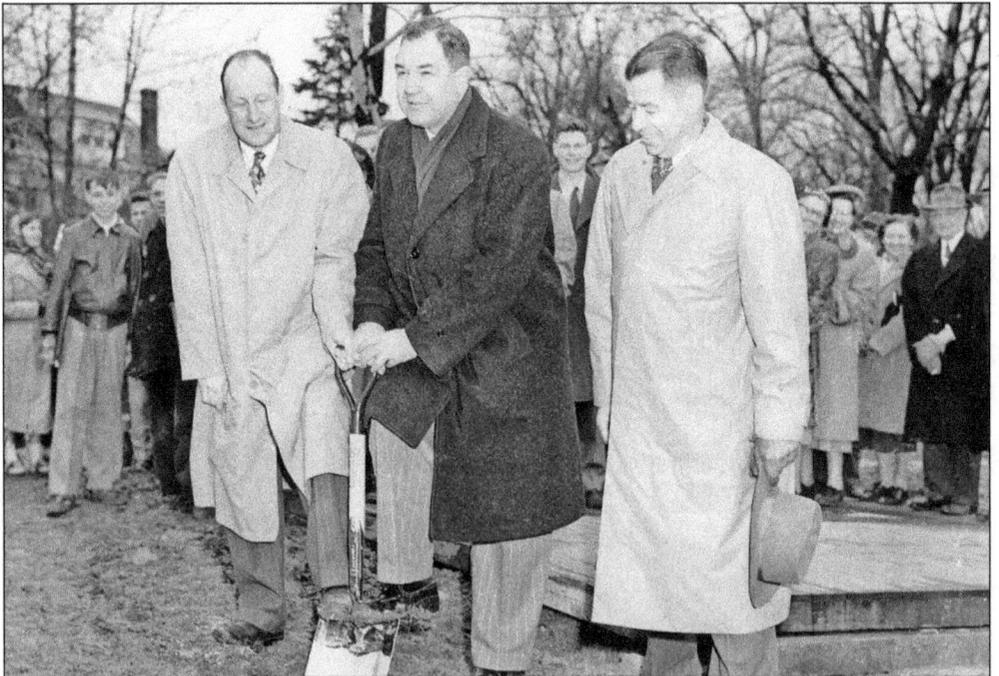

On March 21, 1950, the ground-breaking ceremony for a new Westfield High School took place. Mayor Charles P. Bailey; J. Bliss Austin, president of the board of education; and Supervising Principal Stacy N. Ewan Jr. make the first dig. Bailey held this office longer than any other mayor. In 1995, a new street was cut and developed in the Indian Forest section of town and named in his memory.

Six

EVENTS

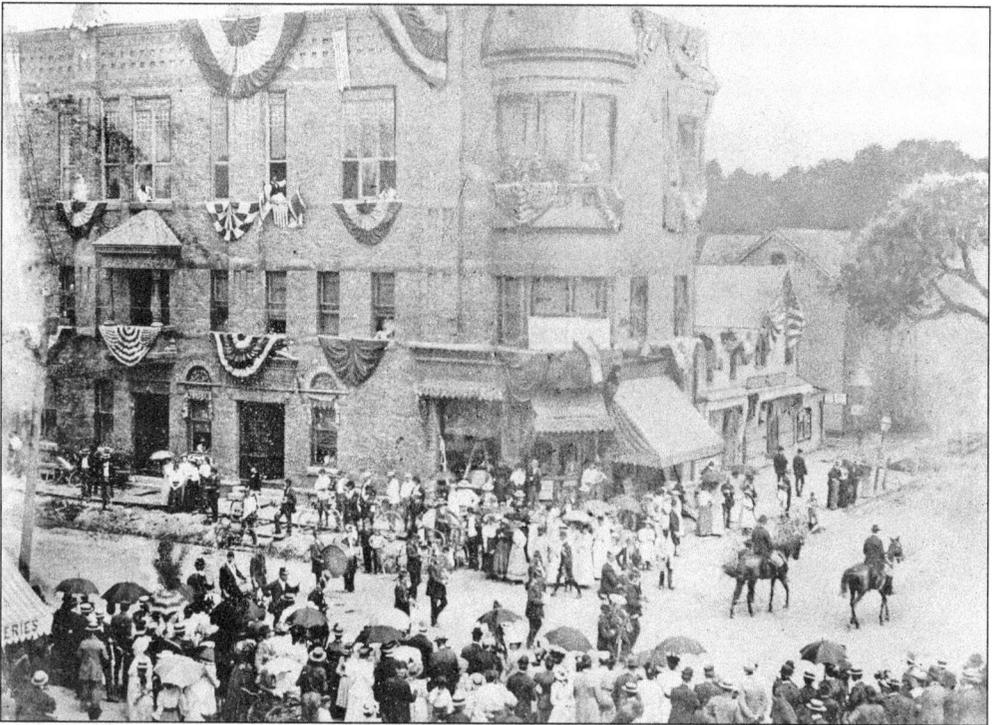

Most of the town attended the July 1894 celebration commemorating the 100th anniversary of the formation of Westfield as a township. Only those who were too sick or immobile did not show up. Although most of the events of the day took place at the Plaza, a parade along festooned East Broad Street preceded the ceremonies. Here crowds are gathered on both sides of East Broad Street to participate in the festivities, which included potato-sack and wheelbarrow races. Pictured is the landmark Arcanum Hall, at the corner of East Broad and Elm Streets, all dressed up for the occasion. The rain does not seem to have had a dampening effect on the festivities.

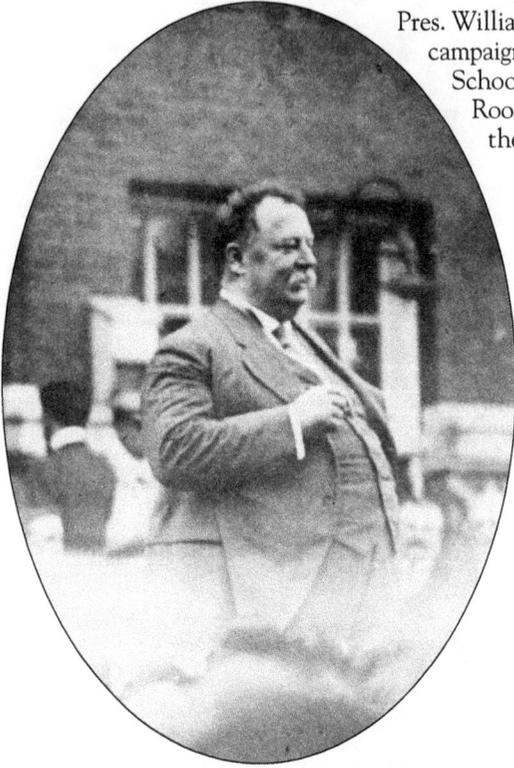

Pres. William Howard Taft, a Republican, is pictured here campaigning in Westfield in front of the old Washington School in May 1912. During the same week, Teddy Roosevelt, running on an independent ticket, visited the same spot.

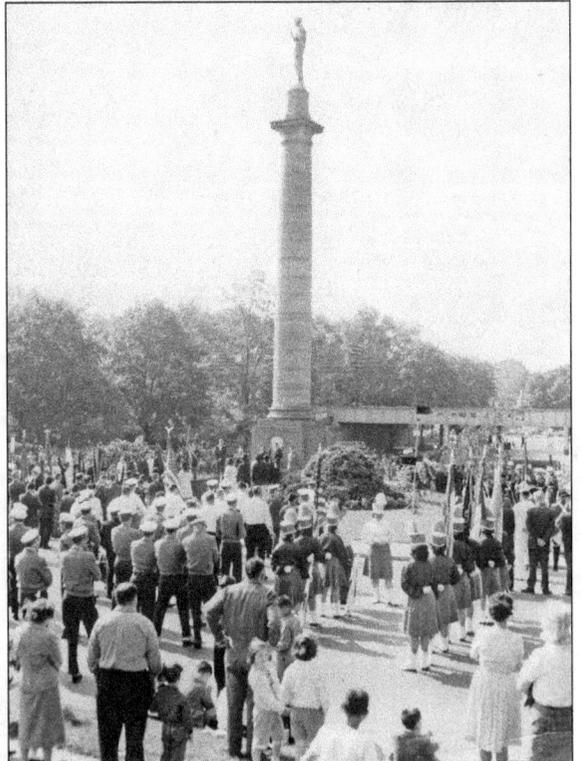

Every Memorial Day, a ceremonious parade marches down East Broad Street to memorialize Westfield's soldiers who gave their lives for their country. In the 1950 photograph at right, crowds gather around Gloriana (also known as Clio) on Memorial Day.

Mindowaskin Park was completed in two stages. The first was in 1907, when William Edgar Reeve, along with a newly formed commission, acquired Clark's Pond from Patrick Traynor. Part of the Reeve property at 314 Mountain Avenue was donated to complete the park in 1918. In June of that year, a dedication ceremony took place. Here Mayor Henry W. Evans makes a speech to the large crowd. Gov. Walter Edge is in attendance.

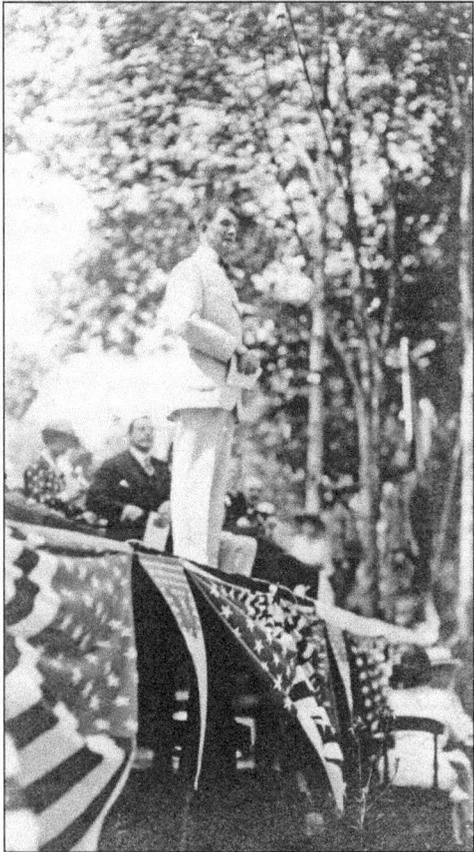

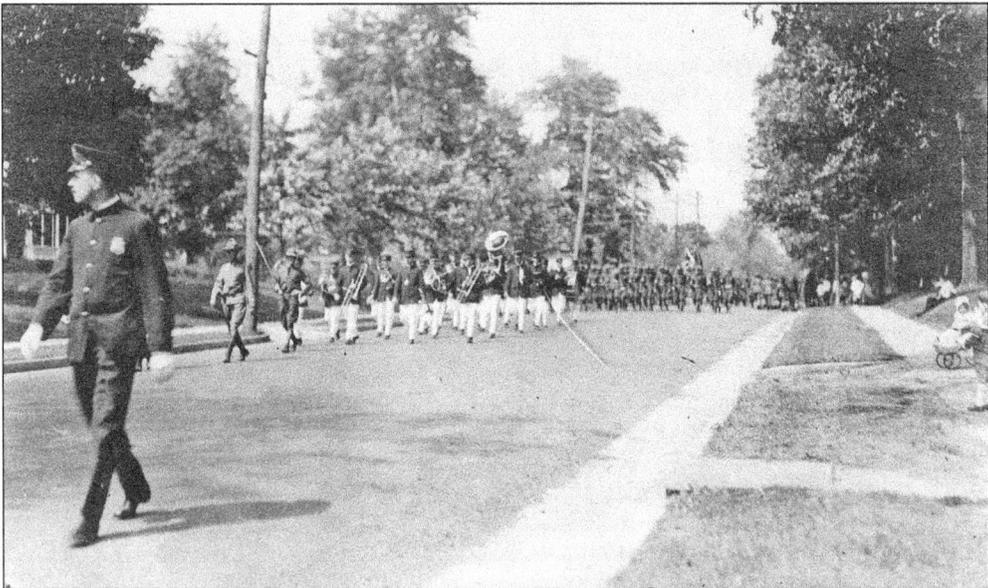

A parade along East Broad Street marches into the park for the dedication. Above, the Westfield Band, along with the Westfield and Cranford Company's state militia reserve, approaches Mindowaskin Park for the ceremony.

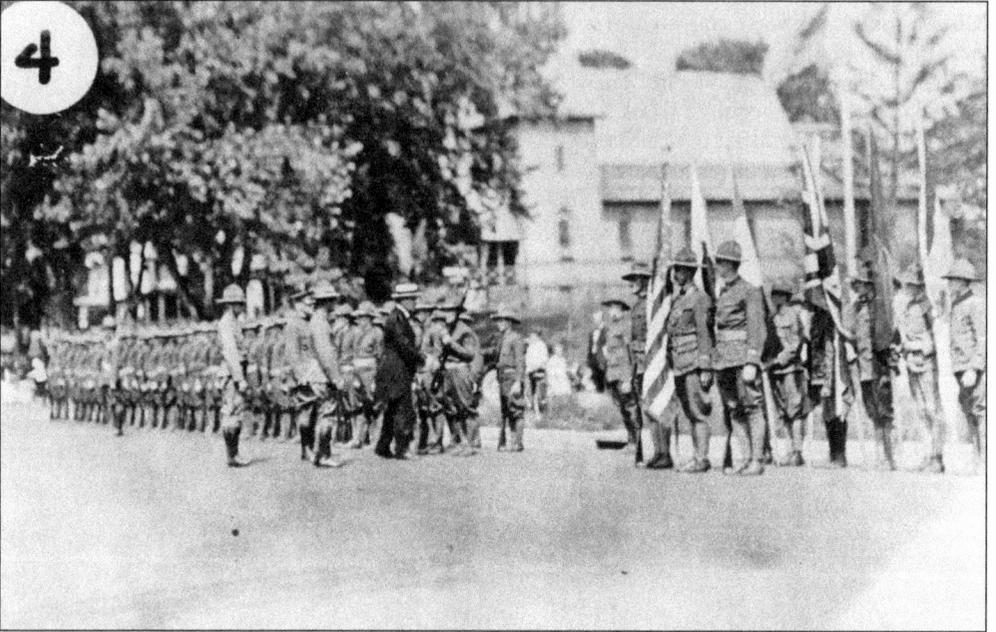

New Jersey governor Walter Edge shakes hands with members of the Westfield State Militia Reserve.

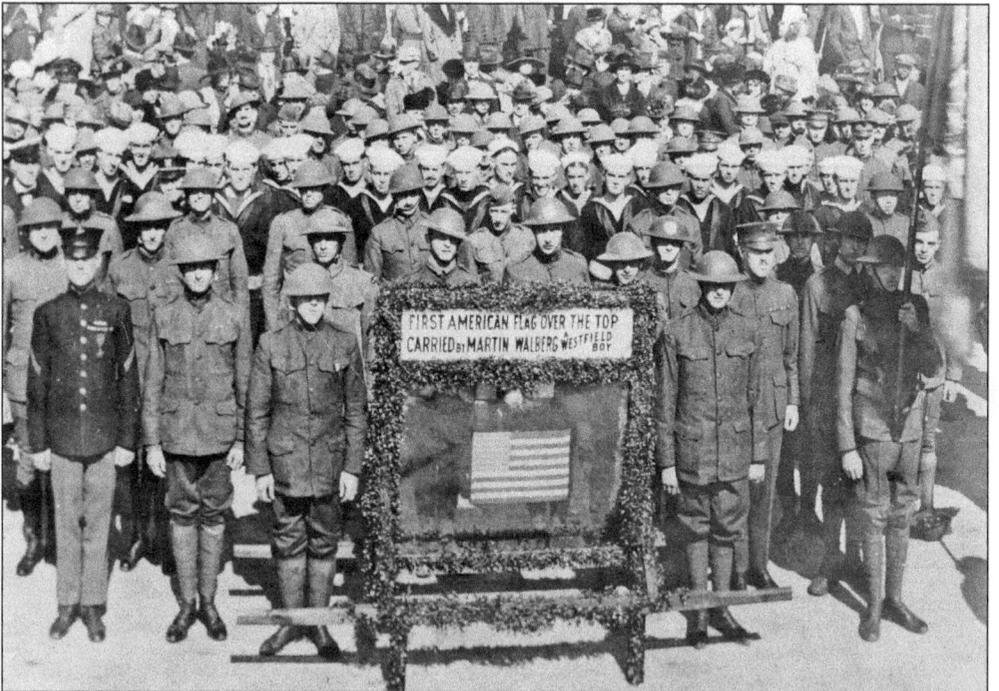

The American Legion is marching in the World War I Welcome Home Day parade on October 13, 1919. The small flag being carried in the front of the line is the one that Martin Wallberg carried "over the top" in France right before he was killed. The story of Martin "Blondy" Wallberg heroically leading the charge at Passchendaele Ridge was reported by his comrade, Pvt. Ralph W. Watkins. Wallberg, a "supreme honor man," was the first Westfield boy killed in World War I.

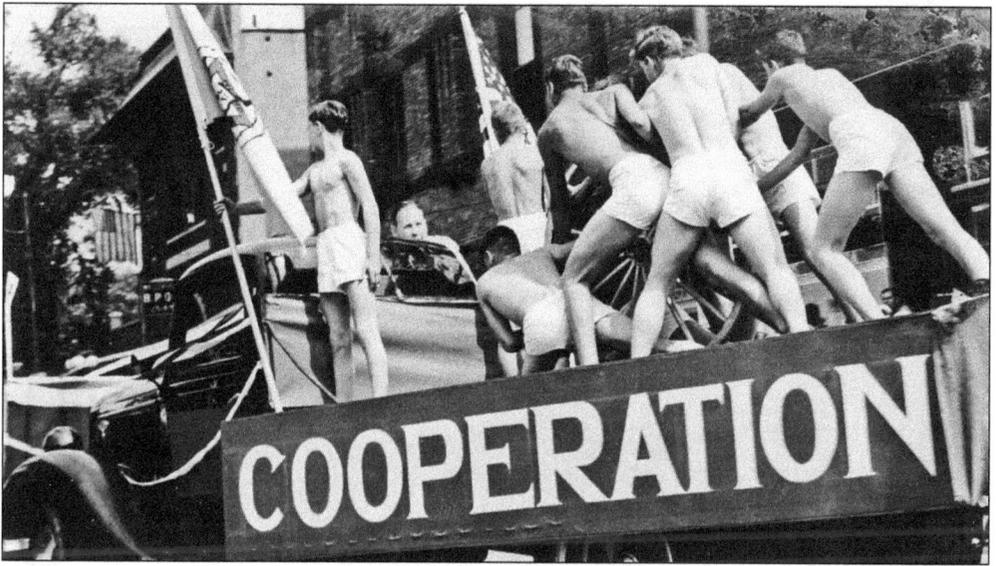

Young men strike a pose on the float "Cooperation" in the Welcome Home Day parade. Apparently these boys are not only showing how cooperation was key to America's successful outcome but they are also displaying their own commitment by wearing nothing but shorts on this cool fall day. The Welcome Home Day parade was another widely attended event in Westfield's history. Below, the float of the Statue of Liberty was temporarily constructed for the momentous occasion.

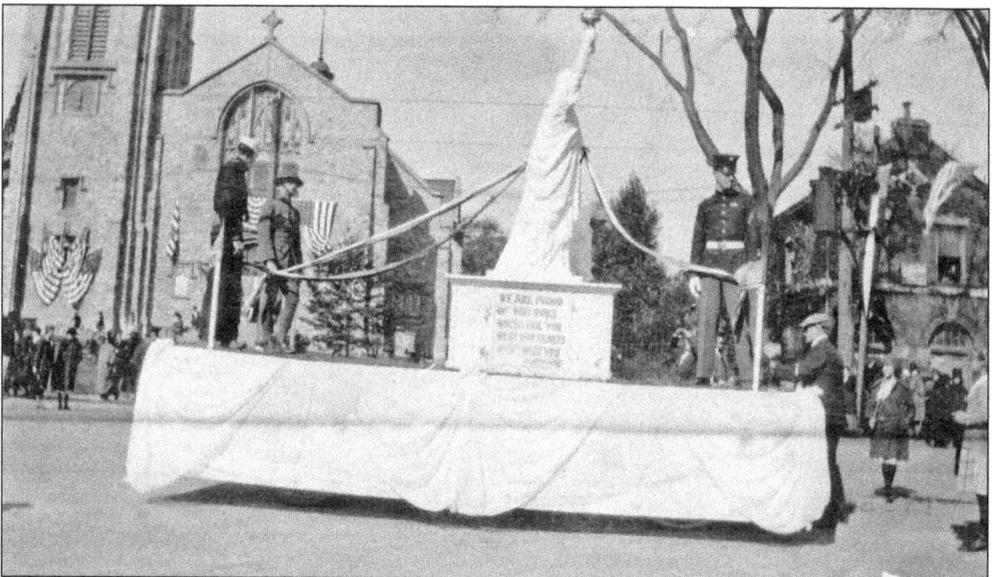

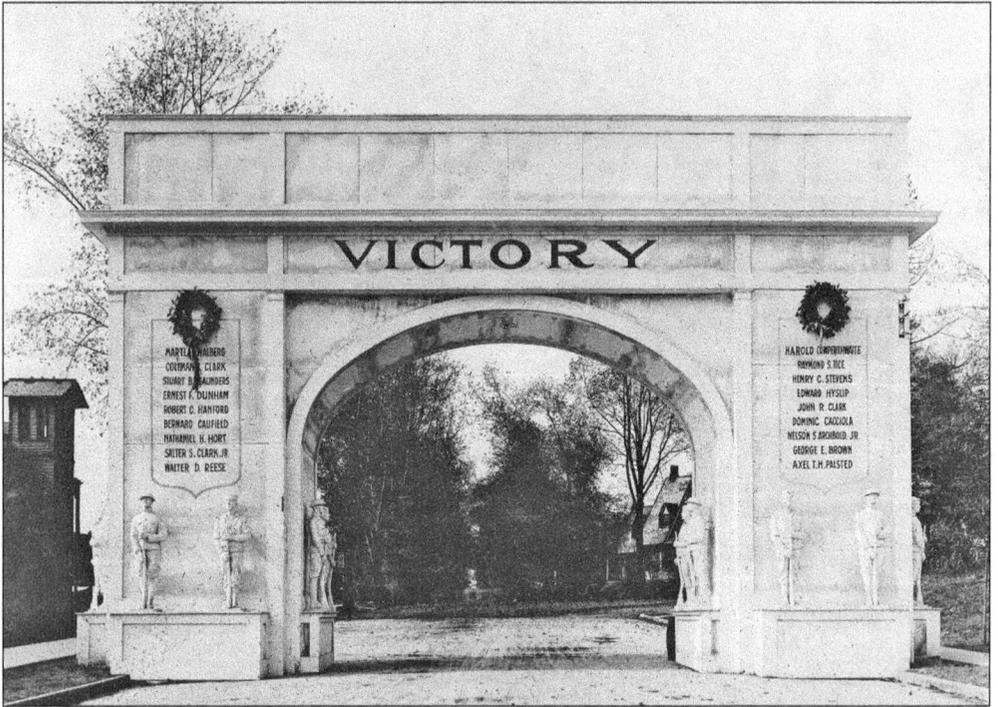

The Victory Arch was also constructed exclusively for the Welcome Home Day parade. It was built to honor the boys of Westfield who made the supreme sacrifice. Below is the Statue of Liberty float passing under the lighted Victory Arch on the evening of the parade. The celebration lasted until after dark.

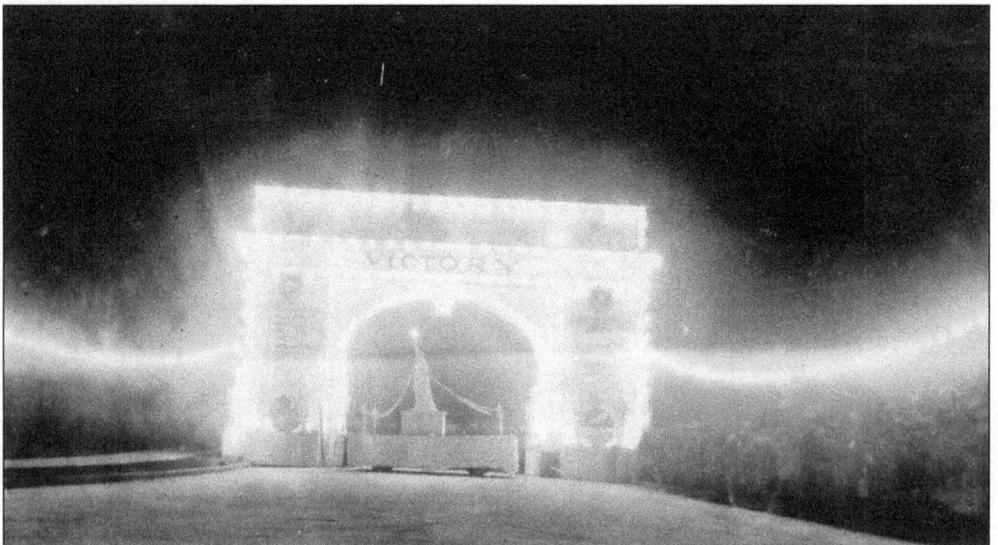

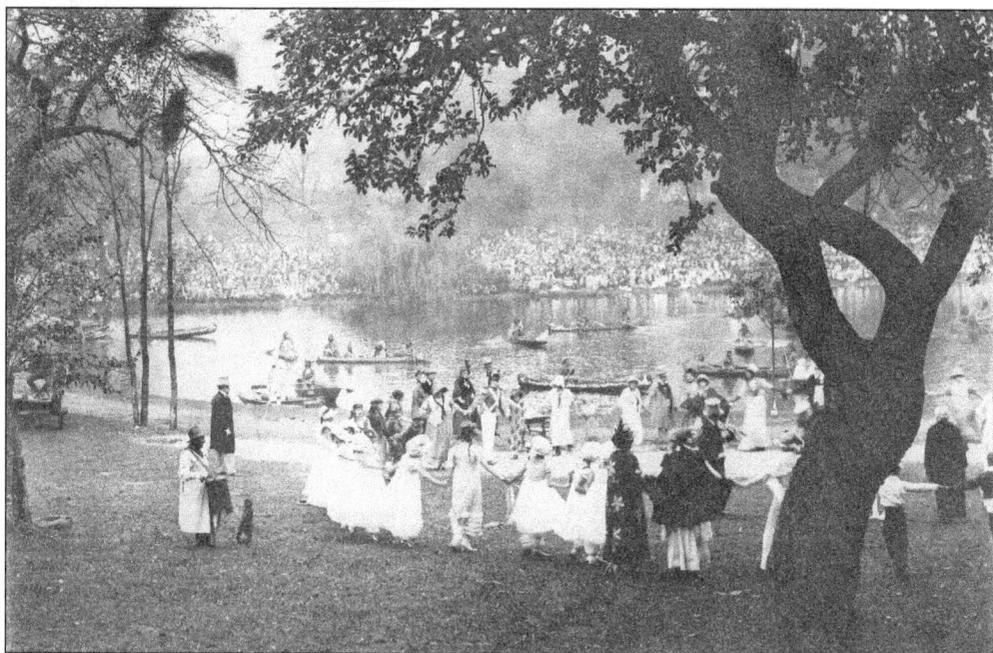

The 200th anniversary of the settlement of Westfield was cause for another huge celebration. Westfield's big birthday party took place on Columbus Day in 1920. At least 500 participants performed to an audience of approximately 1,500. Those who were not involved were in attendance at the community's biggest celebration yet. The pageant, which was similar to a stage show, was divided into five episodes commemorating the five great periods in Westfield's history from 1720 to 1920. The above photograph appears to be a scene from episode one, a reenactment of Native American life, with canoes on Clark's Pond. Episode two told the story of the Revolutionary years. Episode three depicted a typical market day in 1820. Episode four portrayed the Civil War period, and episode five was about the current events of the day—particularly the Great War and Welcome Home Day. Below, eight women perform a dance.

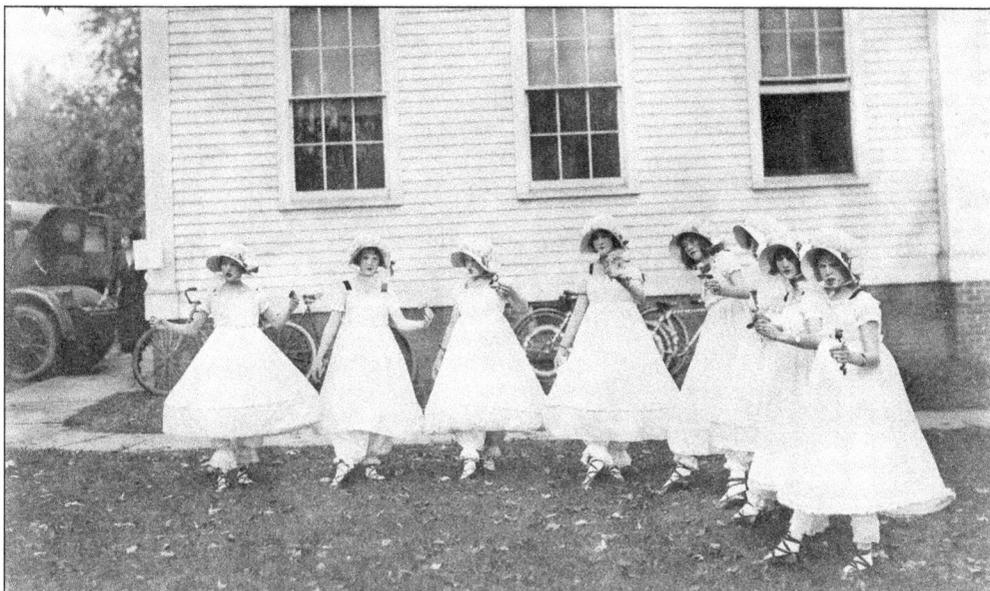

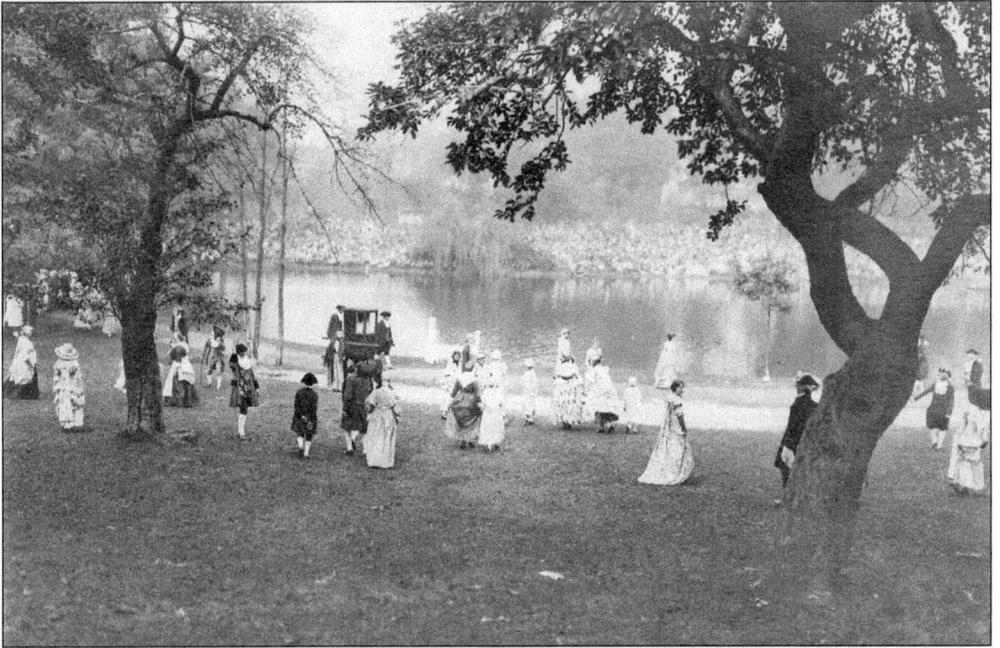

This scene seems to be from episode two, Westfield during the Revolutionary years. The Queen of the Pageant, Lydia Cosgrove, is being carried in a chair designed for the pageant.

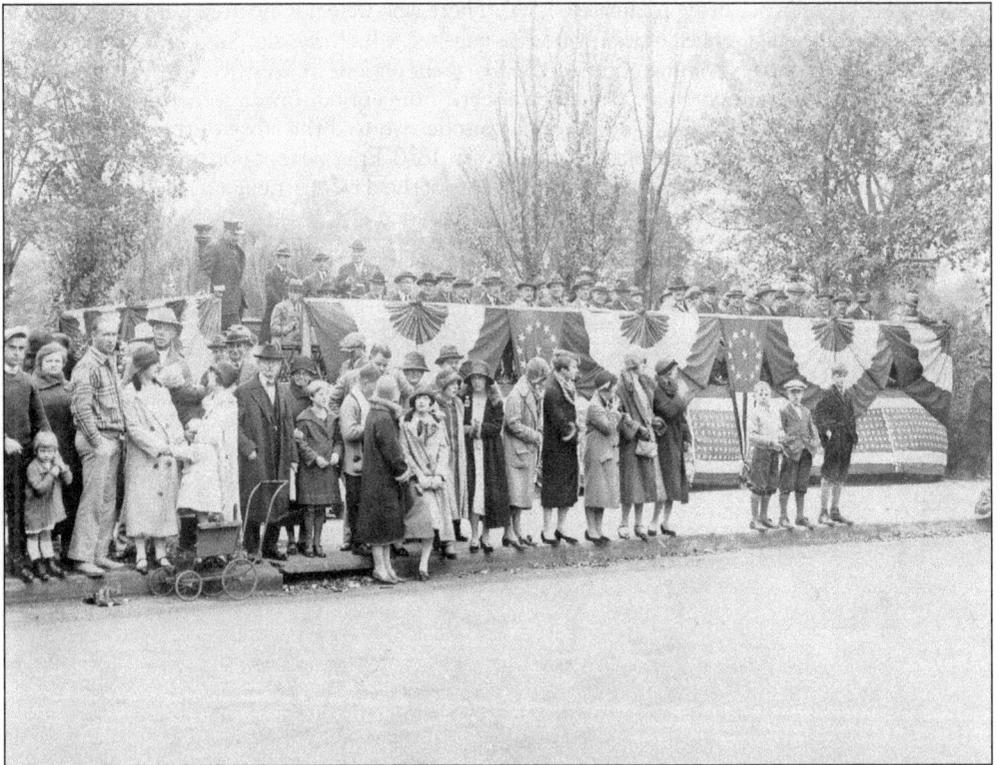

Westfielders of all ages attended this parade on October 12, 1925, to celebrate the 50th anniversary of the Westfield Fire Department.

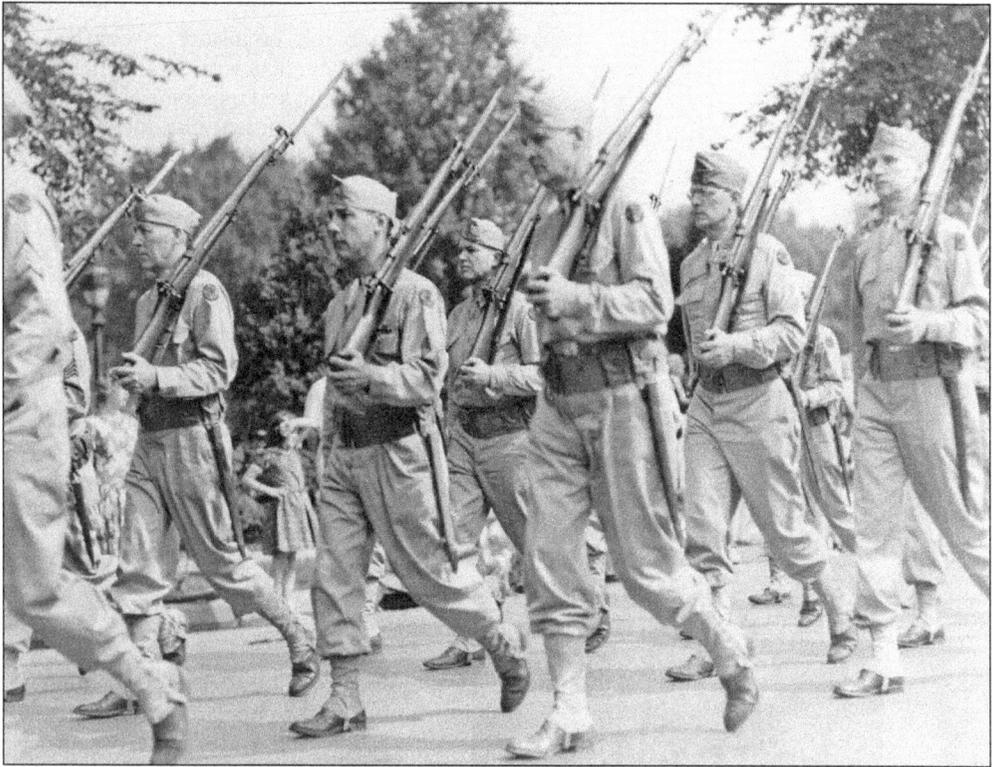

Above are the servicemen donned in their military uniforms and toting their guns as they march down East Broad Street on Civilian Mobilization Day on July 4, 1942. Spectators line the street in support of this successful government effort. Below, the Westfield Band is pictured marching past Mindowaskin Park, along a strip of East Broad Street, on Civilian Mobilization Day.

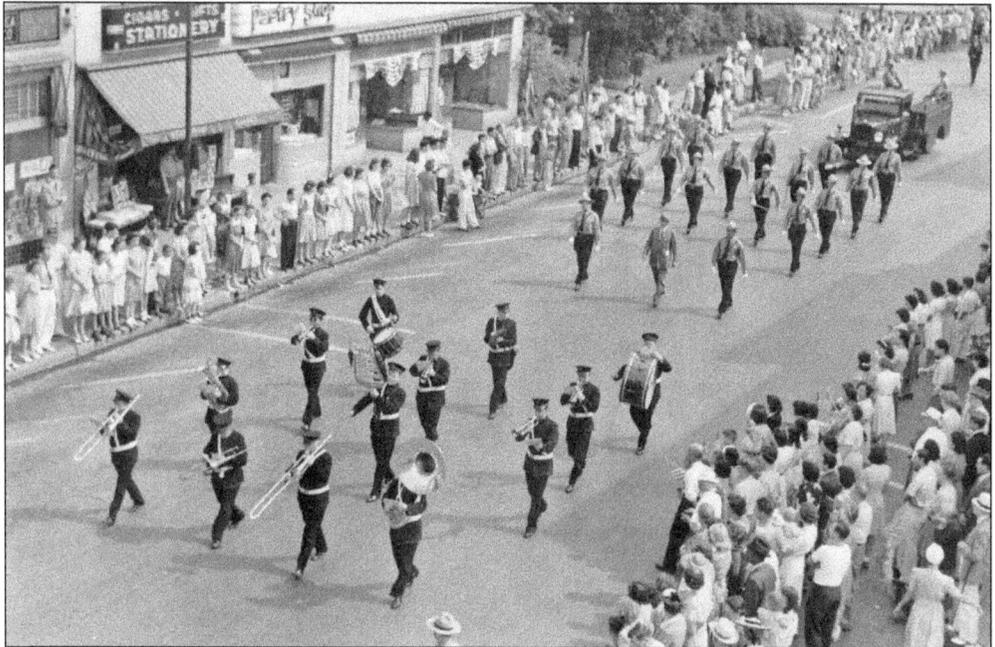

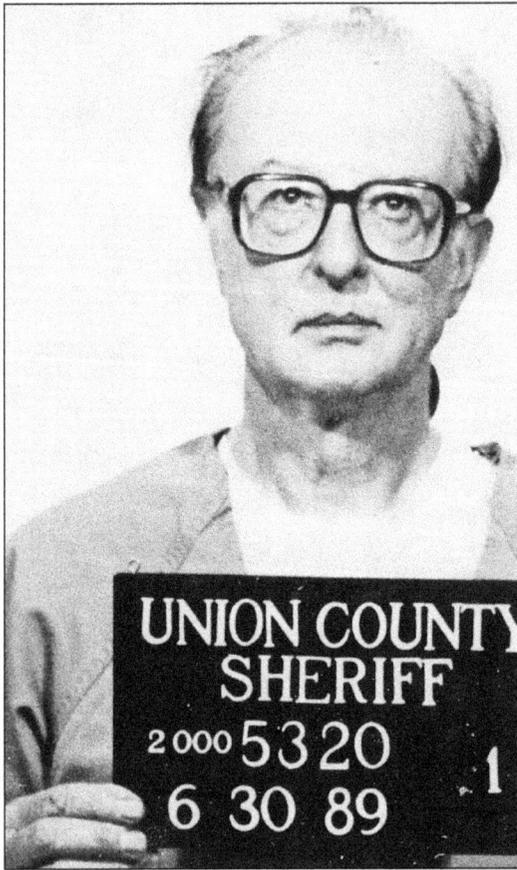

Unfortunately, no history of Westfield would be complete without the inclusion of the horrific and gruesome account of the John List murders. List, nicknamed the boogeyman of Westfield, murdered his mother, wife, and three young children on November 9, 1971, in their mansion at 431 Hillside Avenue. This nationwide news event became even more sensational when List mysteriously disappeared for nearly 18 years. A neighbor recognized him after an episode of *America's Most Wanted* featured the story of these senseless murders in 1990. Living a new life with a new wife in Virginia, List got away with five cold-blooded murders for almost two decades. Pictured at left is his mug shot. Below is the serenely beautiful home where what is probably Westfield's biggest tragedy took place. Known as Breeze Knoll, the 18-room mansion coincidentally had once belonged to the prominent, well-respected Wittke family, who owned the popular downtown retail establishment known as Wittke's Corner for many years. Ten months after the unfathomable murders, the home was mysteriously destroyed by fire. Today a charming new home sits on the property.

Seven

COMMUNITY

When Westfield was incorporated in 1903, Martin Wells became the town's first mayor. He served as a deacon at the Congregational church, where his brother-in-law, the Reverend Cornelius Patton, was a minister. Later, Wells held the position of president of the board of education, where his true passions lay. Wells was also a member of the executive committee of the Westfield Trust Company. His term as mayor only lasted a few months. He is among the prominent citizens who deservedly have streets named in their memory.

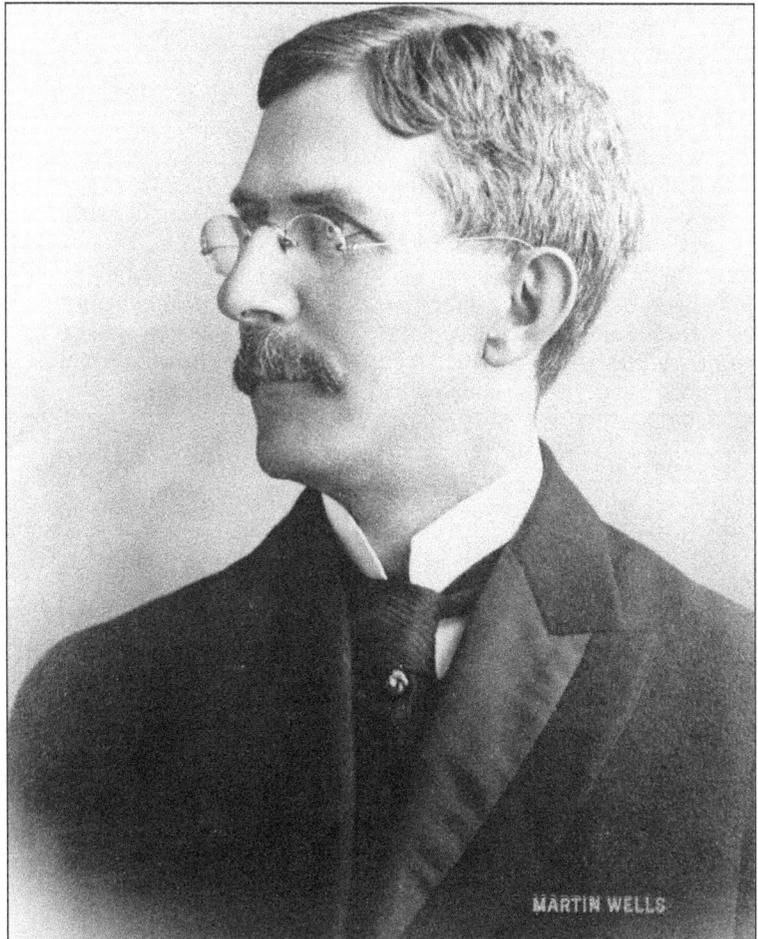

MARTIN WELLS

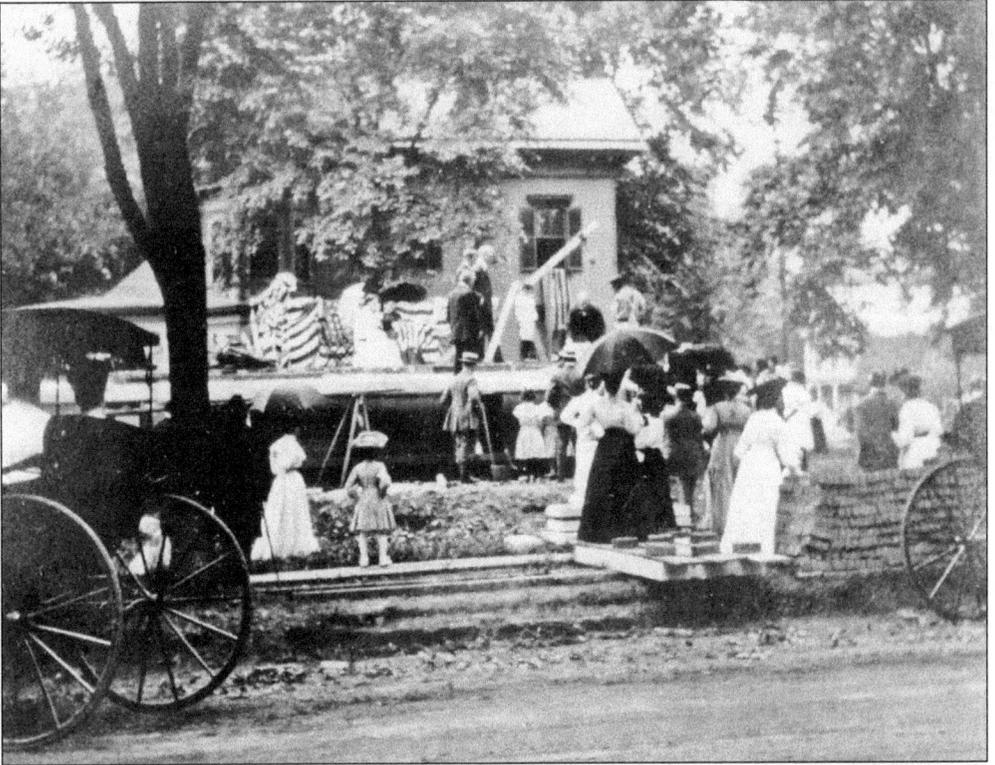

The first public library was begun as a circulating library in May 1873 by the Every Saturday Book Club, a women's literary group. In 1906, this distinctive structure was made possible by a $10,000 contribution by Andrew Carnegie. It was decided by a committee that was formed to canvas public opinion that the location of the Carnegie library would be at the corner of East Broad and Elmer Streets. Salter Storrs Clark, who perished in World War I, and Sen. Arthur N. Pierson were among the committee members. Above, spectators gather for the laying of the cornerstone for the first public library building in the heart of town. Below is the finished library building that served the community from 1906 until 1954.

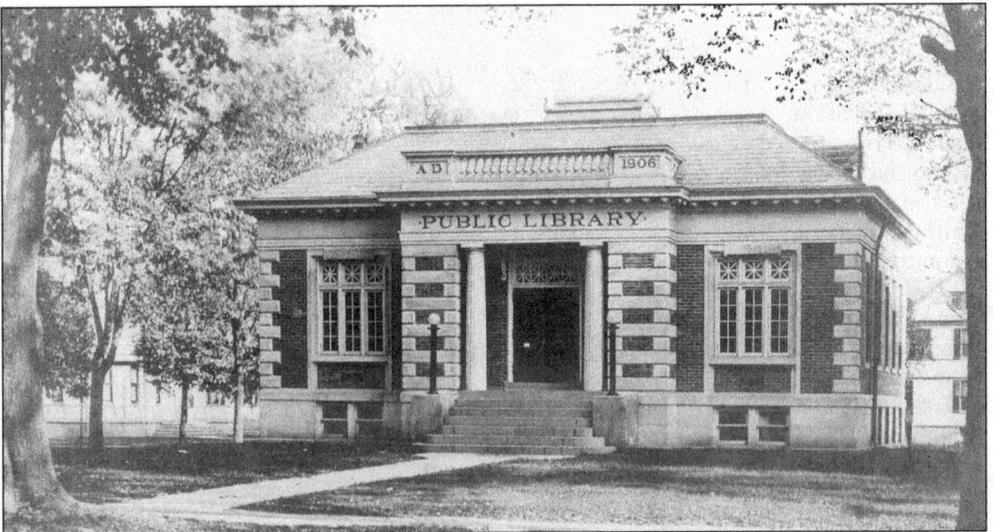

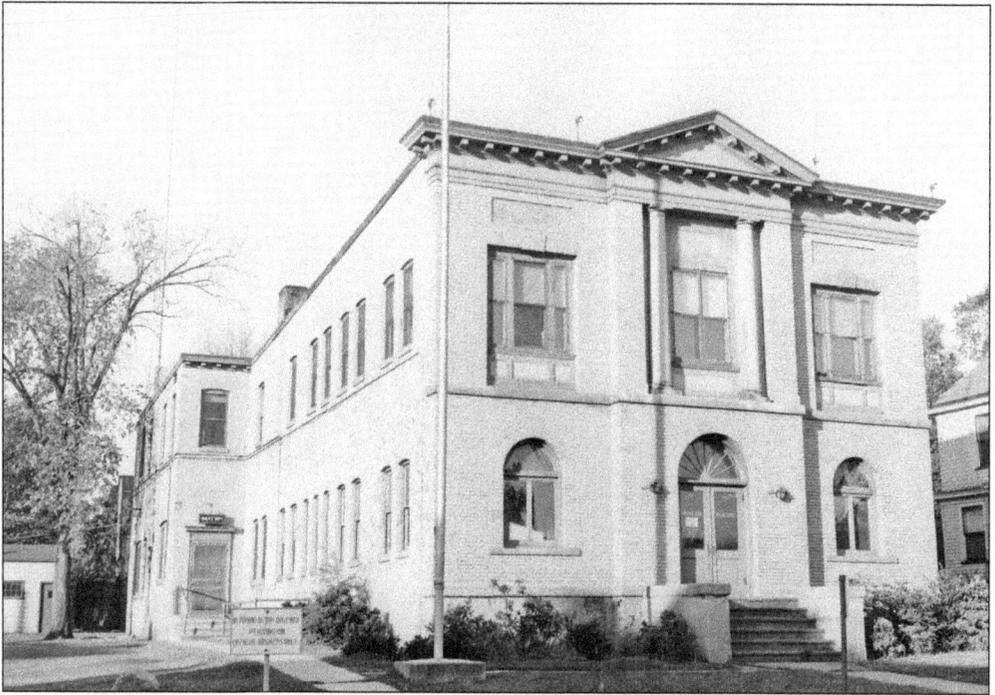

The first municipal building was also constructed in 1906 at 121 Prospect Street. It stood slightly off the corner of East Broad Street and served as Westfield's city hall until 1954, when a new municipal complex replaced it. This photograph was taken around 1911. (Courtesy of G. Alden Barnard.)

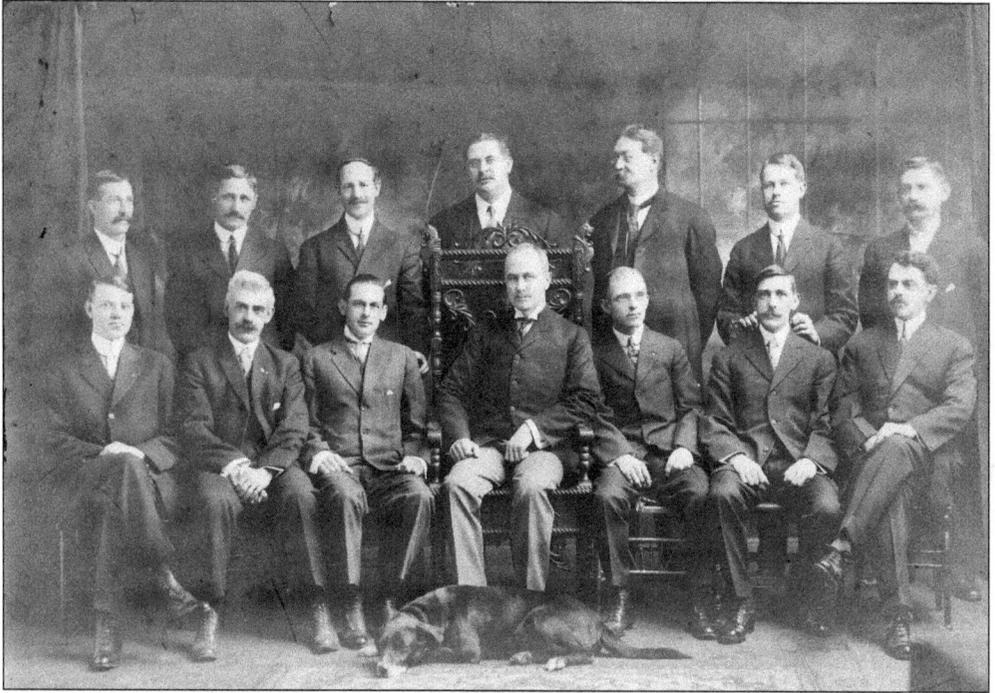

Pictured are the members of the 1912 town council. Mayor J. Allston Denis is seated in the front center with his dog sprawled at his feet.

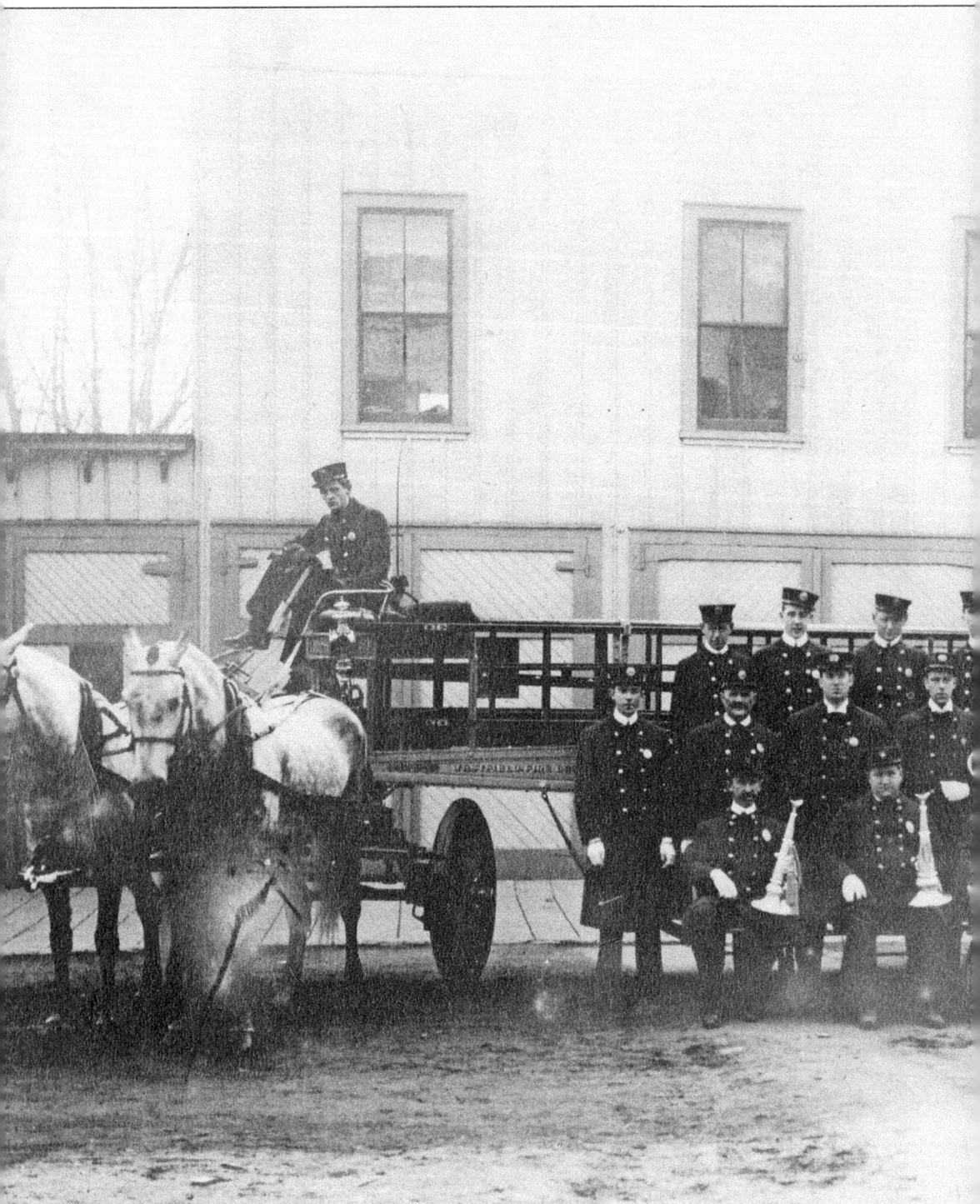

Fire house, North Avenue, be...
when fire apparatus was horse drawn

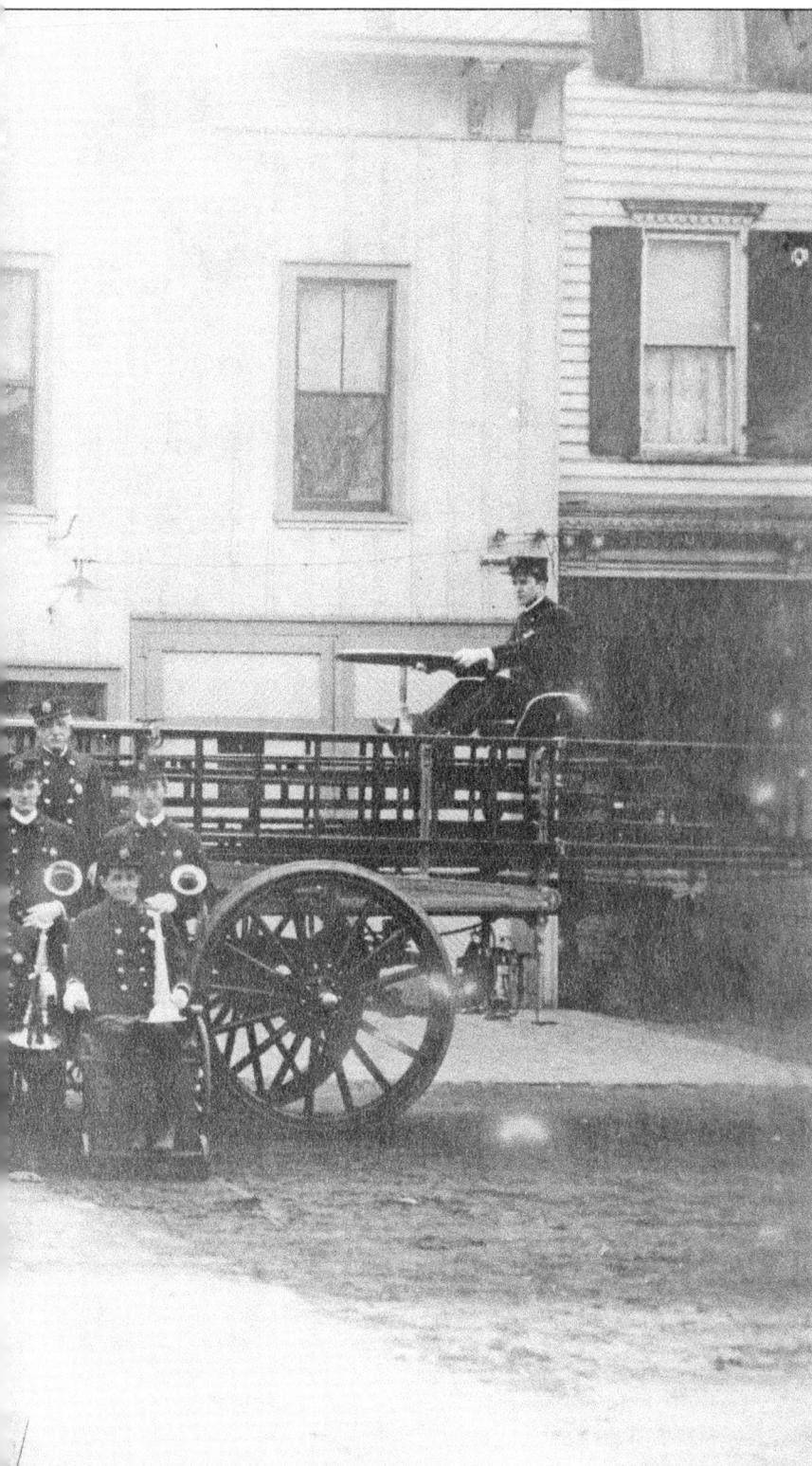

After the destructive fire of 1874, which began in Gales Stationery Store, a volunteer fire department was formed. Most of the male citizens joined the volunteer fire squad. Since its inception, there have been four Hook and Ladder Is. The first was a cart pulled by hand by the volunteers. It is believed that a young boy set fire to the icehouse on Clark's Pond just to witness the hook and ladder squad in action. Hook and Ladder II was a horse-drawn cart. The third one was an actual truck with a wooden ladder, purchased in 1922. In the 1940s, Hook and Ladder IV was purchased for $27,000.

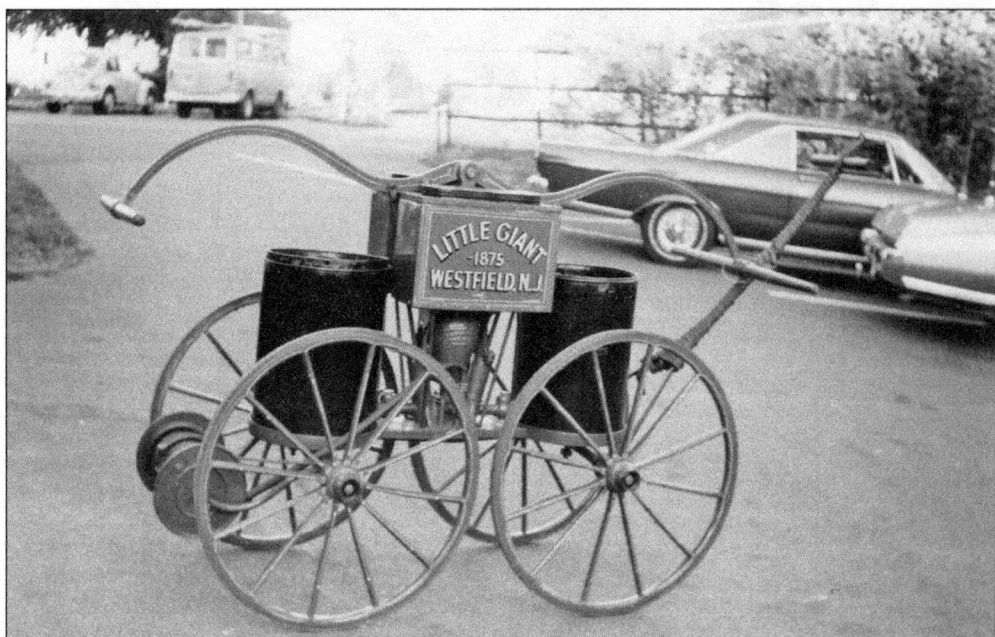

Little Giant, a cart that held two buckets, was the first apparatus used to extinguish fires. Prior to this invention in 1875, neighbors would throw buckets of water from nearby streams to put out fires. Neither of these methods was very effective in combating damaging conflagrations in the late 19th century.

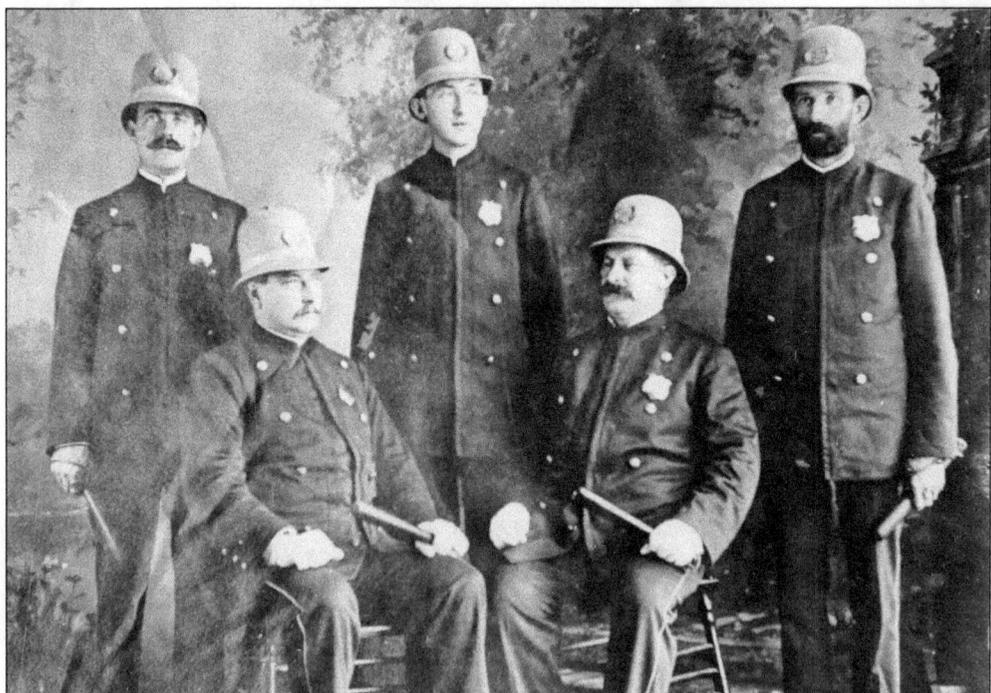

Pictured is the first police department in the 1890s. Members are, from left to right, (first row) John Knapp and James Harrison; (second row) Thomas O'Neill, Elmer Woodruff, and Capt. Cyrus Wilcox.

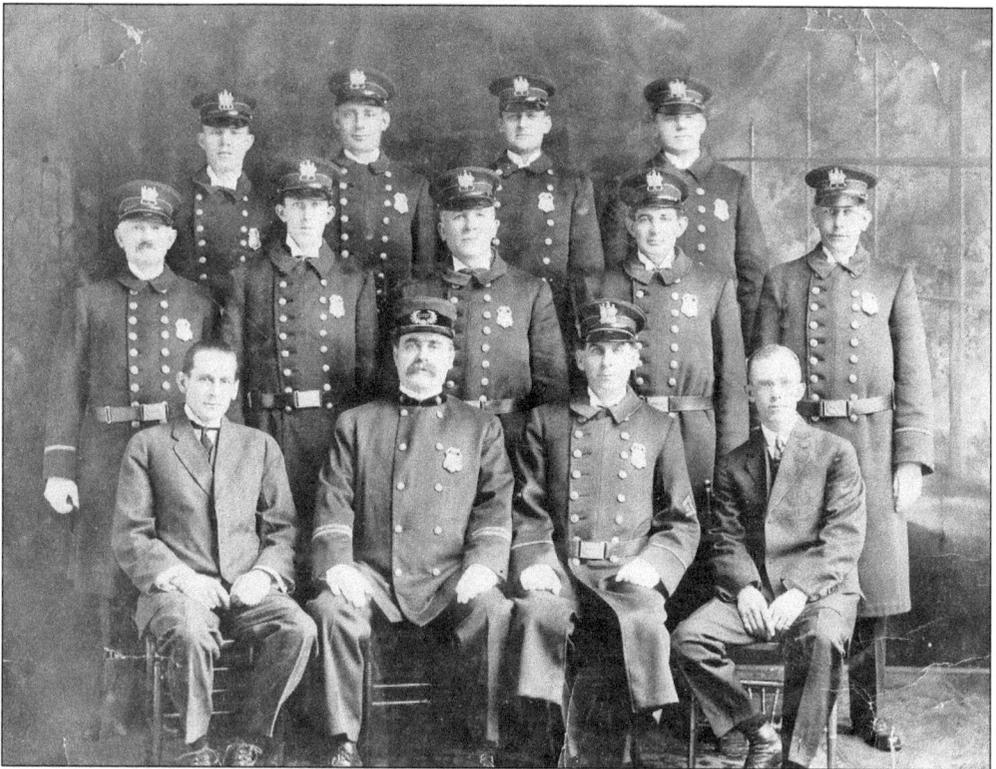

Here the 1914 police force poses for a picture. They are, from left to right, (front row) Mayor Henry Evans, Chief Thomas O'Neill (the department's first chief), Lt. Martin Caufield, and Charles W. Afleck, the police commissioner. Standing behind him is the future chief, John Rosencranz.

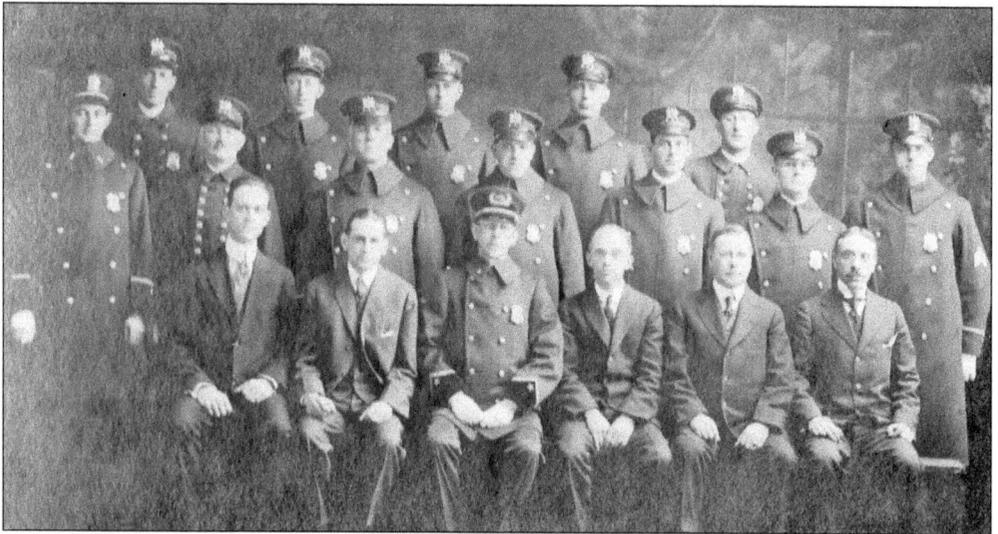

One year later, the Westfield Police Department poses for another photograph. During the year 1915, Rosencranz was appointed chief, and he maintained this position for many years. Under his supervision, the department grew, with modern methods and systems of the time, to be one of the leading police departments for a town of its size in the state of New Jersey. (Courtesy of Karl Baumann.)

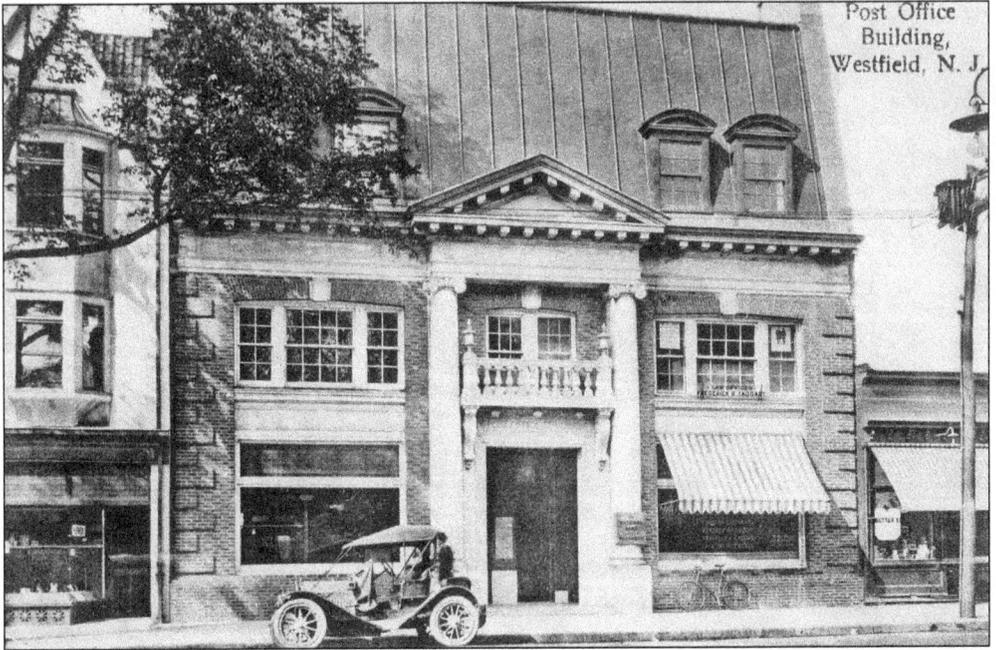
Post Office Building, Westfield, N. J.

In 1805, the first postmaster, Smith Scudder, was appointed. There was not much mail at this time, about 20 pieces bimonthly. The mail arrived on stage route no. 954, which made deliveries from New York to Elizabethtown and extended into Scotch Plains and Plainfield until about 1832. The local postmaster would distribute mail after church on Sundays. Above is the first post office building, constructed in the early 1900s. During this period, communication by postcard was very popular. Typically, postcards were delivered two or three times a day, as evidenced by the content in the personal message below.

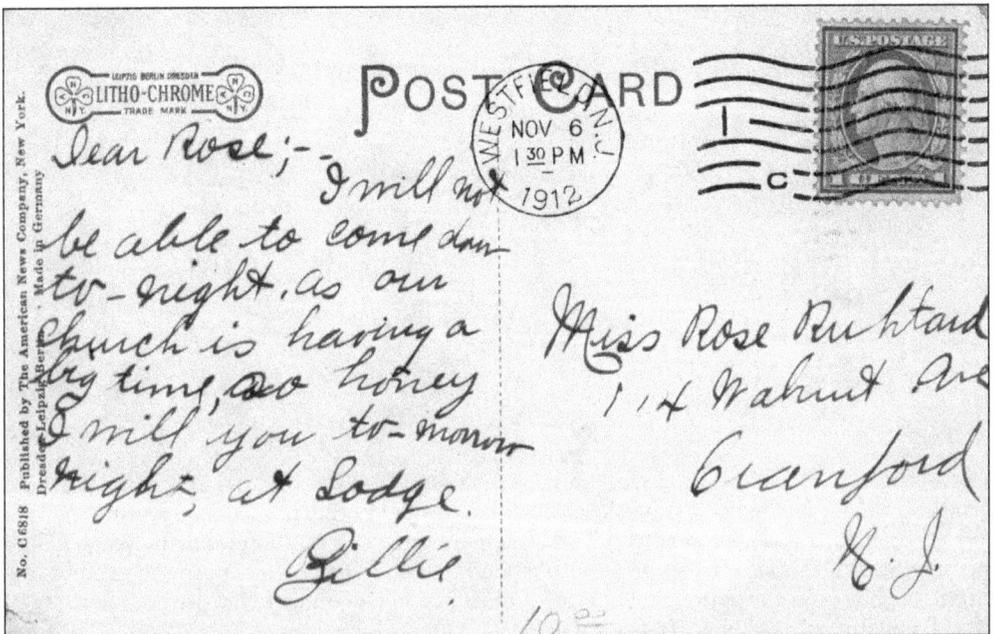

Eight
PEOPLE AND LIFESTYLES

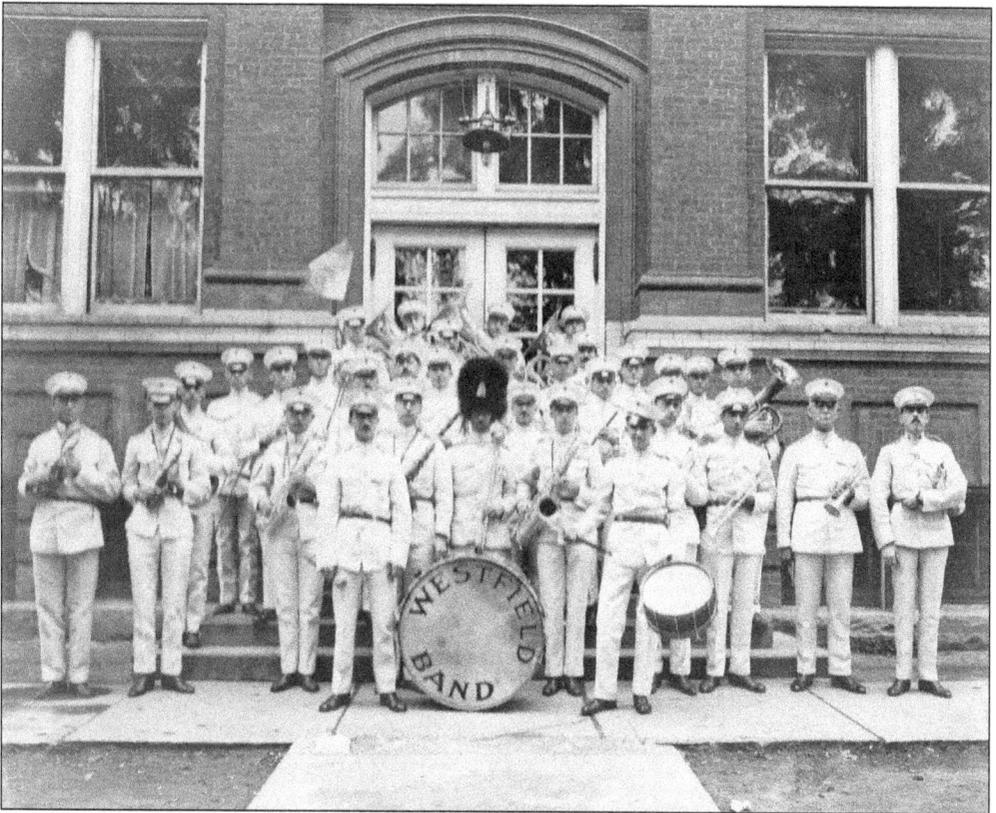

The Westfield Band poses for this 1920s photograph in front of the old Washington School. The band's third leader, William N. Bartow, is standing in the third row on the far left, indicated by an arrow. Bartow signed with John Phillip Sousa and also helped Thomas Edison with his recording experiments.

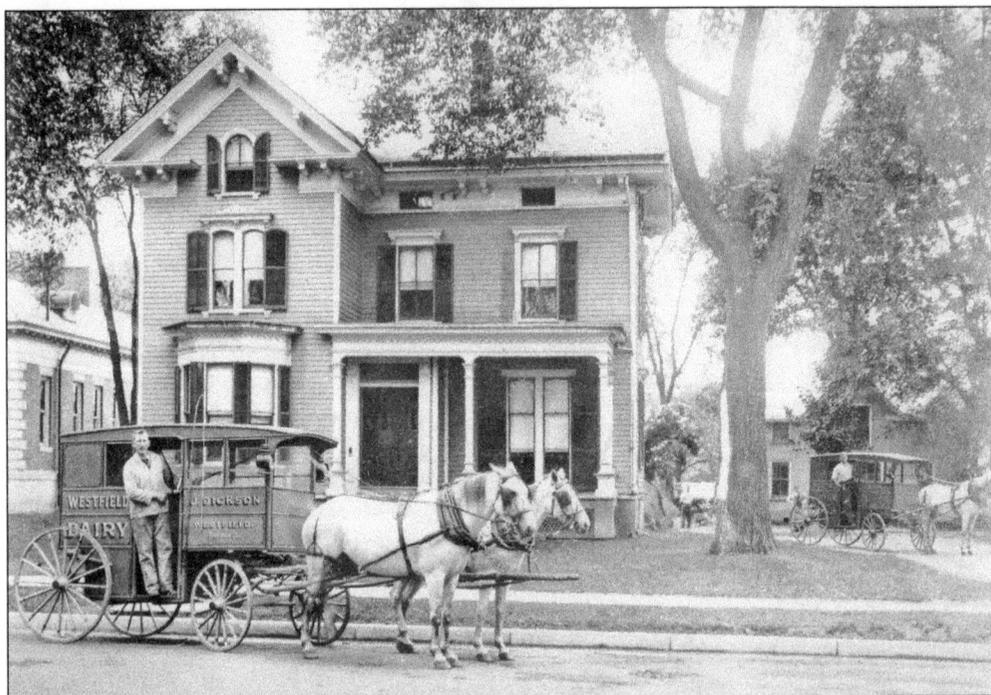

In the 1800s, milk was delivered by horse-drawn carts. In 1880, milk bottles were produced. Prior to this, milk was poured into jugs and sealed with metal clips. It was not unusual for milk to be delivered several times daily. When pasteurization was developed in the 19th century, milk could be stored for longer periods of time, cutting delivery down to once a day. Pictured is the Dickson Family Farm milk wagon in front of the horse-drawn-wagon terminal. The farm was located on the south side of town. The side of the old library building is on the far left of this 1908 photograph.

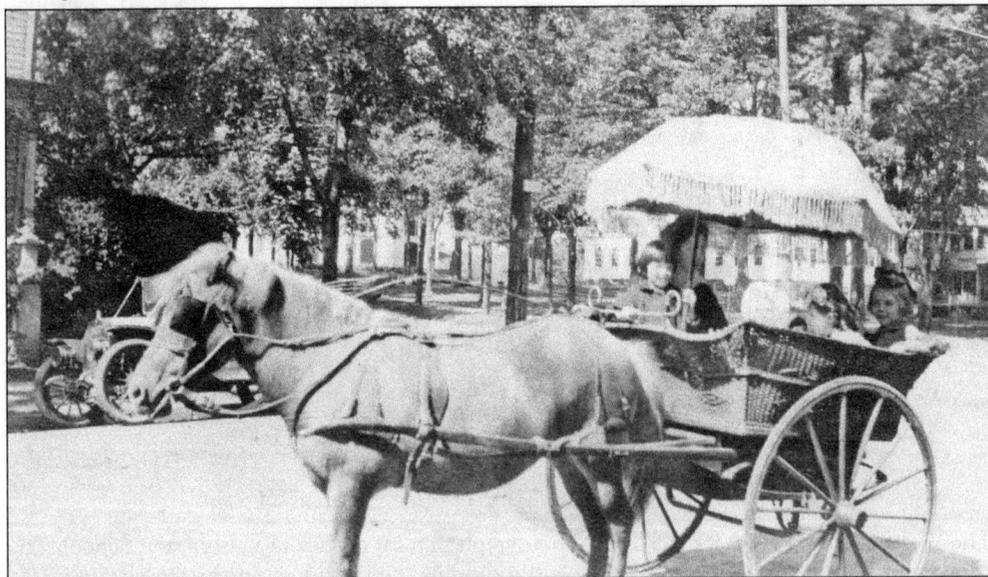

Shaded by an umbrella, the Pierson children and their friends are stopped in their pony cart on East Broad Street some time around 1917. The streets were filled with vehicles of this sort.

Much of Westfield remained farmland well into the 19th century. This 1898 picture of James French's cow, Bessie, was taken on Prospect Street in the neighborhood of Lincoln Road. Today, this neighborhood is completely developed, but the original French home, with some alterations, still stands on Prospect Street in the vicinity (see page 19).

The Stars was a boys club for 17- and 18-year-old young men. Because there were no school- or town-sponsored athletics or activities, this group was formed to play hockey and football. Additionally, it conducted social events at the landmark Westfield Casino. Pictured on Christmas Day, 1897, are the members of the Independent Order of Stars (I.O.S).

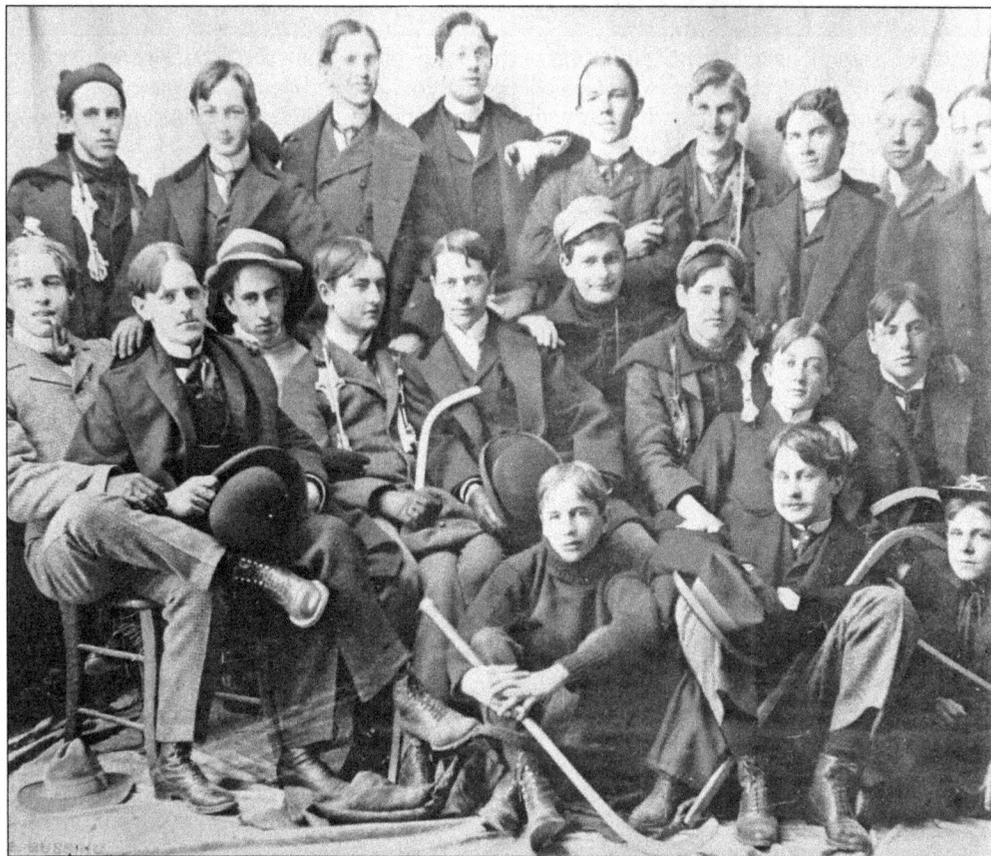

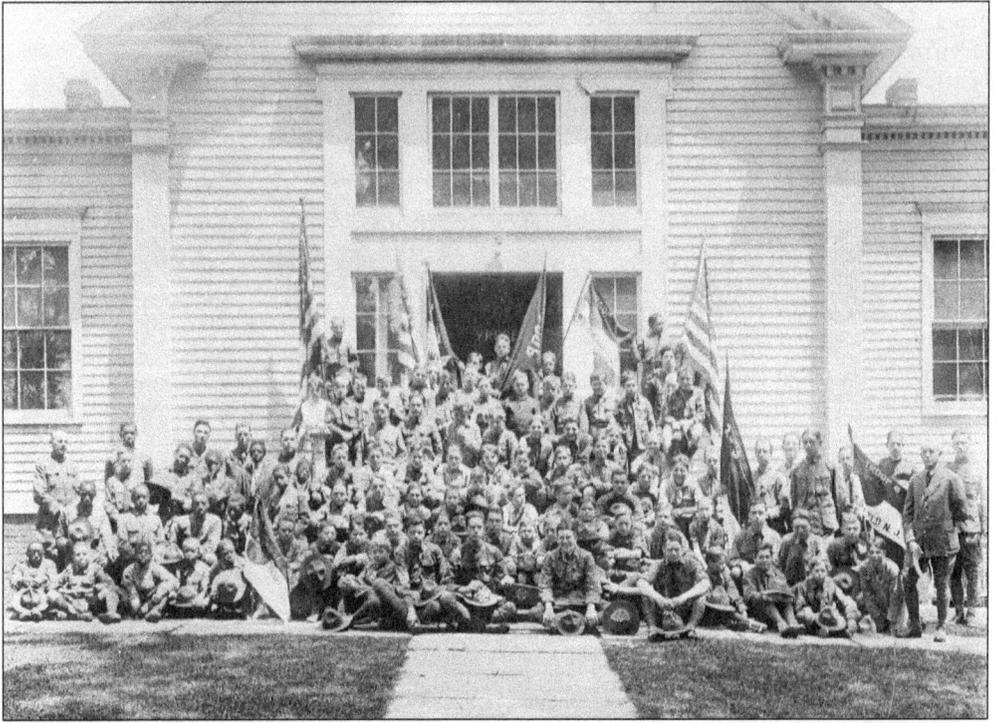

Westfield was a pioneer in the organization of the Boy Scouts. When the Scouts were organized in the early 1900s, several troops were formed. Some were so large that division was needed. This *c.* 1918 photograph shows approximately eight troops, including the several splits and one troop from neighboring Garwood.

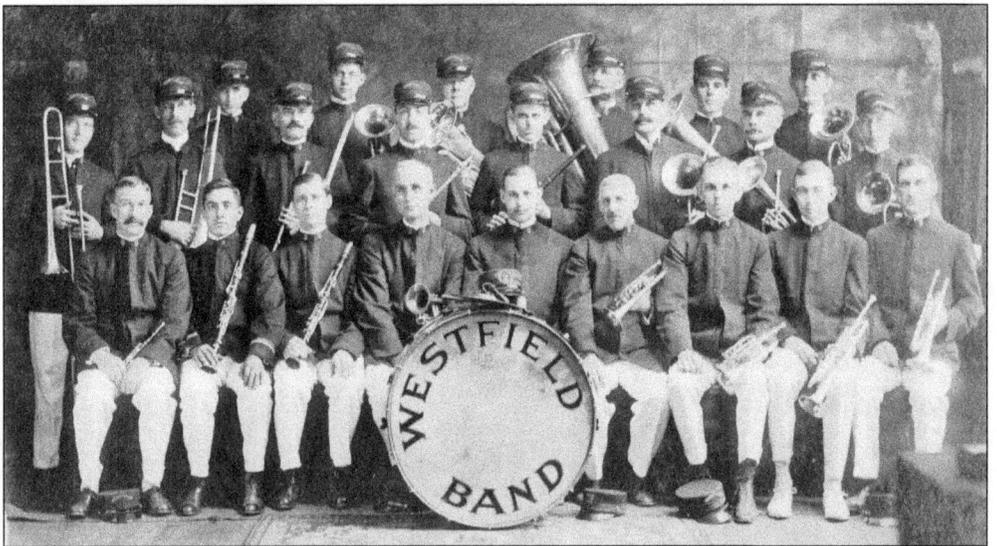

Pictured is the Westfield Band, organized in 1912 by a group of local commuters and businessmen. Many of the members' names are easily recognizable as descendants of early settlers. Wilcox (far left, first row), Harold F. Welch (fifth from left, first row and leader), Frazee (sixth from left, first row), Pearsall (seventh from left, first row), and George Frutchey (fourth from the left, second row) are several examples.

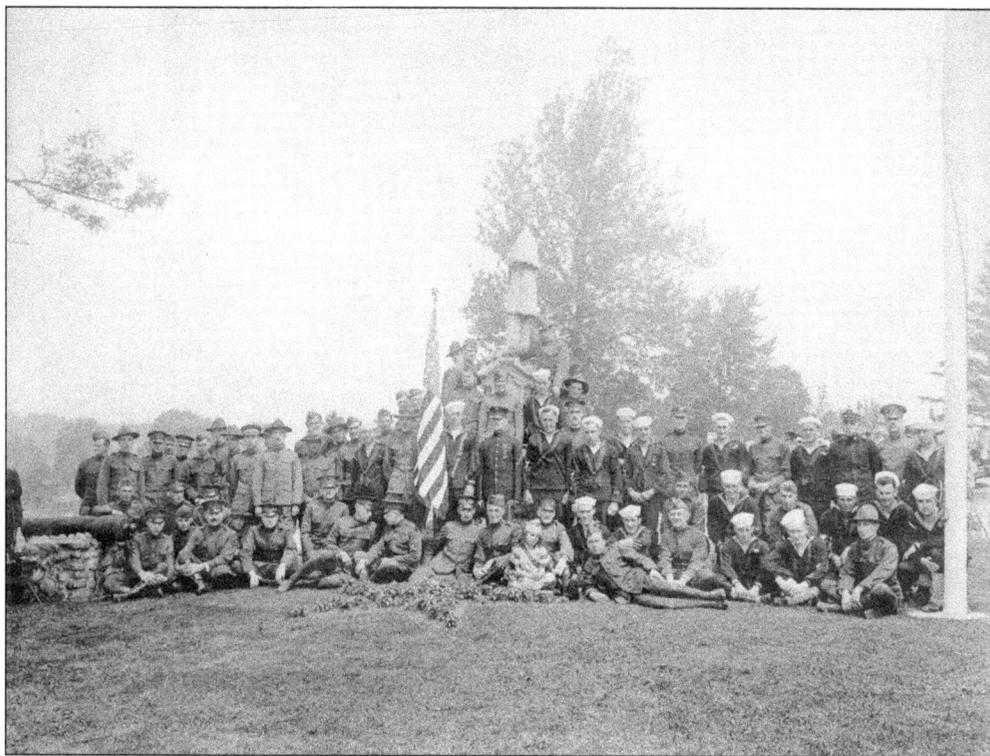

In May 1919, the American Legion post was organized by men who fought in and returned from World War I. The post, named for Martin Wallberg, the first son of Westfield to make the supreme sacrifice for his country in that war, is pictured at its first gathering. This photograph of the Martin Wallberg Post 3 was taken at the Fairview Cemetery on Memorial Day, 1919. (Courtesy of Bruce Conlin.)

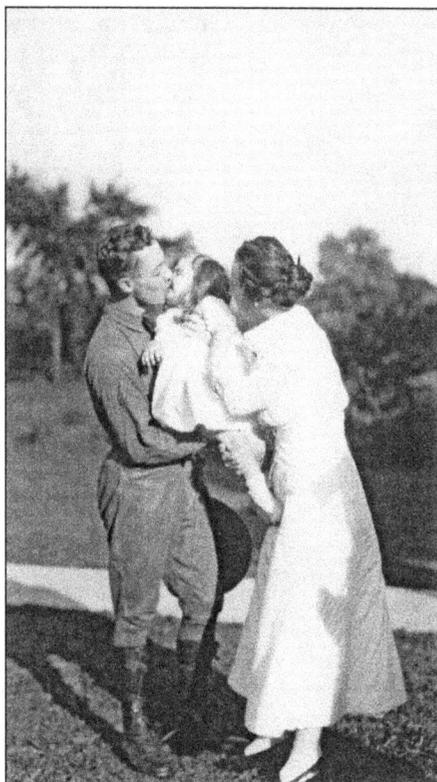

Grace Crane Smith is holding her daughter, Jo Ann, up to kiss her uncle Norman Smith, who is returning from World War I in 1917.

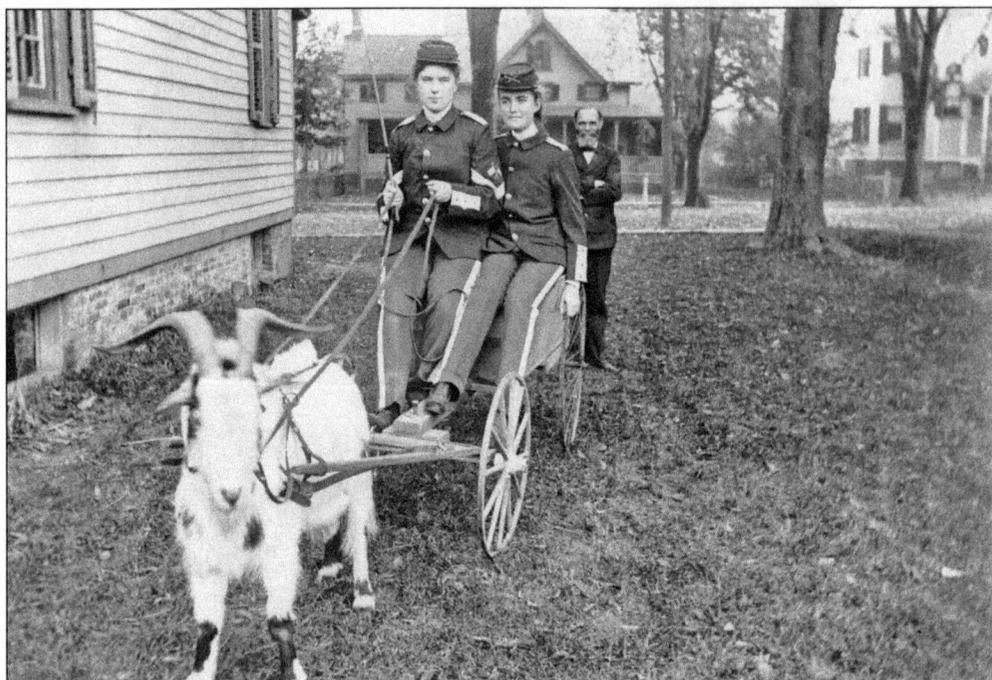

Grace and Harriet Pearsall are riding this goat and buckboard while Edgar Pearsall looks on. This photograph was taken near the family home at 112–114 Ferris Place, named for prominent citizen James Ferris.

The Westfield YMCA was organized through the efforts of some of the town's most noteworthy citizens. Among them were Herbert R. Welch and William Edgar Reeve. In 1922, it was unanimously agreed that the need for such a facility was an absolute. The town gave its full support. A record $300,700 was raised in just 10 days. The building formally opened in 1929. Reeve's portrait is prominently displayed in the boardroom.

Charles Samuel Addams was born in 1912 at 526 Clark Street. A few years later, the family moved to the house pictured above, at 522 Elm Street, where Addams lived until about 1947. In 1992, the home was made an official landmark. Addams's characters formed the basis for two television series, two cartoon series, three motion pictures, and a Broadway show. The inspiration for the spooky Addams Family came from this home at 411 Elm Street. As a boy, Charles passed this house, shown below, on his way to school, and began conjuring up the macabre story of the Addams Family.

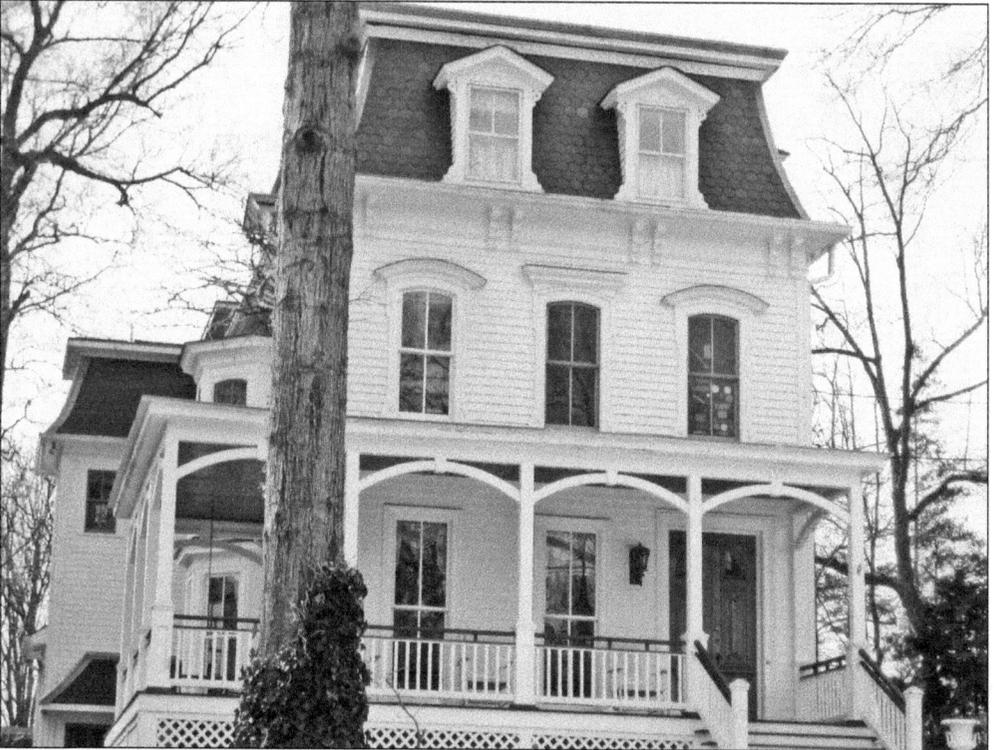

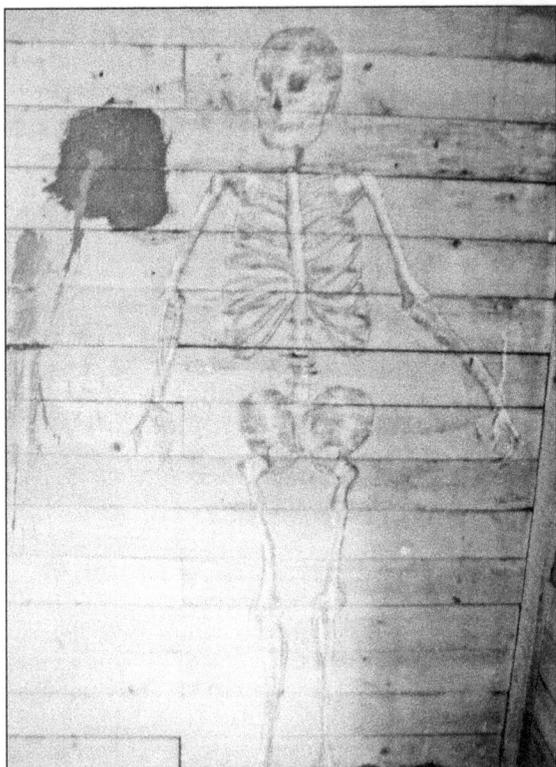

At the age of 8, Addams was arrested for trespassing in a Dudley Avenue home while it was under construction. Addams drew a large skeleton in the carriage house of this home that still remains. At left is the work of young Addams. Below is "Downhill Skier," one of his many cartoons to appear in *New Yorker* magazine. It epitomizes Addams's quirky humor.

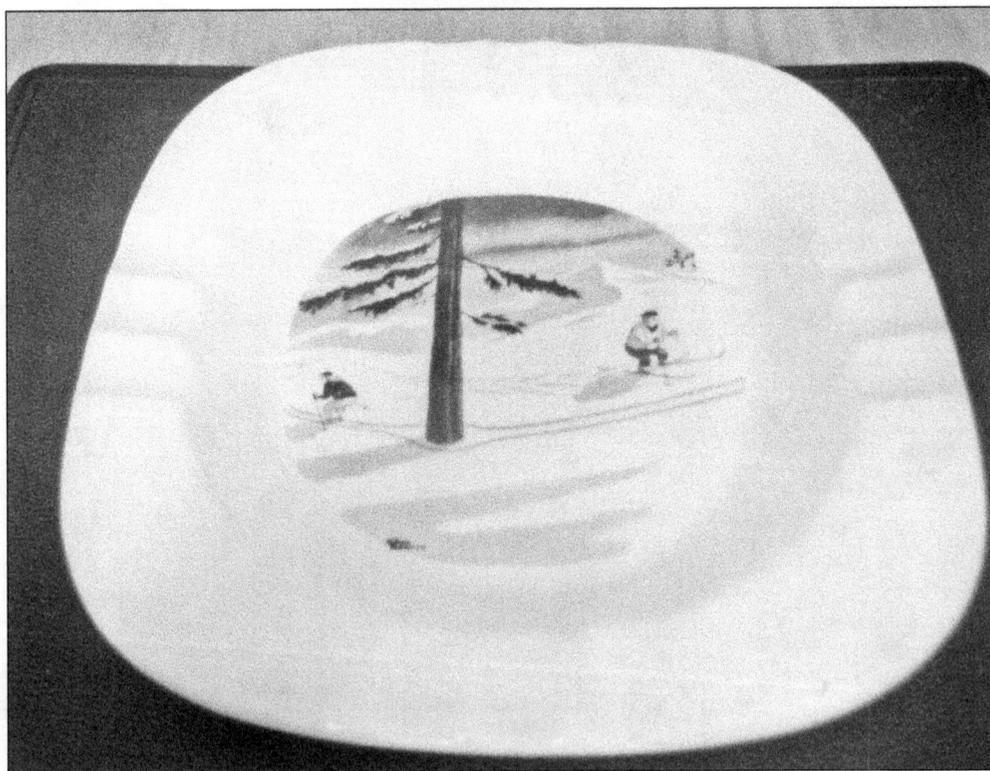

Nine

ENTERTAINMENT

The Westfield Hotel was not only the first hotel in town, but it was also the town's leading hostelry for some 50 years. Built in 1867 by John M. C. Marsh, the project was financed by L. H. K. Smalley and William Stitt, who later became its proprietor. The town jail was located to the left of the building. Town meetings were held at the hotel during 1879 and 1880.

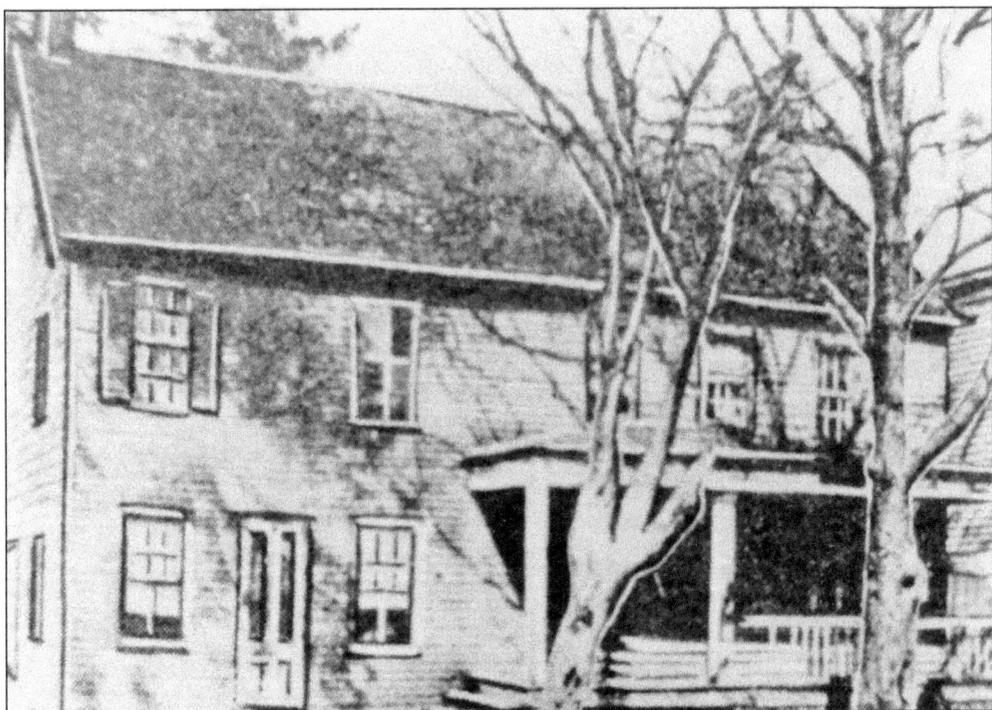

Azariah Clark Sr., a Revolutionary war hero, was the first proprietor of the old Town Tavern located at what is today East Broad Street opposite Central Avenue. In the late 18th century and early 19th century, this corner was a stagecoach stop. These roadways were named Rahway Road and Mechanic Street. At the far left of the building was the old bar, which served the famous Apple Flip, made with rum, beer, and a red-hot flip iron. During this period in Westfield's history, drinking was one of the most popular forms of entertainment.

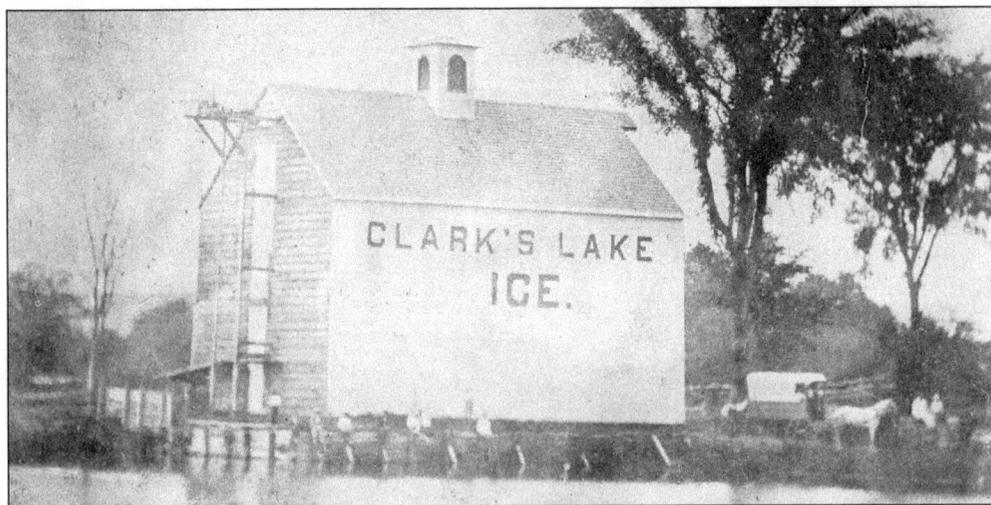

The icehouse on Clark's pond supplied the iceboxes for Westfield residents during the late 19th century. It burned down in 1888. It is believed that an act of arson committed by a young boy interested in witnessing the fire department's hook and ladder unit in action caused the demise. Echo Lake's icehouse then began furnishing ice to Westfield.

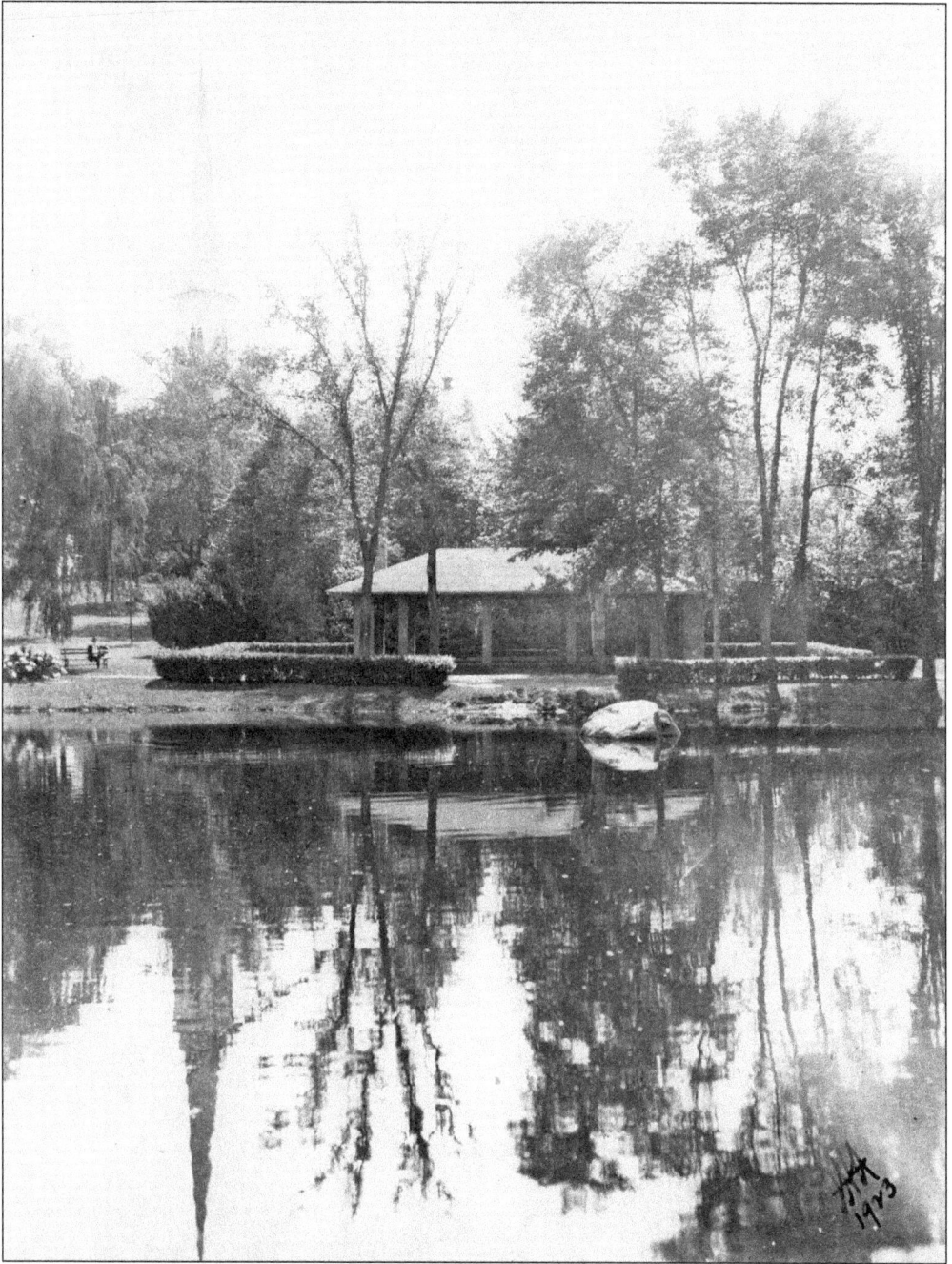

Clark's Pond, with trees and the Presbyterian church steeple reflected in the water, is pictured in 1923. Some time in the early 1920s, a skating house was erected to accommodate the ice-skaters who frequented the pond. Ice-skating in Westfield was a popular sport enjoyed by all ages. The skating house can be seen in the background of the pond at Mindowaskin Park.

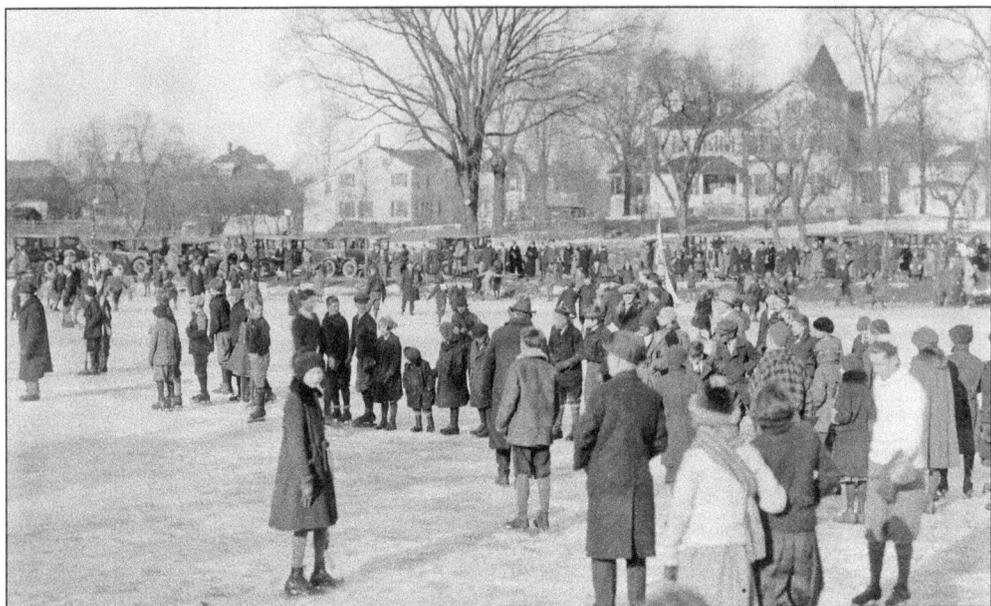

Pictured is a busy skating day on Clark's Pond in the early 1920s. "Aunt Abby" Clark dammed the steam to create this tranquil skating spot. One day, a sign appeared on the pond charging a fee for skating. It was hung by one of her sons. Since the children could not afford this, they were very upset. When Aunt Abby discovered the sign, she immediately removed it, and skating resumed to the joy of all. Clark was beloved by everyone in town, thus earning her nickname, Aunt Abby.

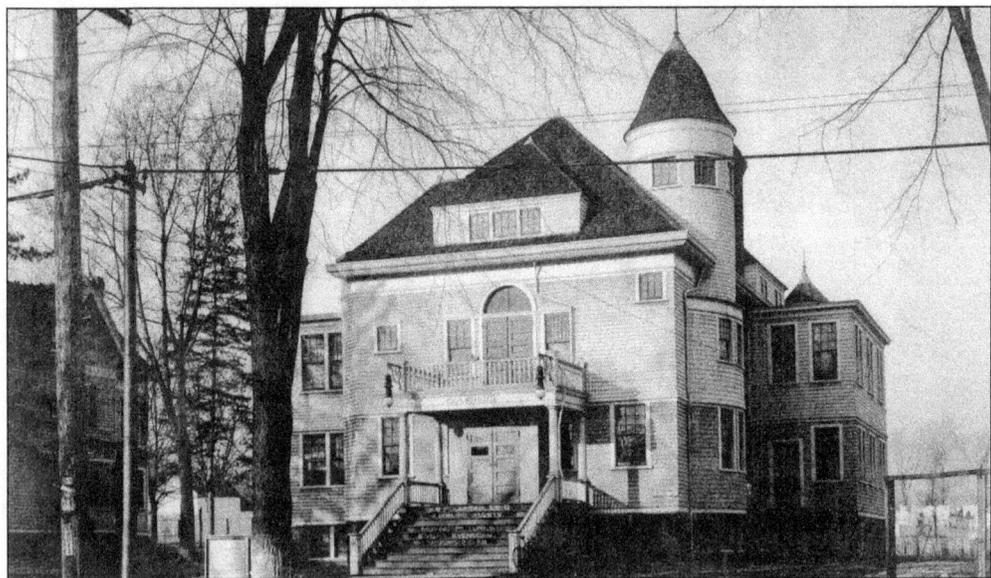

The Westfield Casino or Club was built by Henry C. Sargeant in 1892 for the Westfield Athletic Club. The three-story mansion on Elm Street served as the town's social center for almost 20 years. Originally, it was built to attract vacationers from Brooklyn and Hudson County who had begun summering in nearby Cranford. The casino successfully accomplished this goal by providing an abundance of amusements, including bowling, a movie hall, tennis courts, pool tables, and more.

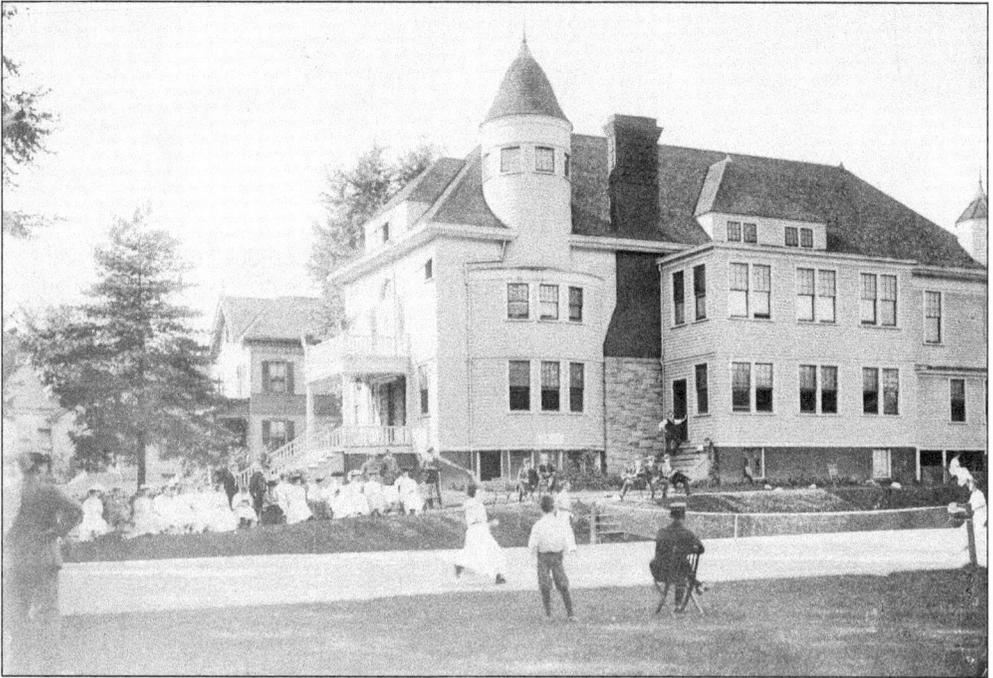

Pictured is the large, architecturally attractive Westfield Club. Spectators enjoy a tennis match. The players in this late-18th-century photograph appear to be dressed formally by today's standards.

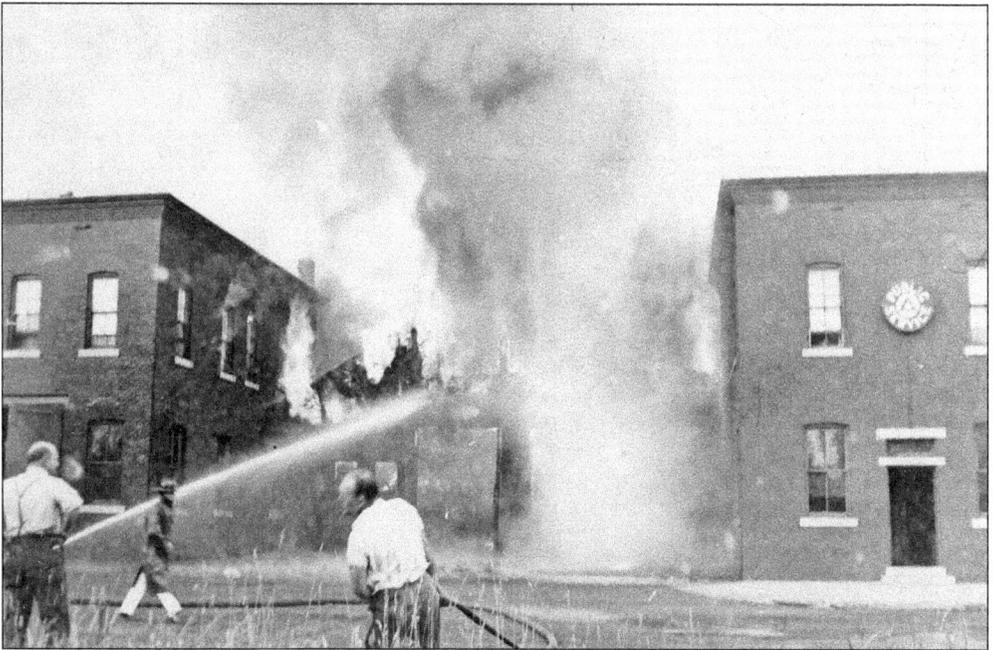

On December 6, 1911, the long-established landmark was lost to fire.

In the early 1900s, the Driving and Riding Club of Westfield controlled the Fairacres Track, one of the best half-mile tracks in the state of New Jersey and known for racing sulkies. Fairacres held its opening meet on July 4, 1900. Built and named for its owner, Robert A. Fairbairn, a resident of Kimball Avenue, a street in the vicinity of the track bears the name Fairacre today. Pictured is the crowded track with spectators enjoying a typical race from the grandstand in this early 1900s photograph. Yellow ribbons were awarded to the jockeys who won these races. Below is a photograph of a ribbon awarded to a winning jockey in a 1935 race.

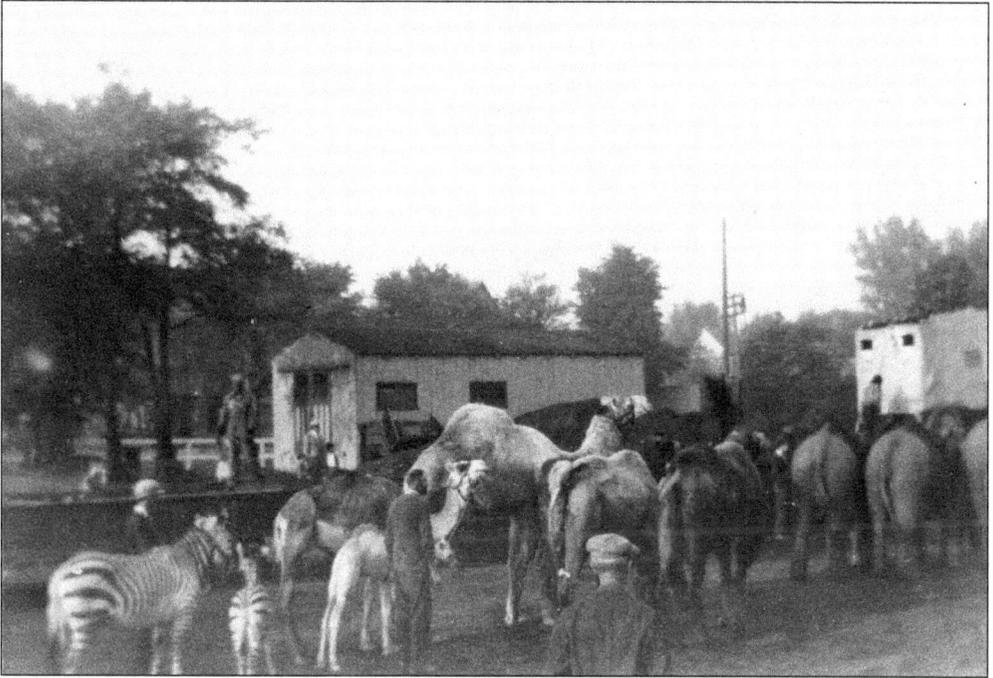

There were several locations for circus events in Westfield during the early 20th century. Property on the south side of town as well as the grounds Roosevelt School now occupies were two such spots. Pictured is the Sparks Circus arriving at the Westfield depot in the early morning some time in 1929. Traveling circuses, which were widely anticipated events, ended in Westfield soon after this photograph was taken.

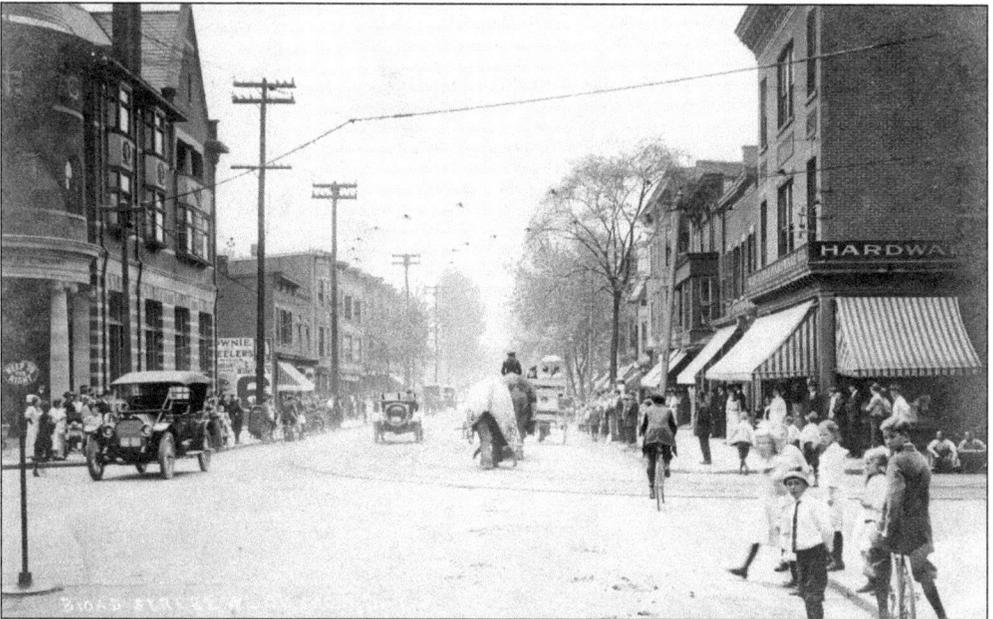

This 1913 image captures the circus parade proceeding down East Broad Street on its way to the circus grounds at the end of Central Avenue. Spectators of all ages gather at the corner of East Broad and Elm Streets to watch the exciting event.

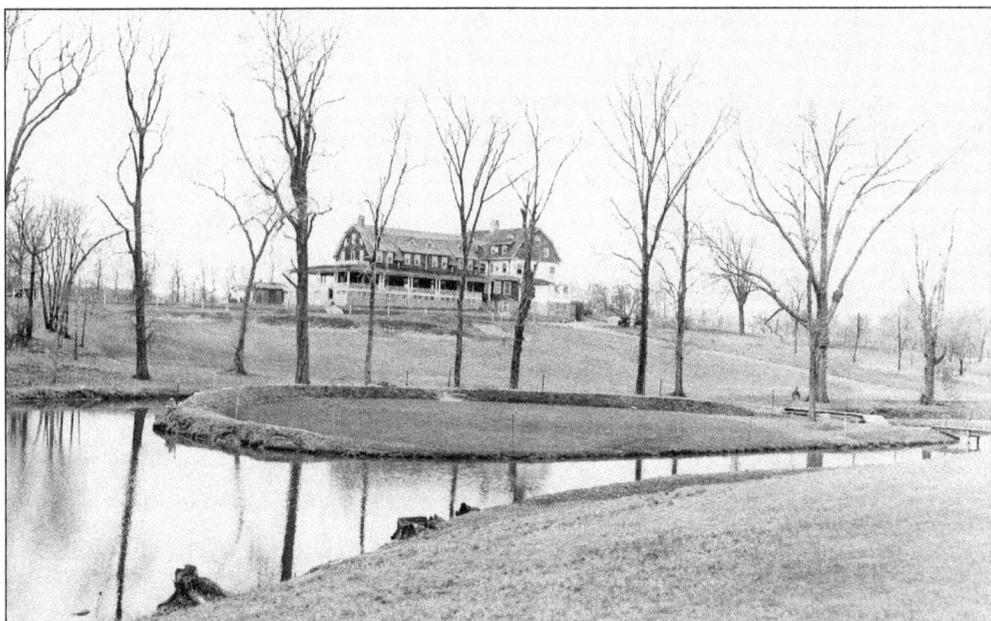

The Shackamaxon Golf and Country Club was built on the border of Westfield and Scotch Plains in 1916. At that time, it was one of the country's largest courses, measuring 6,615 yards. Since its inception, "Shack" has exemplified a luxurious, lush, green, upscale country club course. Above is the pristine and charming clubhouse as it looked in 1926. Although renovated, the building maintains its intact and enchanting appearance today. Below, canoers paddle past the 17th and most challenging hole on the course. Set near the beautiful Shackamaxon Lake, its reputation both locally and nationally among golfers is renowned.

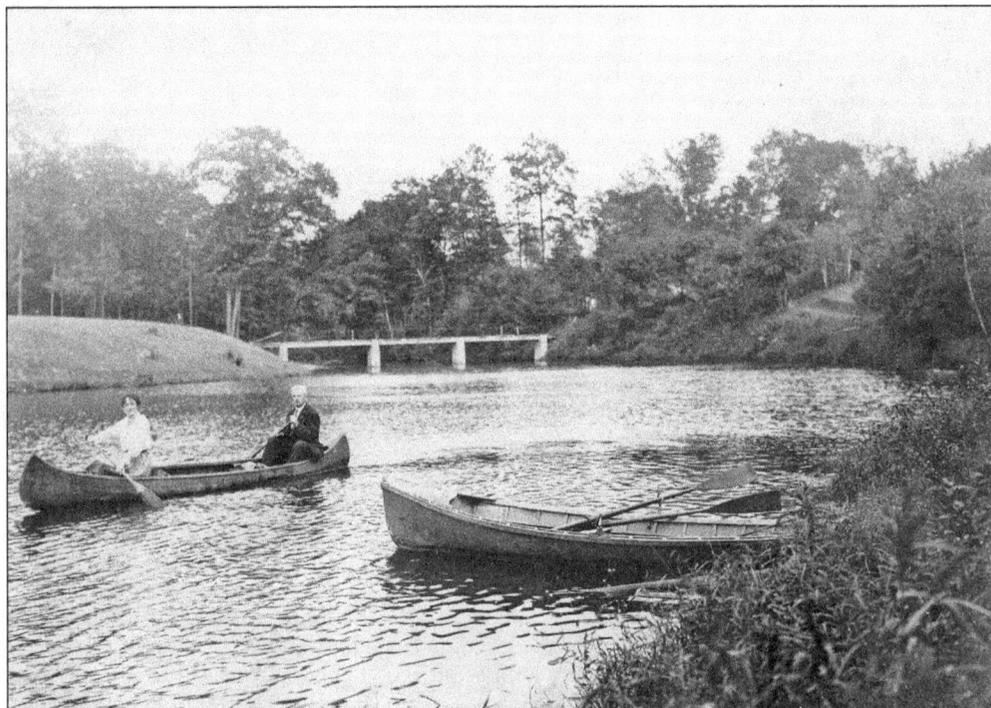

Ten

LANDMARKS AND RELICS

The Home of the "Almanac," Westfield, N. J.

Fireside Council 715, also known as the Royal Arcanum, was once the town's leading fraternal order. Founded in 1882, the group held its meeting first at the old Prospect School and then in Aeolian Hall, at the corner of Prospect Street and East Broad Street. Aeolian Hall perished in the great fire of 1892. The Schmidt-Bird Building at 201 East Broad Street was completed in 1894. When the Fireside council moved into the building in 1896, the name was changed to Arcanum Hall. This stately landmark proudly stands as one of the town's tallest and most architecturally unique structures. It is probably the most recognizable building in the downtown area.

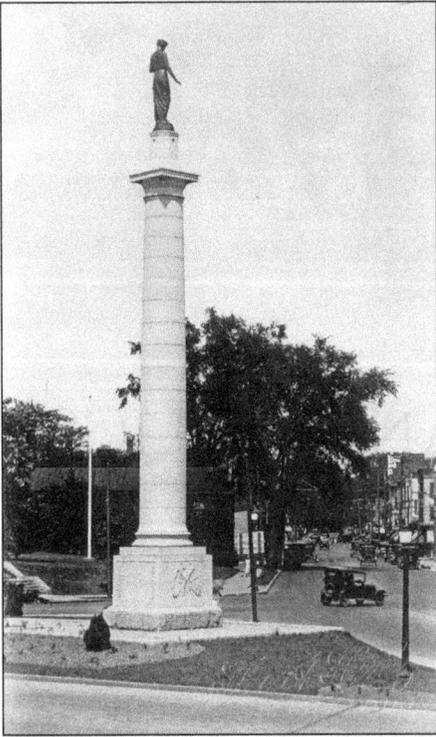

After World War I, a committee was formed to decide how to honor the Westfield soldiers who gave their lives in the Great War. After long deliberations, this striking, tall, and sleek monument was chosen. Unlike the Victory Arch, Gloriana (also called Clio) is a permanent edifice, completed in 1923. The names of the men who perished are carved in the stone at eye level for all to remember. Gloriana is a commanding presence in the center of the Plaza, proudly welcoming all who enter this historic town.

The British cannon "Old One Arm" is Westfield's most famous war relic. When British troops were retreating from Springfield, they stopped in Westfield, and a battle broke out with the Westfield minutemen. Led by Captains Eliakim Littell and Clark, the outnumbered American company defeated the enemy. The British cannon was also captured. Today it sits in the Fairview Cemetery.

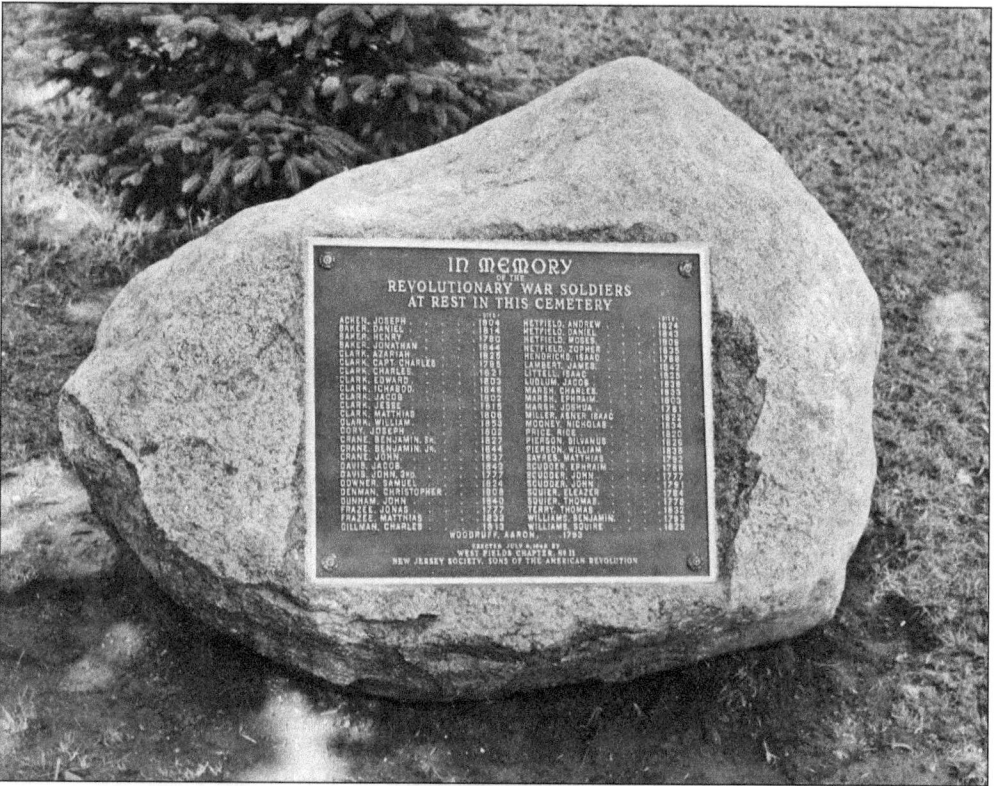

IN MEMORY
OF THE
REVOLUTIONARY WAR SOLDIERS
AT REST IN THIS CEMETERY

Name	Year		Name	Year
ACHEN, JOSEPH	1804		HETFIELD, ANDREW	1824
BAKER, DANIEL	1814		HETFIELD, DANIEL	1842
BAKER, HENRY	1790		HETFIELD, MOSES	1808
BAKER, JONATHAN	1844		HETFIELD, ICHPHER	
CLARK, AZARIAH	1827		HENDRICKS, ISAAC	1788
CLARK, CAPT. CHARLES	1795		LAMBERT, JAMES	1842
CLARK, CHARLES	1831		LITTELL, ISAAC	
CLARK, EDWARD	1803		LUDLUM, JACOB	1829
CLARK, ICHABOD	1846		MARSH, CHARLES	1839
CLARK, JACOB	1802		MARSH, EPHRAIM	1803
CLARK, JESSE	1819		MARSH, JOSHUA	1781
CLARK, MATTHIAS	1806		MILLER, ABNER ISAAC	1854
CLARK, WILLIAM	1853		MOONEY, NICHOLAS	1854
CORY, JOSEPH	1803		PRICE, RICHARD	1820
CRANE, BENJAMIN, Sr.	1827		PIERSON, SILVANUS	1826
CRANE, BENJAMIN, Jr.	1844		PIERSON, WILLIAM	1835
CRANE, JOHN	1837		SAYRES, MATTHIAS	1792
DAVIS, JACOB	1843		SCUDDER, EPHRAIM	1789
DAVIS, JOHN, 3RD	1777		SCUDDER, JOHN	1797
DOWNER, SAMUEL	1834		SQUIER, ELEAZER	1784
DENMAN, CHRISTOPHER	1808		SQUIER, THOMAS	1772
DUNHAM, JOHN	1840		TERRY, THOMAS	1832
FRAZEE, JONAS	1777		WILLIAMS, BENJAMIN	1763
FRAZEE, MATTHIAS	1832		WILLIAMS, SQUIRE	1828
DILLMAN, CHARLES	1813			

WOODRUFF, AARON ... 1793

ERECTED JULY 4, 1948 BY
WEST FIELD CHAPTER, No. 11
NEW JERSEY SOCIETY, SONS OF THE AMERICAN REVOLUTION

Above is the plaque listing the names of the Revolutionary War soldiers buried in Revolutionary Cemetery, across the street from the Presbyterian church. At right is a photograph of the plaque marking the cemetery as an official bicentennial landmark.

This replica of the United States flag that flew over the Confederate capital in 1865 hangs in the corridor of the Westfield Historical Society. The original flag was gifted to the Virginia Historical Society, as the flag was the first to fly over Richmond, Virginia, at the end of the Civil War. The Virginia Historical Society expressed their gratitude by reproducing this 10-foot-by-6-foot flag and gifting it to Westfield.

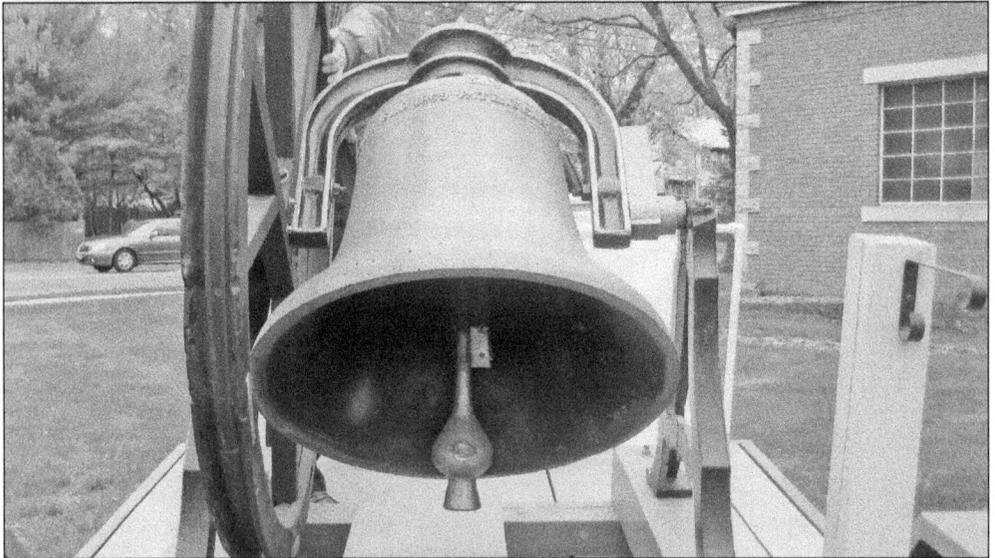

The Town Bell was cast in 1869 and hung in the Prospect School from 1869 to 1921. From 1922 to 1985, it hung in the Madison Avenue Chapel. When the congregation disbanded, the bell was relegated into storage. It then became the property of the Presbyterian church, which in turn donated it to the Westfield Historical Society. It served not only as the school bell but was the town's first fire bell and chimed for special events as well. In 1993 and 1994, the bell was restored by the Westfield Historical Society and the Department of Public Works. Currently it sits on a wagon and is displayed at town events.

The Revolutionary Cemetery was first used as burial grounds some time around 1720. In the 18th century, graves were mostly unmarked. It was customary to only mark the headstones of children. Pictured is the headstone of a son of William and Hannah, who died as a baby in 1730. There are only 18 marked graves with dates prior to 1750.

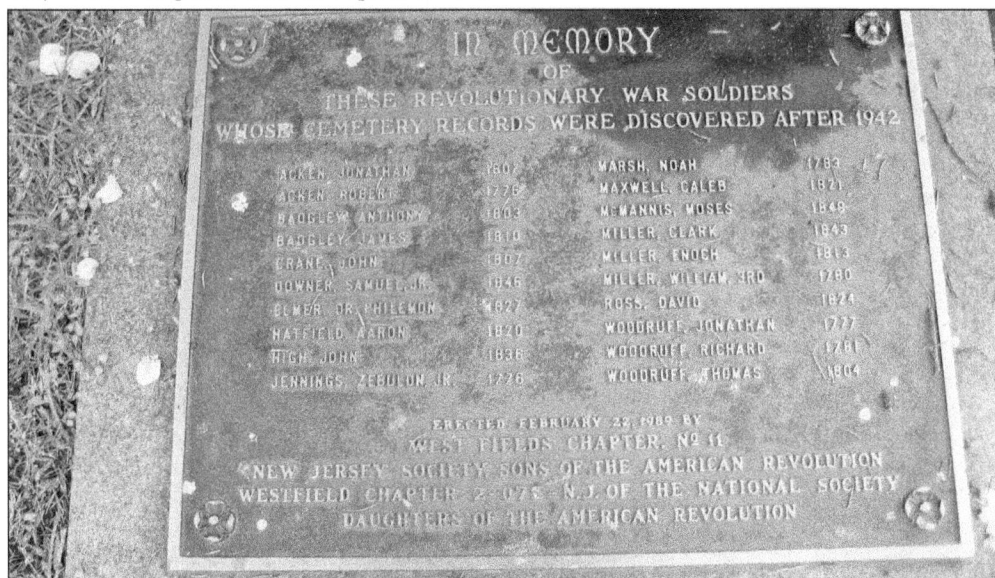

This plaque sits towards the entrance of the Revolutionary Cemetery. It commemorates those soldiers of the American Revolution who were erroneously omitted at the time of their deaths. Many of these names are recognized as early settlers. The plaque was placed by the Sons of the American Revolution (SAR) and the Daughters of the American Revolution (DAR).

Visit us at
arcadiapublishing.com
..

www.ingramcontent.com/pod-product-compliance
Lightning Source LLC
Chambersburg PA
CBHW050611110426
42813CB00008B/2523